Landscape/Landscript
Nature as Language in the Art of Xu Bing

Shelagh Vainker

With essays by Judith Goldman,
Peter D. McDonald and Xu Bing

ASHMOLEAN
MUSEUM OF ART AND ARCHAEOLOGY UNIVERSITY OF OXFORD

Landscape/Landscript
Nature as Language in the Art of Xu Bing

The Ashmolean Museum, Oxford
28th February to 19th May 2013

This exhibition was generously supported by Luzhou Laojiao.

Shelagh Vainker, Xu Bing, Judith Goldman and Peter D. McDonald
have asserted their moral right to be identified as the authors of this work.

British Library Cataloguing in Publications Data

A catalogue record for this book is available from the British Library

EAN 13: 978 1 85444 269 7

Images courtesy of Xu Bing Studio

Catalogue designed by Vermillion Design

Typeset in Milo

Printed and Bound by Deckers Snoeck, Belgium

Cover image: *Landscript*, 2013 (Cat. no. 75) detail

Inside cover and flaps: Map of The People's Republic of China. Xu Bing has
marked the map with annotated routes of the travels he made in the late
1970s and the 1980s (See p.22–3)

For further details of Ashmolean titles please visit:
www.ashmolean.org/shop

Contents

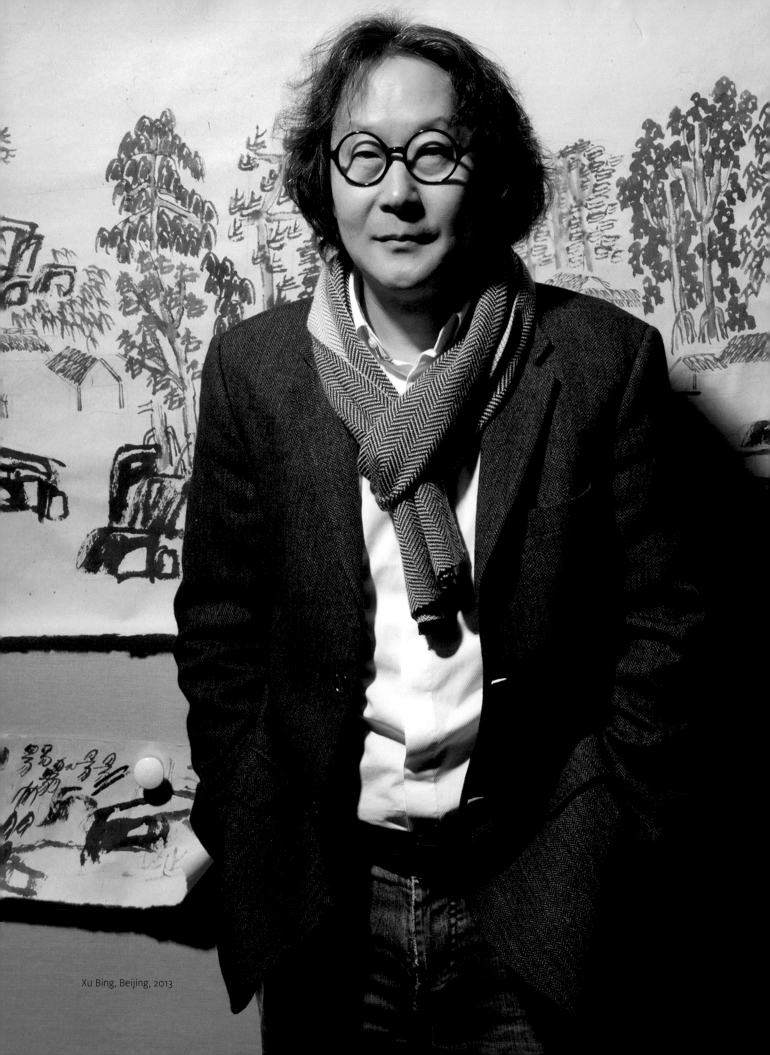

Xu Bing, Beijing, 2013

Director's Foreword

It is an enormous pleasure for the Ashmolean, and for me personally, that our first exhibition of Chinese art in the new temporary exhibition galleries, and our first major exhibition of contemporary art, should be devoted to works by Xu Bing. Xu Bing is one of the leading artists in one of the world's most vibrant artistic environments. Born in Chongqing in 1955, he grew up in Beijing where both his parents worked at Peking University. In 2008 he returned there, after nearly twenty years in the United States, to become vice president of China's most prestigious art institution, the Central Academy of Fine Arts where he himself trained in the late 1970s. His groundbreaking work *Book from the Sky* (1987–91), an ostensibly classical Chinese printed book in which he had invented and hand-carved every single one of 4,000 characters, caused a sensation in China and in the West, and in the USA earned him a MacArthur Fellowship (informally known as the 'genius award') in 1999.

He has since exhibited across Asia, the US, Europe and Australia and even developed a project in Africa (see cat. nos. 91–93). He is a truly international artist, not just in his exhibition history but because so much of his work deals with the connections between different cultures, and in particular explores them through language. The current exhibition deals with the topic of language and nature through looking at the quintessential tradition of Chinese art – landscape painting. It is a tradition that came to the fore in the eleventh century AD, and each generation of Chinese artists has aimed to change it, further it or in some way breathe new ideas into it. Xu Bing has achieved this for his own generation in *The Suzhou Landscripts*

(纸抄纸) (cat. no. 77a–d) by using print, the medium of multiples, to explore the practice of copying that is itself essential to the landscape tradition. It is an honour for the Ashmolean that these works, some ten years in the making, should have their first showing in our museum, and a further honour that he has also created two new landscript paintings for displaying together with them.

Xu Bing, as an artist who crosses cultures and engages with the past, and who is moreover a teacher as well, could not be a happier choice for our university museum. He came to the Ashmolean in 2007 to speak at the conference for the exhibition *Chinese Prints 1950–2006* and we are delighted to welcome him back.

I congratulate all those involved in this beautiful and important exhibition but would particularly like to single out Xu Bing's studio manager, Jesse Coffino and my colleague, Shelagh Vainker, our Curator of Chinese art, who has worked closely with the artist in Oxford, New York and Beijing to create this remarkable show.

I would like to thank Professor Michael Sullivan for his friendship and support of the Ashmolean, and for generously lending to this exhibition. My sincere thanks also, to the sponsors of this exhibition, Luzhou Laojiao, a distinctive class of Chinese spirit. Brewers have been distilling Luzhou Laojiao since 1573, making it the oldest Chinese spirit in continuous production – a very appropriate partner therefore, for the Ashmolean, Britain's first Museum.

Professor Christopher Brown
Director
January 2013

Introduction

Shelagh Vainker

'Today's China is an extremely experimental place, and we live in the midst of it so I should be an extremely experimental artist' writes Xu Bing in 'The Sort of Artist I Am'. Today's China is not just an experimental place but an expanding one too, in its multidimensional reach across the world. One of Xu Bing's current projects – the *Book from the Ground* that he refers to on page 201 as 'using signs that you can see everywhere' – is undoubtedly experimental and, as a book 'that everyone can read ... that has at last levelled the educated and the illiterate', is accessible to anyone living in a town or using modern technology, in any country and regardless of their educational level. *Book from the Ground* uses icons collected from signage in public places, or on documents where no particular language can be assumed, to narrate a single day in the life of an ordinary man, and its name refers to *Book from the Sky* (*Tianshu*, 1987–91), the book that established Xu Bing's career in the early 1990s. The *Book from the Sky* is in four volumes, and its content, while having the appearance of a classical text in Chinese characters, is actually made up and cannot be read by anyone. Both of these inverse projects grasp the life of their respective times (See p. 201 'The Sort of Artist I am'), and both do so through language, while their contrasting presentations of language – universally comprehensible on the one hand, universally impenetrable on the other – are precisely what has made them accessible, and successful, to an international audience.

The new works that Xu Bing is presenting for the first time in this exhibition (*The Suzhou Landscripts*

(纸抄纸) cat.nos.77a–d) address the language that these two projects have avoided – the Chinese language, and in particular its essential pictographic qualities – and explores the ways in which these have defined Chinese people's relationship with nature, culture and particularly with art. Xu Bing is an international artist known for participating in exhibitions in Asia, Africa, America, Australia and Europe. He lived in the United States for eighteen years and is associated with work that explores and disrupts assumptions about the relationships between different cultures, as Peter D. McDonald discusses in his catalogue essay (pp. 184–99). Xu Bing is nonetheless, as he states, a Chinese person through and through, and here he turns his attention to the essentials of Chinese culture as exemplified by its most fundamental aspect, its writing system. This, he maintains, has influenced the way in which people express themselves, how they relate to nature, even the ways in which they move around, and this influence flows from the visual elements contained within the written language.

The importance of the written word in Chinese art – as inscription, decoration or calligraphy with brush and ink – is one of the most discussed topics in the history of Chinese art. Xu Bing's interest in it is not connected to the use of characters in artworks, antiques or collectibles, but rather lies in the systems within the written language itself: how the visual elements articulate or create a relationship between the language user and the myriad objects around him, and how the repetitious use of those elements

builds additional systems, or conventions. In 1999 he participated in a project that took a number of artists to the Himalayas and there, for the first time, he 'looked at a mountain and drew a mountain', composing a sketch that described the mountain by drawing the Chinese character for 'mountain'. He called the new method 'landscript' and in the new works in this exhibition has assimilated it into his own versions of paintings in the classical landscape tradition. In so doing he not only refines his expression of the relationship between art, man and nature in using the conventions of the Chinese pictorial language to comment on the conventions of Chinese landscape painting, but breathes new life into that same tradition. In that he acts not only as a contemporary artist, but as one picking up a responsibility borne by Chinese painters since the end of the Song dynasty (960–1279). Indeed, when his artwork is considered alongside his writing and his senior position in a leading public institution, he might be considered as just like a scholar official in the literati painting tradition established during that period.

However, Xu Bing lives in a wider world than that of the Song dynasty and his new works break from the tradition that they update in a particularly significant aspect: the inscriptions are in English. It doesn't at first glance look as though they are in English, for the words are configured to look like Chinese characters, in the Square Word Calligraphy that Xu Bing invented in the 1990s, and this is a manifestation of something that runs through all of his work – the mixing of Western learning with the Chinese philosophical attitude to the natural world.

Xu Bing's formal education was disrupted by the Cultural Revolution (1966–76), during which he spent three years (1974–7) in a rural village beyond the Great Wall. This experience came under one of the guiding socialist principles of that time, that the educated should be involved with the ordinary, and it is one from which he has never been able to depart. It lies behind his belief that art should connect with society, that it should engage widely and be participatory, and that it should keep pace with the times. This exhibition is centred around works engaging with the Chinese painting tradition, in which landscape has held the pre-eminent position for almost a thousand years. Xu Bing addresses the landscape tradition through the essentially Chinese cultural qualities on which it is based yet the exhibition also looks at the ways in which his landscape art has connected not just with Chinese society but beyond: in the first section with Europe, in works from his youth when socialist educational policies derived from the Soviet Union and in art ultimately from France; and in the third section with the whole world. His Forest Project uses language and nature in a way that is global, and demonstrates his conviction that contemporary artists have a responsibility to promote the protection of the environment and to progress from making landscape painting that describes scenery to using art to protect nature. In this Xu Bing is again experimental and grasps the life of all our times. |sv

Notes on Xu Bing's Prints

Judith Goldman

On an overcast morning in October 2012, I accompanied Xu Bing to the Long Island print studio, where he was working on a series of lithographs *The Suzhou Landscripts* (纸抄纸). Although he arrived in New York the day before, he looks fit and rested, and not like a man who has spent the last week travelling from Beijing to New York, with a stop in San Francisco at the Asian Art Museum. He is ready to work and has brought along his calligraphy brushes, stamps, seals, special ink and pyjamas – in case he needs to spend the night. It is almost a decade since he began the series and he hopes to finish it on this trip.

At Universal Limited Art Editions, the staff are prepared for his visit. The artist's studio is empty, its walls bare except for the four lithographic proofs, each carefully annotated with green tabs and corrections in red pencil by Xu Bing. Studying them, he checks the corrections. He says little. With only three days in New York, he must work fast. His manner is deliberate and unhurried. There are other people in the room, but they do not distract him. Jason Miller, a master printer, stands to one side, waiting to assist him. Shelagh Vainker, curator of Chinese Art at the Ashmolean Museum, who is organising an exhibition of Xu

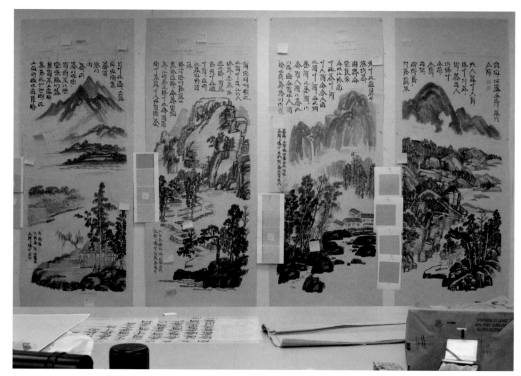

Fig 1 Working proofs for *The Suzhou Landscripts* (纸抄纸), October 2012.

Bing's landscapes, watches and takes notes; Xin Yao, an assistant of Xu Bing's, moves around the room taking photographs.

Each lithograph is after a hanging scroll in the collection of the Suzhou Museum. Following Chinese tradition, Xu Bing has copied ink paintings by seventeenth-century masters from the Qing and Ming Dynasties. They are not exact copies. He does not replicate the originals (which are themselves copies); instead, he transforms them into dazzling calligraphic landscapes. The prints, layered with words, signs and visual puns, would appear finished, if one didn't already know that they are not and that, according to the artist's instructions, there is more to be done. Blacks need changing, a river lightened, a tree removed. The red is not a Chinese red. The sheets, printed to simulate the look of ancient Chinese papers, should differ more in tone – one sheet needs yellow, another red. And the text – its width must be increased by 2 millimetres.

Xu Bing spends the day making changes on the Mylar sheets, the twenty-first-century substitute for lithographic limestone, while Jason concentrates on getting the right red. His first attempts fail, but on the third try Jason mixes the perfect colour – the vibrant, fiery red of Chinese lacquer. Meanwhile, in another room, Jill Czarnowski works on the digital printer to adjust the colour of the papers. Together, the four lithographs comprise one work, but because each is a copy of an earlier work, Xu Bing has had the paper printed in four different tones. Now he wants to make a change in colour so subtle that it may be difficult to achieve. Too much tonal difference will pull the work apart, too little will flatten it out, merging the images so that they read as a mural. The tonal adjustments do not pose a problem and are made easily. That night, when Xu Bing finishes working, a sense of relief fills the studio. The day has gone well. Decisions have been made, crises averted. Xu Bing has

finished one landscape and turned his attention to the revision of another. The spontaneous look of the landscapes – the fast marks and flowing lines – belies their complexity. To print one four-part lithograph requires thirty-five separate plates. The printing of the entire edition will take two months, if there are no additional changes. With the exception of the woodcut, printmaking is an infinitely mutable media. It allows an artist to move forward and backward, to delete whole passages or add and reinstate others. It fosters a provisional state of mind. Among its prerequisites are patience and perseverance. It offers the perfectionist countless options (Xu Bing has described himself as a 'picky perfectionist' with 'exacting eyes'). Every decision leads to revisions, every change to still other alterations. Printmaking is a complicated, indirect, seemingly endless process, and one for which Xu Bing is temperamentally well suited.

———————

'That which belongs to you is yours…. It is your cultural background and your life. It determines the inclination and style of your art. Your background is not of your own choosing. This is especially true for Mainland Chinese artists.' Do not push against fate, Xu Bing tells us in his infrequent, always revelatory essays. 'What's yours is yours, even if you don't like it; there is nothing you can do about it.' For Xu Bing, acceptance is not only a Zen-inspired philosophical position , it is a matter of character. To accept one's tradition and history is also the underlying premise of his radical art.

According to Xu Bing, he was predestined to become a printmaker. He grew up around books and prints. His parents worked at Peking University – his father as head of the history department, his mother in the library. When he was four years old, he often accompanied his mother to work, where he'd play in the stacks with books that seemed as large as he was. He

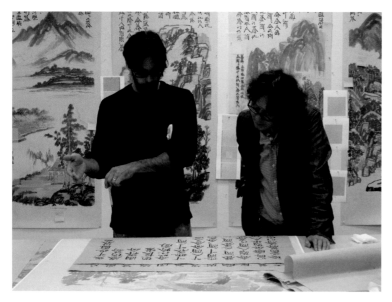

Fig 2 Jason Miller and Xu Bing at Universal Limited Art Editions, 8 October 2012.

fell in love with books before he could read – not with the stories they told but with the way they looked and felt. He is drawn to the texture of paper, the smell of ink, the shape of fonts and the way type sits on a page. Print pervaded his childhood. He cut up printed illustrations found in discarded magazines and pasted them into a scrapbook which he describes as 'an anthology of Socialist-era Chinese printmaking', and pored over illustrations in his father's bound copies of *Red Flag* (*Hongqi*), the flagship magazine of the Communist Party. His predisposition to the rigours of printmaking came from his father, who demanded that his son draw a page of characters a day ('my father's instruction was as rigid as a block of wood', he writes). His study of calligraphy triggered a lifelong fascination with words and meanings, and their visual renderings. It also taught him to sit up straight, concentrate and follow the rules.

In 1966, at the onset of the Cultural Revolution, colleagues of his father, banished from their teaching positions, left Xu Bing with a set of woodcutting tools, French printing ink, print catalogues including *Northern Woodcuts*, and a collection of books on French and Russian art. The

gifts were a godsend to the eleven-year-old boy. The Cultural Revolution left his family disgraced and in disarray: his father was paraded through the streets and jailed; his mother was re-educated and demoted. Art, already an interest of Xu Bing's, now offered solace. The books introduced him to European art, and to China's modern woodcut movement and the work of Gu Yuan, a future teacher. With school suspended, Xu Bing spent hours teaching himself to cut and engrave wood and practising calligraphy. His graphic skills served him well. In 1974, when he was relocated to Shouliang Gou village in the mountains outside Beijing, his talent as a draughtsman and calligrapher earned him much-needed respect. As the village portraitist and letterer for weddings and funerals, he was in demand and accorded special status.

In 1977 Xu Bing received a letter of acceptance from the Central Academy of Fine Arts in Beijing. To attend CAFA, China's premier art school, was his childhood dream, and if he was initially disappointed by his acceptance in the printmaking, rather than the painting department as he hoped, later he would say it was a lucky turn of fate. Xu Bing's years at CAFA influence the kind of artist he becomes and the course of his career. He was a diligent student with a nascent love of craft and penchant for hard work; immersing himself in printmaking, he dedicated himself to mastering the techniques of each medium and understanding its properties. 'The success of a work', he writes, 'lies in finding the most appropriate control of its materials. This is the artist's duty as a craftsman.'

Each graphic medium consists of a syntax that must be mastered and understood, each requires specific tools to achieve its effects. Woodcut, a relief medium, depends on contrasts between blacks (areas which stand in relief) and whites (areas which are cut away). Images are made by marks incised into the wood's surface by cutting away lines between designs with knives and gouges, or by any other means – sandpaper, a

wire brush, a nail (it is an unforgiving medium that offers no remedy for mistakes). Historically, each graphic medium represents a technological advance over its predecessor, a faster, more efficient way to produce an exactly repeatable image. Metal engraving yields a more refined network of lines than woodcut; an etched line is infinitely more fluid than either one; a drypoint line is more fragile and delicate. Lithography, a late nineteenth-century invention, dependent on the resistance of oil and water, freed artists from tools entirely, allowing them to paint or draw on the transfer surface with any material they chose. Finally, photography and the media that follow in the age of photomechanical and digital reproduction, require not only new skills of a more cerebral and mechanical order, but a new vision.

All of this matters to Xu Bing. During his years at CAFA, he mastered each graphic medium. *Knifework* (1977), his first woodcut assignment, demonstrates the variety of marks a woodcut knife can make. His early *Shattered Jade* series (1978–85), depicting rural life in Shouliang Gou village, reflects the beguiling directness of the woodcut. Whatever the medium, Xu Bing appears to have instinctively understood its properties. The tonal gradations of *Stones* (1987) could only be achieved with mezzotint, the eighteenth-century process

Fig 3 Shelagh Vainker and Xu Bing at Universal Limited Art Editions, 8 October 2012.

that produced halftones. Bevelled angles, a speciality of the woodcut knife, create the dynamic movement in *Young Women Threshing Rice* (1981). His prints appear effortless but, as his copy of Rembrandt's *The Blindness of Tobit* (1979) reveals, Xu Bing worked hard at mastering techniques.

In the 1987 *Five Series of Repetitions*, he explores the process and properties of the woodcut. His subject, repetition, is potentially a dull one, but he charms the viewer with images of farmlands and schools of tadpoles; carving each image sequentially, with a whimsical flourish, he reveals the woodcut's reductive and repeatable nature, and the variables of its printing surface. The series, completed for his Master's Degree at CAFA, was accompanied by an essay, 'A new exploration and reconsideration of pictorial repetition', in which he analysed the distinguishing characteristics of printmaking and explained his affinity toward the media. After finishing the *Repetitions* series, Xu Bing stopped making woodcuts. He had taken the medium down to its essentials and there was nothing left to do. This marked the end of one stage of his career. Moving on, he left the parochial world of printmaking behind and hasn't made a purely pictorial print since. But his interest in print continued, growing more nuanced and ambitious, and his focus shifted to the conceptual nature of the print and its ability to convey information.

Like Andy Warhol, print, in one form or another, is the material out of which Xu Bing makes art. Every graphic work – from *Book from the Sky* (1987–91) to *Book from the Ground* (2007-) to the recent lithographs *The Suzhou Landscripts* (纸抄纸) (2004–12) – is a meditation on the nature of print, on signs and symbols, on reproduction, repetition, and repeatable images. In Xu Bing's hands, print is a malleable media, which he uses to make the simplest of impressions in *Ghosts Pounding the Wall* (1990–91) or to offer instruction in *Softening the Brush* (1995) and *Holding the Brush* (1996). He is an artist first, but he is also a dedicated teacher who never forgets the print's capability

to offer instruction and transmit information. For Xu Bing, the image and the idea it conveys are inextricably connected.

———————

I first saw Xu Bing's prints in 2001 at his Brooklyn studio, a cement-walled unfinished space that occupied the ground floor of a former Italian bakery. The room was dank and dark, empty except for a desk, a locked glass-panelled bookcase holding Chinese books and a print cabinet. The prints that Xu Bing showed me were woodcuts from his *Repetition* series. At the time, I didn't know that the woodcuts had been made fourteen years earlier or had an extensive exhibition history, or that Xu Bing, while still a student, had shown his graphics at the British Museum and the Louvre. A few days later, I sent Xu Bing a note thanking him for the visit and inviting him to collaborate on a publishing project for my imprint, Deuce II Editions, which publishes artist's books and prints.. His assistant wrote back – a gracious, non-committal note. Xu Bing was busy, she said, working on his 2001 retrospective at the Sackler Gallery in Washington DC, but he liked the idea of a future project.

Over the next two years there were phone calls, emails, occasional coffees and a weekend trip to New England to visit an intaglio printer and typesetter with Xu Bing and his family. Again, I received a gracious thank you note, but this time it was from Xu Bing himself and less non-committal. In 2004 Xu Bing and I visited Universal Limited Art Editions and its director Bill Goldston agreed to print the project. It was the perfect place, not only because of the quality of ULAE's printing, but because no other printers would have put up with the project's erratic schedule or have gone to the lengths they did to achieve the results Xu Bing wanted. Over the course of ten years, the project grew in scale and ambition, but its subject – the Chinese tradition of copying – did not change.

There were long periods between lithographs, and interruptions for exhibitions and other projects. In 2008 Xu Bing returned to China to become vice president of the Central Academy of Fine Arts, but even that didn't disrupt the project. In the twenty-first century lithographs are drawn and painted on sheets of lightweight Mylar (limestone slabs are no longer required). Xu Bing finished the last two landscapes in his Beijing studio, although the move did create logistical problems about how and where to pick up proofs. Jesse Coffino, the director of Xu Bing's New York studio, found solutions, making arrangements for meetings and pick ups wherever Xu Bing happened to be: in Beijing, London, or at the Chinese Embassy in Washington D.C. He also suggested that I meet Shelagh Vainker to tell her about the project which I did at the opening of Xu Bing's *Tobacco Project* at the Virginia Museum of Fine Arts in September, 2011. It was there that Xu Bing and Shelagh Vainker first discussed this exhibition and it was in the Print Room at the Ashmolean that December that I picked up Xu Bing's final revisions.

While working on the landscapes, Xu Bing began and finished the *Mustard Seed Garden Landscape Scroll*, his version of the famous seventeenth-century painting manual. The Chinese tradition of copying was on his mind and the two projects, though very different, informed each other. In China, copying is a respected teaching tool. Artists copy in order to learn. In the West, copying is associated with fakes and forgeries. Fascinated by the cultural difference, Xu Bing wryly took on copying as his subject. For the *Mustard Seed Garden Landscape Scroll*, he copied images from an early version of the manual, cut them apart and, after rearranging them, hired craftsmen to carve and print the images on a scroll. A conceptual work, conceived of as a reproduction, the *Mustard Seed Garden Landscape Scroll* bears no trace of Xu Bing's hand. In *The Suzhou Landscripts* (纸抄纸), he adopts a different stance: choosing lithography, the most painterly of the print media, he lavishly paints his

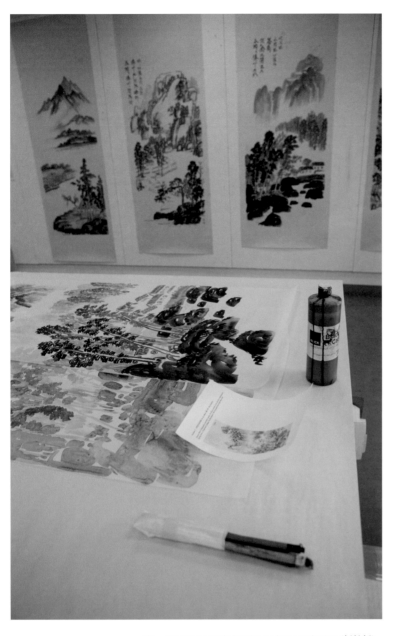

Fig 4 Working proofs for *The Suzhou Landscripts* (纸抄纸), before the Square Word Calligraphy and the red plates.

version of ancient landscapes in his inimitable, calligraphic style. They do not look at all like prints; Xu Bing has gone to great lengths to create the look of paintings, even digitally replicating the colour of traditional paper. Throwing all categories into question, he has made an original of a copy in a limited edition. At the same time, he acknowledges and updates the Chinese tradition of landscape painting and assumes his place in it.

The landscapes evolved over time. And as they grew richer and denser, Xu Bing's attitude to them changed as well. At times, he appeared bemused by them, surprised by their presence, like a guest he wasn't expecting. Once he said that they were not like anything else he had done before. Another time, after studying the proofs, he found them uproariously funny. When the lithographs were finally finished and all together for the first time, they looked like traditional Chinese paintings. Soon after, he added the square calligraphy text and the pictographic symbols; layering them with meaning, he transformed the landscapes into visual treatises on the meaning of Chinese painting and print. Watching Xu Bing work has taught me about time and printmaking. He rushes nothing, even if he's late. He forces no decisions. He has an awesome regard for the printed mark and word. The slow process of printmaking suits him. He began with a concept but no plan – that grew out of the process. For Xu Bing, printmaking is not an auxiliary media, but a major one out of which he makes art. |JG

Part One
The Path to Landscript

The Path to Landscript
Works 1974–1987

Shelagh Vainker

Xu Bing's earliest experiences of landscape were direct, walking in the former imperial parkland of his childhood home at Peking University (Beida) and accompanying his father on fishing trips to the wild natural spaces beyond the university grounds. (fig.1) Their own garden was small and filled with plants, both edible and ornamental, that his father had nurtured from seed. People and landscapes are both part of the natural world, yet the relationship between them requires a means of expression that is artificial. It cannot be articulated without language – verbal or visual – that is itself a human artefact. This intervention lies at the heart of the works that are at the centre of this exhibition – the 'landscripts' that Xu Bing first created in 1999 and which assume a new complexity in the set of four prints, begun in 2004 and completed in late 2012, around which the exhibition is organised (cat. nos 77a–d).

The landscripts have the appearance of traditional Chinese landscapes, as developed since the Song dynasty (960–1279); their difference and their contemporaneity is in the use that Xu Bing has made of the pictorial aspect of Chinese writing to create the elements – the rocks, trees, water, grass and so forth – that form the landscape composition. The Chinese ink landscape tradition is a long one, familiar in the households of educated people in China for more than a thousand years, but in the environs of China's leading university in the first decades of the People's Republic of China, it was not much in evidence. Challenged

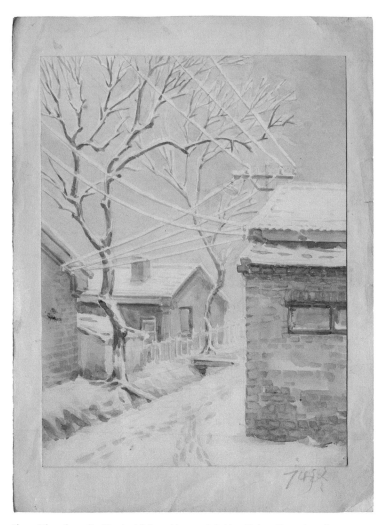

Fig 1 View from Xu Bing's childhood home at Peking University, watercolour on paper, 21.5 x 16.5 cm. The mount has been annotated *Winter, 1974* by Xu Bing's father, who was head of the University's history department.

for its associations with China's feudal past and harnessed to policies that implemented Mao Zedong's declaration at the 1942 Yan'an Talks on Art and Literature that art must serve the people, landscape painting was neither widely visible nor freely practised. Rather, the visual representations of landscape that Xu Bing encountered in his childhood were those that appeared in periodical publications that he saw at home.

The most important of these for Xu Bing were the complete bound volumes of the Communist Party flagship magazine *Red Flag* (*Hongqi* 红旗), and the illustrated sections of discarded journals that his father would collect for him from the university teaching rooms and which he subsequently pasted into separate volumes of his own. He has written that these woodcut illustrations, which came from socialist publications and derived in style and technique from the art form adopted by the Communists in the 1940s, constitute part of his 'artistic DNA'. Xu Bing's work always carries complexity, and the materials it uses and the forms it assumes are wide-ranging; there is nonetheless consistency and recurrence, and much of it can be traced to the values associated with these early encounters. Printmaking is the technique in which he was formally trained; in works where print is not the medium, repetition itself is often still an important element, while the conviction that art can benefit society is detectable or implicit in most of his work and explicit in some projects (cat. nos 72–3, 91–3). In his early works, particularly those relating to landscape, there is moreover a concern with the simplicity of rural life for ordinary people. The early drawings and prints in the first section of the exhibition show all of these characteristics to a greater or lesser extent; they also embody reductions and repetitions that provided the groundwork for the project that established his name, *Book from the Sky* (*Tianshu*, 1987–91), and anticipate the forms and concept of landscript.

In 1974 Xu Bing finished school and, in line with the practice for urban youth during the Cultural Revolution, was sent to the countryside to experience how people lived. Together with four other students he spent three years in the village of Shouliang Gou in Yanqing county, north of Beijing beyond the Great Wall. It was still within Beijing municipality but required two days' journey by bus to reach, and visits home were allowed only once or twice a year. As yet untrained as an artist, and despite the challenging environment of rural labour and harsh living conditions, Xu Bing still found many opportunities for drawing and printmaking. The drawing instruction he had received in art classes at school accorded with the Soviet styles adopted as the official model for visual arts in China in the 1950s. His teacher at school, Feng Lisha, had trained at the Academy

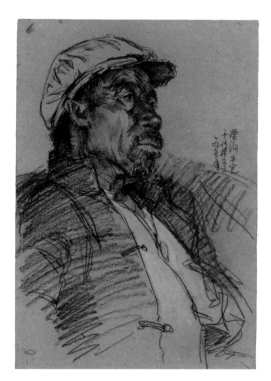

Fig 2 Portrait of a herdsman, 1977, pencil and watercolour on paper, 39 x 27 cm. The herdsman was from Shaliangzi, the commune in the village neighbouring Shouliang Gou in northern Hebei province, where Xu Bing lived between 1974 and 1977 as an educated youth sent from Beijing during the Cultural Revolution.

for Applied Arts where that ethos prevailed and Xu Bing had consequently been taught to draw in a realistic, representational way. This is reflected in cat. nos 1 and 5, both completed in 1976, and is perhaps most evident in the slightly blunt, straight lines of the scene in Peking University that was done on a trip home in August of that year.

In Shouliang Gou he drew in the evenings, initially mainly portraits of the village's inhabitants and later on more landscapes. (fig. 2; cat. no.5). Like the early landscape drawings, these portraits demonstrate the stylistic consistency that prevailed in art in China at that time. They also however testify to Xu Bing's talent: his depictions of the villagers, drawn before he had received any formal training, achieve a close comparability with those of the workers and peasants depicted by Wang Shiguo, Jin Shangyi, Lin Gang and other leading oil painters of the generation before Xu Bing.

Xu Bing's practice of art at school was not, however, limited to Feng Lisha's classes. Circumstances in school during the Cultural Revolution demanded the production of public text. Xu Bing, recognised by his teachers and peers for his ability, produced hundreds of big-character posters along with stencilled text for mimeograph publications that fulfilled the requirements of the school's political office. He worked on these with particular dedication and has written that, as the child of a family marked as politically problematic (p. 6), he and others like him applied themselves relentlessly to such revolutionary tasks, striving to prove their worth. In fact, Xu Bing worked himself to ill health and only joined his classmates in the countryside after some months rest at home. Once there his skills were again put to use for others, though now for cultural as well as political purposes. Among the villagers he was in demand for writing couplets on banners celebrating New Year, weddings, funerals and other occasions. His possession of brushes and ink alone set him apart in their eyes, while

his knowledge of language was itself a source of some wonder. Reading and writing skills were not widespread in Shouliang Gou, with some of the younger villagers competent but many of the older generation quite unable to write or even recognise characters. His calligraphy for funerals replaced the characters that the elder villagers had habitually transcribed from scraps of print onto white cloth as a means, Xu Bing only later discovered, of communicating with the nether world. In addition to encountering this 'ghost writing', as it was known, he in turn marvelled at the writing he saw painted on furniture, where auspicious phrases of four characters were arranged overlying each other as a single character. The dynamic of these mutual illiteracies is present in much of Xu Bing's work.

Within the wider commune his skills were employed in the production of the Huapen quarterly magazine *Lanman shanhua*, (Brilliant Mountain Flowers) for which he made the physical text, created the images and designed the layout. The content included articles – written by fellow students, though never by Xu Bing – songs (including scores) and illustrations. His contribution was in the design and production, and he took the opportunity to expand his experience of different typefaces and logos. On visits home to Beijing he viewed art exhibitions and on a few occasions met with the oil painter Li Zongjin, the husband of one of his mother's colleagues and his 'first real professional art teacher'.

In the absence of any formal education during this three-year period of deracination Xu Bing thus continued to learn, from infrequent encounters with metropolitan art and artists, and from practising alone whenever he could. The portraits, landscape sketches, ritual calligraphy and journal printing all resulted from opportunities that he created or seized to improve his skills and explore new methods. All to some extent informed later works, yet the key influence of the period on

Fig 3 Persimmon tree, around 1980, red chalk on paper. This drawing is typical of the rural scenes Xu Bing sketched in southern Hebei province while preparing his degree project in 1980.

his subsequent creativity lies less in the art he produced at that time than in the profound effect that the rural environment exerted on him. (fig.3) In an article published in 1981 he wrote:

> Of course a life of wresting food from nature should not be the lot of people of our times, yet still I deeply cherished that period of my life and I really missed my old village home, I often used my holidays to go back there and stay for a few days. In that place a grinding stone, a dirt road or a random haystack would all give me a warm feeling, it was all so plain, so real and also so beautiful, every time I thought of it my heart leapt.

This affecting description of the strengths of what could easily be depicted as an unforgiving episode appeared under the title 'I picture things that I love'. It was written shortly after his graduation from his first degree in January 1981 and is illustrated with drawings (including cat. nos. 8, 12,13) and prints from a series of eventually 128 small woodcuts that he produced between 1978 and 1983 entitled *Shattered Jade* (cat. nos. 44–57). In addition to the development of technique, this series and his other undergraduate work are in fact characterised by a combination of personal closeness to ordinary life as experienced at Shouliang Gou, and the formal socialism that

pervaded the teaching at the Central Academy in the late 1970s and early 1980s.

Xu Bing attended the Central Academy direct from Shouliang Gou in March 1977. He was amongst the first intake of the restored admissions system after a ten-year hiatus during the Cultural Revolution, and entry was not simple. He recounts his own experience of the process in the essay 'Ignorance as a form of nourishment', excerpts from which follow in this catalogue (p. 27). From the Academy's point of view, it was a matter of selecting from more than ten years' worth of talent from all over the country. For graduate study alone there were more than two thousand applicants, and in the end fifty-four graduate students and fifty-five undergraduates were admitted, with a further twenty in a special training class. Xu Bing had applied to study oil painting, perhaps inspired by his meetings with Li Zongjin, but was assigned to the department of printmaking, which he has subsequently described as a more versatile medium affording the greatest possibilities for keeping abreast of modern life.

His teachers included Gu Yuan, Li Hua, Zhan Jianjin, Luo Erchun and Wu Biduan, of whom both Gu Yuan and Li Hua were veterans of and leading figures in the woodcut movement of the 1930s and 40s. Gu Yuan's influence on Xu Bing was profound: as a child he had wanted to study at the Central Academy and at school he had written an essay, appropriated from a model piece on the painter Lin Fengmian, called 'I love Gu Yuan's art'. Not long after his graduation it was Gu Yuan's advice, 'The path you are on will best be developed in China', that provided Xu Bing with the confidence to pursue his work and decline opportunities to study abroad. Xu Bing's appreciation of Gu Yuan, written in 1996, recognises the innovation Gu brought about through creating woodcuts that expressed his own first-hand experience of rural life in the liberated areas of north China during the 1940s.

Gu used a technique that stemmed from both Chinese folk culture and international socialist art in order to express subject matter that addressed social conditions at that time. His art thus had a broad appeal precisely because its ideologies were in the interests of the people. This directness of experience, clearly expressed and connected with the society of the day, is regarded by Xu Bing as an essential quality of art that can transform artistic methodologies, and influence social and cultural conditions.

If Gu Yuan embodied the success of a direct and sensitive connection between artist and society, he also, along with other teaching staff, represented more overtly the socialist policies that still prevailed in the late 1970s and early 80s. The curriculum at the Central Academy was entirely based on a socialist approach, with an emphasis on Communist ideology and Soviet technique. The late 1970s however was a time when ideas other than communist ones began to circulate and be expressed. Xu Bing has written of how the Democracy Wall events and Stars Group exhibitions of 1978 and early 1979, as well as the April photography exhibitions and Gao Xingjian's plays, right in the centre of Beijing where he was then studying, passed him by intellectually . He was present at the events, but listening and sketching rather than participating. The political climate that made them possible also resulted in the display in China of art exhibitions from abroad. In 1978 at least two exhibitions of European art took place in Beijing. *An Exhibition of Copper Plate Engraving by Piranesi, Italy* (意大利皮拉纳斯 铜版画展览), consisting of 177 prints and five copper plates, was held in Beijing and Tianjin under the auspices of the Chinese People's Foreign Friendship Association. The unillustrated mimeograph catalogue has an introduction signed 'Carlo Bertolli, Rome', but no details of dates, gallery venues or provenance. Xu Bing would have seen this exhibition, but it made no particular impression on him. The influence of

the other 1978 exhibition he saw, however, appears in many of the drawings he made between then and 1981, including those in cat. nos. 7–14.

The *Exhibition of Nineteenth-century French Rural Landscapes* (法国十九世纪农村风景画展览) was held at the National Gallery of China between 10 March and 9 April 1978, and included almost ninety paintings from museums across France (cat. no. 16). It was an official exhibition, with a catalogue foreword by the French Minister of Culture in which he emphasised the themes of peasant labour in the paintings, and included works from the Louvre and nationally owned regional museums from across France. It covered the period 1820–1905 and the schools of the Barbizons, the Academy, the early Impressionists and the Fauves, with masterpieces such as Millet's *Young Shepherdess Spinning* , Lehrmitte's *Harvest* and pieces by Boudin, Corot, Courbet, Derain, Gauguin, Marquet, Millet, Monet, Pissarro, Renoir and Sisley. The selection seems to have been true to the exhibition's title – most of the paintings were pure landscape or depictions of rustic society with figures toiling or chatting. As such they resonated with both Xu Bing's own experience of life in the countryside, and the aspect of Gu Yuan's art that he had appreciated so much. Several of the artists are represented in the selection he has made from the Ashmolean's French drawings collection for display alongside his own early drawings (cat. nos.16–28).

 The Barbizon school, the Realists, the Impressionists and the Fauves were all painting in France at a time when Russia's increasingly Francophile empire was waning (like China's later on), with a court that spoke French, gilded its furniture, holidayed on the Riviera and looked to Western Europe as a cultural model. During this period there flourished in Russia a school of painting, the Peredvizhniki or Wanderers, whose leading light was Ilya Repin (1844–1930). Repin

studied in Paris in the 1870s and throughout his career favoured as his subject matter ordinary people, and historical and revolutionary themes, though he eventually painted members of the imperial family as well as the intelligentsia. One sketch he made while staying at the country home of Tolstoy depicts the celebrated writer ploughing the field of his widowed neighbour in a style and composition very similar to Millet's drawings of such subjects. In fact, Xu Bing was familiar with Repin's work from a book lent to him by Zhang Zhilian, a professor in French studies at Beida.

There was indeed an affinity between France and Russia, not just in the sphere of court elegance but also among the intellectual classes, who shared concerns over social change and realism in art. The French Revolutionary legacy of 1789, re-asserted in 1848 as one of a string of uprisings across Europe, gave rise to Delacroix's *Liberty Leading the People* (1830), which provided the definitive composition for heroic revolutionary images in the USSR in the early twentieth century, for Chinese oil paintings in the 1950s, and for propaganda posters, papercuts and so forth during the Cultural Revolution.

When after 1917 the new Soviet Union was establishing its artistic position, Repin was held up as a progressive and a realist at the institute in Petrograd (Leningrad) that later bore his name.

Fig 4 Northeast China, March 1979, pencil on paper. The drawing is titled *Beidahuang*, literally the 'Great North Wilderness'. The region was opened up for cultivation in the 1950s and 1960s, and became well-known for the school of woodblock printing that developed there.

It was here that considerable discussion took place over artistic style, which resulted in Socialist Realism being adopted throughout the system; similar debates were played out in Beijing in the 1950s. A leading figure in this was Xu Beihong (1895–1953), who had been involved in directing art education in China from the late 1920s following his own experiences of studying and practising in Europe, especially Paris, throughout that decade. It was a period of experimentation in France that some of Xu Beihong's fellow artists from China embraced, while Xu Beihong committed his interest and energies to academic painting, concluding that not only was French history painting of the nineteenth century a noble expression of its own time and place, but that it could also serve as a model for the future path of Chinese painting. On his return from Europe, he not only produced several large-scale figure paintings showing major Chinese historical heroes or incidents, but was also instrumental in establishing the French academic Realist style throughout art schools in China. Later, this patriotic element in Xu Beihong's ideas provided a foundation for a socialist line in art. After 1949 he became the first president of the Central Academy of Fine Arts, but died in 1953, just as the first group of six painters from China was about to embark on a period of study at the Repin Institute in Leningrad. Between 1954 and 1960 around thirty artists from China spent periods of up to six years training there, among them Xu Bing's later teacher Wu Biduan, and meanwhile the Soviet artist Konstantin Maksimov (1913–93) gave classes in Beijing at the Central Academy.

Thus the system in which Xu Bing had been instructed itself drew, via Soviet socialism and Chinese historicism, on precisely the artistic milieu that he stood before, in 1978, in the National Gallery of China. (fig.4) The fact, then, that he saw the exhibition of nineteenth-century French paintings, loved it, and went on to make drawings

Fig 5 Mountain climbing, 3 June 1979, pencil on paper. The scene is similar to traditional Chinese landscapes, particularly in the lone figure on the path, though the techniques show Xu Bing's Western training.

that are discernibly similar to some of the works in it, is not a simple matter of 'influence' or 'inspiration' ; rather it is the product of cultural interactions between three far-flung nations over a period of at least a century, and a revolutionary trail coursing through France in 1789, most of Europe in 1848, Russia in 1917, China in 1949, right down to the then very recent revolution of Xu Bing's own experience in the mid-1970s.

One element of the revolutionary experience prescribed for educated young people in China during the 1970s was the action of 'gaining grass roots experience'; for Xu Bing his period in Shouliang Gou undoubtedly qualified as such, but he continued to travel and spend time in the countryside during his undergraduate study at the Central Academy. (fig.5).The Academy organised *chadui* trips that involved taking groups of students to a rural or industrial area to participate in the labour and lives of the peasants or workers. One such trip, in June 1979, was to Changbai in the far northeast, one of China's two main forest regions and the centre of a large logging industry (cat. nos. 8, 9). His series of drawings of the forestry industry at Changbai combines human activity and the natural world, and moreover depicts one of China's essential environmental resources as well as a region now protected for its natural beauty.

The place that Xu Bing drew most, though, during this period was a village near Handan in southern Hebei province that he describes as being in the Taihang Mountains, and which was similar in many ways to the northern Hebei village where he had earlier spent three years. In 1980 Xu Bing spent about six months there, returning later in 1981 as part of a Central Academy organised trip. He was working on his degree project for presentation in January 1981: the principal works for it were the prints *Women Threshing Rice* and *Bustling Village on the Water*; they were accompanied by a series of drawings (including cat. nos. 8, 9, 12 and 14) and the small palm-sized woodcut series *Shattered Jade* (cat. nos. 44–57). These were the product of his first studies of the printmaking technique and artistically aimed to recapture the spirit of his teacher Gu Yuan's work, as outlined above. The two major prints represent his own development and were met with great acclaim.

The drawings from this period, which also constitute an exploration and development of technique, meanwhile embody many of his artistic concerns. One of these, in contrast to the

Fig 6 Rural store, July 1980, pencil on paper. This sketch was probably completed in southern Hebei. The simplicity of the scene is in accordance with Xu Bing's preference at that time for everyday things as subjects.

directness of the woodcuts that he discusses in relation to Gu Yuan, is the quality of indirectness, of implication rather than depiction. The most obvious aspect of this – and particularly noticeable to those viewers familiar with traditional Chinese landscapes – is the absence of human figures. While the drawings of scenery at Shouliang Gou, the railway housing at Fengtai (1978, cat. no. 6) and logging at Changbai (1979, cat. nos 8–9) all include small, schematic figures as a reference to the activities of the place, the Handan drawings of 1980 include none at all. Rather, we see the horse trough glistening from recently spilt water, the door-cloth looped to one side, the chopsticks still resting across a bowl on the kitchen range, the cotton shoes airing in the sunshine among the vegetable supplies – in fact, any number of references to daily life, simply lived.

The village of Handan lies on the eastern side of the Taihang mountain range running north–south and marking the eastern end of north China's Loess Plateau. It is a stone village, with houses and roads cut from rock, as they had been for centuries, possibly millennia; some of the houses were built of large stones, others cut directly into the cliffs in the same way as the better known cave dwellings in the cliffs to the west. They are, in fact, particularly associated with northern Shaanxi and appear in many of Xu Bing's sketchbooks alongside drawings of ancient tomb models, papercuts and other examples of folk culture.

In the 1981 essay cited above Xu Bing writes:

> I have a preference. I am not one of those people who like the bright and colourful, the bustle of activity. The more something is plain and unobtrusive, the more it can attract me, the more it can stir my feelings, even making me find it hard to forget for a long time. To my eyes the beauty of Guilin and West Lake falls far short of the beauty of the north's ancient mountain slopes and small villages. Precisely because these scenic places are too pretty, they don't need artists to reveal them, anyone can grasp their splendour. Moreover all in all their beauty has no direct connection with ordinary people's surroundings The source of natural beauty lies in the objective connection between life and nature, and the most direct connection between natural things and life is nowhere stronger than in the things that are a common sight at people's sides. In reality these ordinary objects often hold great aesthetic value and fascination (fig.6).... A small kitchen range probably doesn't merit an oil painting but for me it still merits a picture because these things bear the traces of life What I love is not just the object itself that is depicted, but those ordinary and simple traces.

Traces and imprints

The limits of the socialist aspects of portraying the simplicity of rural life and landscape in China became apparent to Xu Bing after his graduation in 1981 when he was kept on at the Central Academy as an instructor. He has written of his experience teaching the basic drawing class, and how the changes he made to it came about. The

curriculum was slow and detailed: it began with plaster casts of a head, then progressed to bust, half-length, full-length and on to life models, building up skill at a gradual pace with much repetition that resulted in students observing less and less the more they drew, and the dulling of response. His method was to augment their work, placing before them objects that they had seldom come across as drawing subjects: an inverted tree root, with spaces in it that differed from those of the plaster casts; a sculpture wrapped in newspaper so that the students would have to think how to represent the newsprint, and so forth. This new pedagogical approach resulted in his writing a series of ten articles published in the journal *Art Instruction* (美术向导) throughout 1986 and 1987 that became standard texts for the teaching of art in higher education, and earned Xu Bing the 1989 Huo Yingdong Prize awarded by the State Committee for Education.

Though much shorter in length, the 1981 article cited above had also become a highly regarded model account of creativity and was used in the curriculum in numerous art schools. Moreover, the essay that appears in the extracts later in this catalogue (p. 27), though reprinted and translated in the 2009 Beijing exhibition catalogue *Xu Bing Prints* 徐冰版画, originally appeared as the opening piece in a successful volume called *The Seventies* 七十年代, edited by the poet Bei Dao and with contributions by various artists and writers who came of age in that decade. Xu Bing's writing shares much of the plainness and directness of his non-linguistic artworks, achieving a naturalness of thought and expression that eludes many dedicated writers. Although his writing is not strictly *wenyan* 文言, or 'literary language', in style, the fact of his producing texts as well as works of art could be said to place him very much in the *wenren* 文人 'literary scholar–gentleman' tradition.

Xu Bing has also written, very occasionally, as art critic. The article 'How do they think? How do they paint?' appeared in *Meishu* 美术 (Fine Art) in 1985 and is a review of the *Exhibition of New China Youth Art* held that year in Beijing (and in which Xu Bing himself won a prize). He focuses his discussion on three of the works, elucidating the artists' working practices and their thinking in the rapidly changing environment in which young artists found themselves at that time. He shows the variety of their creative responses to this turbulent environment emphasising that they are not content to use old methods to express the changed times, and concludes with an account of his own use of Freud's dream-recording experiment to better understand his own creativity.

The 1980s was a period when ideas from outside China flowed in, along with histories of Western literature, philosophy and art. It has been described as a time of 'culture fever' and although Xu Bing did not become an aligned member of any of the myriad intellectual or artistic groups that formed, he did join in reading everything to hand and learning as much as he could, recalling it as a time when he did 'less artmaking and more reading'. Few works made significant impact on him, though Duchamp, whom he read about in a book lent by his mother's friend Chen Peng was an exception. His reading eventually led him to D.T. Suzuki's *Introduction to Zen Buddhism*, a work whose unsystematised flow of thoughts expressing eloquently things that Xu Bing felt or instinctively knew, relieved him from the pressures of Western logic and affirmed his Asian identity. As such, his response to the influx of foreign culture into 1980s China was one that addressed its fact and its entirety, rather than engaging with the specifics of any particular Western school of thought, artistic movement or individual philosopher. The reference above to Freud is a rare instance and demonstrates the sincerity of his efforts to understand the different systems of thinking that he ultimately put aside.

Within the sphere of art, in addition to written or filmed information, numerous exhibitions took place. Some of these made no impression whatever: the British Council exhibition of English watercolours, for example, or an exhibition of German Expressionist painting. However, the impact on Xu Bing of an exhibition of North Korean propaganda art was, by contrast, decisive. The bold compositions, strong colours and resolutely positive content that was familiar from his teenage years now looked like 'a mirror to the future of art in China'. To him that future appeared bankrupt and prompted him to look even more closely at Western works. An important opportunity to do so came in late 1985, with one of the first exhibitions of American art to travel to the People's Republic of China. It constituted one leg of Robert Rauschenberg's Overseas Cultural Interchange project devised for countries that were either undeveloped or had totalitarian governments. It travelled for six years from 1984 to venues around the world including Mexico, Chile, Venezuela, Japan, Cuba, the USSR, Berlin in the then DDR, Malaysia and, in 1985, China. It was exhibited at the National Gallery of China from 15 November to 5 December and attracted more than 300,000 visitors. Shown at the end of the year that had seen the emergence of a phenomenon that became known as the '85 New Wave (and which later staged the 1989 China Avant-Garde exhibition), and debates in art circles contesting this and other new art movements, the effects of the Rauschenberg show were far-reaching.

The year 1985 had also seen the publication of some influential articles on art from outside China. Two of these appeared in the quarterly journal *World Art* 世界美术 that the Central Academy had established as early as 1979 and that was a key source of information about art beyond China. It carried illustrated articles, mostly in translation, about modern and classical art from all over the world, including ancient

Egyptian, Greek and Roman, and European art from the fifteenth century onwards. In the first few years of publication Russian art featured prominently, along with numerous articles on French, English and American painters. In particular there were articles on Millet [1980.1, pp. 71–5; 1981.1, pp. 2–11] and other nineteenth-century artists from Europe and America, while twentieth-century pieces favoured the Vienna Secession and early twentieth-century movements. Towards the mid-1980s, however, more and more articles appeared on Abstract Expressionism, conceptual art, and contemporary artists such as David Hockney and Andy Warhol.

The first issue of 1985 was an influential one, including as it did a general article on modern Western art movements and another on conceptual art. Xu Bing has referred to the impression that Andy Warhol made on him, and the references to Pop Art in this issue may have resonated with him: Warhol's use of commercial goods as subject matter for transforming into artworks (connecting to people's daily lives) as well as the conceptual art practice of painting directly onto walls. In their case this was to evade the art establishment by making the works unownable, while for Xu Bing the use of walls for painting would probably have evoked the big-character slogans of the Cultural Revolution, and the plays on commerce the newly emerging consumerism of Chinese society. The first 1986 issue of *World Art* carried a further piece on Warhol – a two-page article on his portraits, mostly of American icons and a multiple set of Jackie Kennedy – that stimulated Xu Bing's already strong interest in repetition.

The foreign works mentioned above are referred to because Xu Bing related or responded to them in some way. They were, however, just a few in a deluge. He has written that the information he was receiving during this period of 'culture fever' was hungrily absorbed, and also that the North

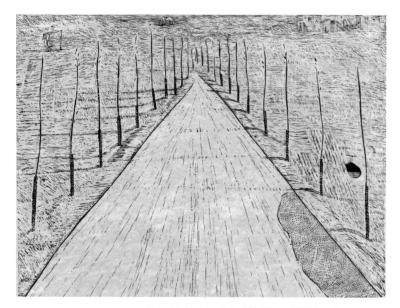

Fig 7 *'Nature' 2 – A Seed* '自然' 2一片种子, 1985,
Woodblock print, 45.0 x 60.0 cm.

Korean exhibition had left him determined to
escape from that artistic style: he would create
a new kind of art, but had no idea what it would
look like. He has described the various results
as 'inchoate scribbling', yet there are prints from
that same year, 1985, that show a new direction in
their treatment of familiar subject matter.

The *Nature* series demonstrates this, most clearly
in *A Seed* (cat. no. 59, fig 7), which depicts an
avenue of newly planted trees in an apparently
empty landscape. The road is the one observed
in 1982 from a bus somewhere in north China
(cat. no. 41) and on the roadside an extended
pile of seeds bears the tyre marks of a recently
passed vehicle. The hemp protection around
the young tree trunks, a grazing horse and a
tethered one in the distance next to a group of
farm buildings at the far right (that are so derelict
they merge with the agricultural landscape) all
imply human presence in the same way as the
early drawings. To the left of the road is grass
and earth, to the right earth alone, and the mark
of a knot in the woodblock, purposely left. The
carving of the grass and earth is in repeated and
changing directions, and gives an effect similar

to the crops in the early sketches that anticipate
landscript. However, there are various other
drafts in Xu Bing's archive, in ink and in pencil,
that visually relate quite coherently to the forms
that appear in his prints *Five Series of Repetitions*
(cat. no. 71) and in the *Book from the Sky* (*Tianshu*,
天书). Conceptually, the idea of repetitiveness
afforded by print – both in its inherently fixed
quality (in contrast to brushstrokes) and its
possibilities of repetition (which Xu Bing linked to
standardisation in modern life) – distinguished it
essentially from the classical. In fact, that quality
further made it an appropriate medium for the
contemporary. This conclusion, linked to his
experimentation with printmaking techniques,
led him to the works *Five Series of Repetitions* that
constituted the groundwork for the *Tianshu*. While
the *Tianshu* is steeped in language, however, the
Five Series connect to nature and to landscape.

Landscapes trodden and transformed

The landscapes that Xu Bing conceptualised in
his prints of the late 1980s were drawn from
places he had visited throughout the decade.
He travelled frequently on visits organised by
the Central Academy, as well as by his own
arrangement; he was sent all around the country
and he wanted to see as much of it as possible.
He had a map of China on which he marked
every journey in red, hoping ultimately to obscure
the mountains and rivers, provinces and towns
below. It was customary for him – indeed for all
artists – to carry around a sketchbook at all times,
and Xu Bing filled at least forty during the early
1980s. Some contain notes, writing and drawings
of things he had seen, but most are landscape
sketches from start to finish. Many are drawn
from trains and particularly buses, accounting for
much of the abbreviation in the representation
of scenes that were passing before his eyes. As
a result, many of the places he drew cannot be
precisely identified, the more so for not being
dated. His travels included, for example, visits

to Dunhuang, Dazu, Xi'an and Hebei in 1983; a three-month sojourn in northern Shaanxi in 1984; visits to Qinghai and southern Gansu in 1985, and so on. He did go as far south as Hunan, but on the whole remained north of the Yangzi.

His independent travels reflect a new freedom of movement in the 1980s; previously, travel between cities was officially sanctioned, either for work purposes or to visit family during holiday periods. Xu Bing had, of course, previously travelled a reasonable amount for both reasons, and in fact the Central Academy's organisation of trips was itself a version of an earlier practice. During the 1950s and 60s, many ink painters were sent around the country on specific projects, mostly associated with depicting the motherland for patriotic purposes, which itself included their familiarisation with it. The People's Liberation Army organised at least two artists' treks in the mid- to late 1950s to produce commemorative paintings of the 1934 Long March, while in 1959–60 the artists Fu Baoshi and Guan Shanyue made a well-documented tour of northern China, producing dozens of landscape paintings as a result .

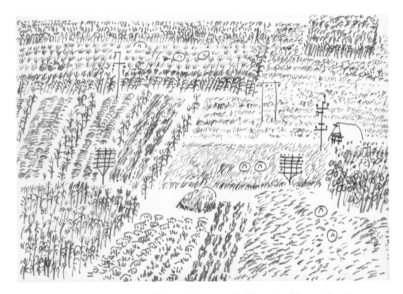

Fig 8 Landscape, probably north China, early 1980s, pencil on paper. The fields and plots in this sketch are planted with different crops that Xu Bing has represented quite schematically, in anticipation of the Five Series of Repetitions prints and his landscript sketches.

The sketches that Xu Bing made between 1982 and 1986 include landscapes that can be seen in the *Shattered Jade* woodcuts and in later prints (cat. nos. 29, 30, 32, 33, 35, 40, 41, 53, 54, 57 and *Nature* 1). Most obvious is the small rounded hillside planted with different crops, in patches. These hillsides, along with the details of plants in other works, are at once a visualisation and a conceptualisation of the Chinese landscape (Fig.8). The small, repeated strokes that compose any particular area of these landscapes function not only as representations of the particular crop but also as a reference to repetition in Chinese painting and printing. As such they are both close to the land and connected to literature. This ambiguity is developed in, and indeed forms the core of, the landscript prints at the centre of this exhibition. It represents a duality, though not necessarily a conflict, between nature and culture, the natural world and the sphere of languages.

Some of the ink sketches that demonstrate this more clearly were drawn in 1985 – the year in which the articles on modern American art and conceptual art appeared in *World Art*, in which Xu Bing reviewed the youth art exhibition, and in which debates began to rage around the modernisation and Westernisation of Chinese Art (most particularly at the Huang Shan conference in April). It was also the year in which the Rauschenberg exhibition was shown in Beijing and the China New Wave avant-garde movement was established. Xu Bing's engagement with these intellectual developments in the academic art sphere has been outlined above. A number of his artworks show that despite having 'read more and produced less' at this time, the intellectual ferment was spawning a new direction in his work. A group of three sketches of sheep on a mountainside shows this, in the inversions of black and white, the variations in the number of sheep depicted and the row of schematised trees along the top of the mountain (cat. no. 42). They are experiments in reduction that appear, transmuted, in the *Five Series of Repetitions* prints,

while the elements in the sketches are all familiar from Xu Bing's earlier drawings (the farm animals particularly, from the Handan drawings of 1980). While this drawing holds some of the concepts that Xu Bing developed in the *Repetitions* series and possibly the *Tianshu*, another drawing from the same year relates more explicitly to the landscripts that followed later (Cat no. 35). It is a preparatory sketch for a print called *Homeland*, in which the hillside land is maximised, with four small tomb mounds surrounded by a variety of crops, each depicted with repeated marks that are in some cases quite descriptive of the particular vegetable and in others is so abbreviated as to only imply it.

These inversions, reductions and repetitions of form were occupying Xu Bing's mind a great deal at this time: indeed, he has said he was obsessed with repetition, and with his commitment to creating a new kind of art, he began to experiment in his printmaking. The qualities of printmaking that hold particular appeal for Xu Bing are, he has written, fourfold. The completeness and the specificity to form that defines a print and distances it, as a sort of idealisation, from its subject is one quality. His longstanding interest in and experience of typography is another. A third is the fact that printmaking requires labour and patience, giving rise to the satisfaction of craftsmanship. Finally, he says, the indirectness of it suits him – an aspect already mentioned with regard to his early drawings. This level of ease and familiarity with printmaking, and the command this and his technical skills gave him with the medium, made him well equipped to take it in new directions. The possibilities that printmaking afforded for repetition, and the role of repetition in the works to which his own intellectual enquiries had led him, were to provide the new creative direction on which he had resolved in the wake of the exhibition of North Korean propaganda art.

The first clear departure came in mid-1986 when he was travelling in Qinghai province. He visited the construction site of the Longyang Gorge dam, which was then being built to control and exploit the Yellow River. He etched directly onto copper plates, creating 'plein air' prints in a combination of medium and subject matter that had never before been used in China. To produce these he employed the travelling printmaking kit he used for his peripatetic teaching – the journeys around schools in north China that were, in conjunction with his innovative teaching methods at the Central Academy, to earn him the 1989 Huo Yingdong Prize. The following year he experimented with mezzotint in the *Stone* series, but it was the *Series of Repetitions*, also produced in 1987, that particularly embody his transition between the early woodcuts and the work regarded as 'modern', and that have been considered as the first of his pieces that connect to contemporary art beyond the Chinese sphere.

Conceptually, the key element of contemporaneity in the *Repetitions* series lies in Xu Bing's belief that printmaking, in its use of standardisation to produce multiples, is an appropriate medium for expressing modern life, which at that time was directed by standardisation – and thus repetition – in everyday surroundings. He gives as examples buildings, tools, packaging and video monitors. This thinking was informed, though not uniquely driven by, the reading and looking at works from outside China that had occupied him since the early 1980s, and in this way, the print becomes a means of connecting with the modern world as well as with daily life.

In terms of technique and craftsmanship, the long multiple-block scrolls of the *Repetitions* series are an exploration of the fundamentals of woodblock printing. At one end, the scroll is almost entirely black, because very little of the wood has been cut away to create an image. At the other end, it is almost entirely white because so much of the block has been cut away that very little outstanding image remains. The sections in between show

various stages of carving, so that the most complete or legible image is at the centre.

That image, however, while legible, is only somewhat pictorial, and has rather the look of reduction and patternmaking.

In the *Repetitions* scroll that is displayed in this exhibition (Cat. no. 71), titled 自留地, the content relates most closely to the landscape sketches Cat. nos. 33, 36, and 37 from the early to mid-80s, and the small woodcuts *Field* (1980) and *Garden Patch* (1982) (Cat. nos. 45 and 51). The repeated lines of small strokes or reduced images are very much as seen on the sketches of hillsides in Hunan (cat. no. 36) or southern Gansu (cat. no. 32), with the same 'patchwork' effect. An important distinction of the patches in the printed scroll, however, is the inclusion of a single character in the corner of each patch. These are all family names, and in fact the scroll is a representation of the socialist agricultural economic system known as *Ziliudi* or 'private plot' instituted in the 1950s following the collectivisation of landownership. Under this system all land was state-owned and its cultivation organised through a system of people's communes. *Ziliudi* was an arrangement by which individual agricultural households were allowed the use of a plot of land whose produce they could keep for their own consumption or sell on as they wished. It was suspended during the Cultural Revolution as a 'tail-end' of capitalism, but revived later by Deng Xiaoping. The subject matter of the scroll thus relates to the then contemporary version of the timeless issue of people gaining food from the land. At the same time, the fact that the *Ziliudi* system is itself an exact inversion of the ancient well-field (井田) land organisation system of the Zhou dynasty (c.1050–221 BC), by which the produce of one plot of land for every privately

cultivated eight was handed to the landowner, connects the print not just to a specific practice in contemporary life and the general relationship of man and nature, but indirectly also to an aspect of traditional Chinese culture.

The subject content of the scroll is thus rich in allusion to nature. The forms it assumes, however, have much to do with language. The patches of privately cultivated land are shown in an arrangement that is related to one of the first forms of printmaking that Xu Bing was involved with: newspaper production. The rectangles of repeated strokes or reduced images function, visually, as blocks of text, and just as in newspapers, some are horizontal, some vertical and all are set closely right up against each other. As a student Xu Bing would often say 'the print can be just as powerful as the *People's Daily*' [XBBH p17]; in the *Ziliudi* scroll there is perhaps an indirect reference to this idea. The relationship to language is developed further in the marks themselves, which anticipate quite clearly the use of characters for landscape forms in the landscripts.

The contemporaneity and the technical explorations of the *Repetitions* scrolls are both evident in the *Tianshu* (1987–91) that followed them. To the extent that in the *Repetitions* series these explorations are applied to nature, and in the *Tianshu* they are applied to language, this series may be said not just to have, in Xu Bing's words, provided the groundwork for the latter. but also in a sense to be a companion work to it: a pair of extended series addressing, through the medium of print, the standardisations of modern life using representations of peasant life in the one and in the other the world of the educated or, put another way, nature and language. |sv

On early landscape influences
From Ignorance as a Form of Nourishment *(2008)*

Xu Bing

I was assigned to Shouliang Gou Village. We were two boys and three girls altogether, the village's "educated youth" detachment.

The place was in the mountains of Saibei (north of the Great Wall) and very poor. That year's harvest had failed and so the village divided up the allotment they had received from the national government to support us educated youth and gave us a room to live in on the pig farm. It was surrounded by pig pens with two large woks that were both used to cook our food and heat the pig feed. It was an old room, mouse holes everywhere. If the wind picked up outside, dirt would blow in through the holes. During the high alpine winter, warmth came from the few leftover cooking coals placed immediately in a mud basin. There was a centimetre at least, of ice on the water tank that had to be broken every time water was fetched. Work started late in the winter, and sometimes, before starting off for work, I could copy a page from the *Caoquan Stele*, brush and paper freezing together.

It could be said that my earliest lesson in art "theory" and the founding of my artistic ideals took place on a mountain slope facing Shouliang Gou. There was a grove of apricot trees on the mountain there, a little sideline for the village. Guarding the trees was an offensive task, and nobody wanted to go. So I said I would do it. That summer, the mountain slope became my paradise. First off, I never ate even a single apricot. That brought with it the satisfaction of self-control. Otherwise, I focused on enjoying the changes taking place in the natural world around me. Each day I brought my box of paints and a book to the mountainside.

After dinner in the village, I would visit local houses to do portraits, photographing the originals and giving each subject a copy. The portraits have something of Wang Shiguo's (1911–1973) style (I did have a copy of the *Selected Sketches of Wang Shiguo* handy at the time). He was good at peasant portraits, and because my point of reference and the subjects I painted were so well aligned, I did a pretty good job with them. For no other reason than the dim lighting (only one lamp was hung for every two rooms), the majority of these portraits are dark.

The blackboard newspaper developed into the mimeograph printed periodical *Brilliant Mountain Flowers*, which was the crystallization of our efforts to encourage artistic and literary production by the peasants and the educated youth. My role was limited to that of art design and carving the waxed stencil paper. The content wasn't my business. There were enough writers among my classmates already. All of my interest lay in "typeface": the trends in typefaces used by big papers like *The People's Daily* and *Wenhui Daily*, the differences between the text design and symbols used in the editorial and arts and literature sections. I had this wild ambition that one day I would compile the *Encyclopedia of Chinese Word Art*.

In all honesty, apart from the romantic notion of throwing myself into the vast landscape, I did have a selfish reason for insisting on being sent down. As an educated youth, my chances of getting into the Central Academy were greater than if I had gone on to work at a neighborhood factory in the city, and going to the Academy had been my childhood dream. |XB

Translated by Jesse Coffino

Opposite: Xu Bing sketching at Renqiu Oilfield, Hebei Province, 1982.

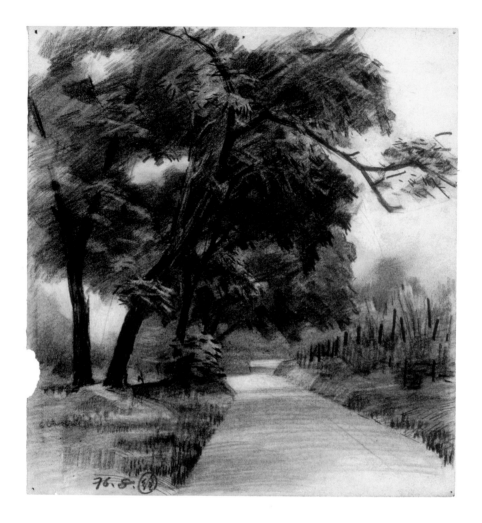

1

Peking University

August 1976

Signed 徐 (Xu), encircled

Pencil on paper

19.5 x 18.2 cm

This sketch was drawn on the campus of Peking University (Beijing Daxue, also known as Beida), where Xu Bing's father was head of the history department and his mother worked in the department of library sciences. The circle around the single-character signature, routine in seal marks, is unusual in hand-drawn inscriptions and rare within Xu Bing's work.

The drawing was produced on one of his infrequent trips home during his re-education in the countryside as an urban youth sent down to take part in rural life during the Cultural Revolution. Visits home to see family were allowed about once a year, though Xu Bing has written that he did not always take the opportunities, preferring to wait until there were art exhibitions with which his visits could coincide. This was before he became a student at the Central Academy of Fine Arts, and the drawing instruction he had received up to this point was limited to the art classes he had attended at the Peking University Middle and High schools. The school art classes were taught by Feng Lisha, a graduate of the Central Academy of Arts and Crafts, which was established in 1956 and where the instruction emphasised Soviet-style drawing. Some of that flavour is evident in this work.

The drawing is dated only shortly before the death of Chairman Mao on 9 September 1976. Mao's death prompted the ending of the Cultural Revolution (1966–76), which had begun ten years earlier with disturbances at Beida. Students from the university were also closely associated with the May Fourth Movement of 1919. The university was first established in 1898 as the Imperial University of Peking; its grounds were formerly part of the imperial Summer Palace and remain renowned for their beauty.

2

Briquet stove

1969
Pencil on paper
20.0 x 14.0 cm

This is the earliest work in the exhibition, drawn in the middle of the Cultural Revolution when Xu Bing was fourteen or fifteen years old. It depicts the briquet stove in the Xu family home at Peking University. Because of the seniority of his parents' positions the house was spacious by the standards of the day, and included a small garden; in the first decades of the People's Republic of China housing was typically assigned by and located at places of work.

The marble-topped piece of furniture to the left of the stove is European, probably French. The style of drawing again reflects the art teaching Xu Bing received at school, though the subject incidentally represents one that was widespread among French Realist artists of the nineteenth century. They, too, used the (then newly invented) briquet stoves at home, and drew what was at hand; Cezanne's *The Stove in the Studio* in the National Gallery, London, painted around 1865 in his modest Paris accommodation, is an example with a similar composition.

3

The Friendship Hotel, Beijing

Early 1970s
Pencil on paper
12.9 x 18.3 cm

This very early drawing depicts the Friendship Hotel, one of the major hotels in Beijing and at that time a venue almost exclusively for foreign visitors: Zhou Enlai used it for welcoming distinguished guests and it was one of the few residential options for foreigners working in China as locally employed experts. In the drawing the number of cars, then mostly restricted to official ownership and use, denote it as an exclusive place. Silver birch trees appear in several of Xu Bing's works, including a woodcut published in *Meishu* 美术 (*Fine Art*) magazine in 1981 as an illustration to his essay 'I picture things that I love'.

The hotel was built in 1954 in a traditional architectural style and is located in northwestern Beijing towards the Summer Palace, not far from Xu Bing's childhood home at Peking University. Other landmark buildings in Beijing that Xu Bing drew at this period, such as the planetarium and the zoo, are drawn in blue ink rather than the pencil he used for most outdoors scenes.

4

Farm buildings,
Shouliang Gou village

1974
Pencil and crayon
27 x 39 cm

These farm buildings at the top of the village include a sheep pen (on the left), two thatched barns for corn and rice, stables (beyond the tractor) and two stone buildings (on the right) used for cows and their fodder. Shouliang Gou, the village in northern Hebei where Xu Bing spent three years during the Cultural Revolution. It was beyond the Great Wall and winters were bitterly cold, accounting for the rapidness of the drawing here. In addition, materials were difficult to obtain: the paper is wrapping paper from the local production brigade supplies and the white is produced using children's crayon. The quality of the crayon was not good and it partially froze as Xu Bing drew; the effects of it later melting are visible.

5

Landscape, northern Hebei province

December 1976
Pencil and crayon on paper
19.5 x 27.3 cm

This drawing depicts the landscape around the village of Shouliang Gou in Yanqing county, Hebei province, where Xu Bing lived between 1974 and 1977 as an urban youth sent to the countryside for re-education. The village to which he and his classmates were assigned lies to the right of the foreground of the composition.

It is drawn on wrapping paper that he brought back from the production brigade's stores; he liked to use it for the rustic look it had even before a mark was made. He cut the sheets to size himself, which may account for their small size as paper was not easy to come by in the village. He would draw at the end of the day after finishing work and for some time his subjects were the residents of the thirty-nine households of Shouliang Gou, sketched in their homes as he sat in the warmth. When an elderly man died not long after his portrait had been completed, the older residents from that point on preferred not to be drawn and Xu Bing switched to the landscape for subject matter: 'When the sun was setting those apparently soulless mountain tops in front of the village began to transform into something better-looking.'

6

Fengtai, southwest Beijing

1977
Pencil on paper
19.3 x 27.3 cm

Xu Bing drew this scene when travelling through Fengtai train junction in 1977. The drawing is typical of his work in pencil at that time, and he has used an eraser to create the steam and smoke. It is one of a number of industrial subjects that he drew in his early career and in which he typically included figures, though they are almost entirely absent from his landscapes.

Fengtai junction is a hub for China's national rail network and the site of the country's main train maintenance depot, established there in 1892 and entrusted with Mao Zedong's personal locomotive. The area has since seen considerable development and now includes a substantial leisure area for aquatic sports, a space museum and so forth; in the Qing dynasty (1644–1911) it was the site of a Manchu army camp. In the Beijing floods of 21 July 2012 it was one of the worst-hit areas of the capital.

7

Fengtai, Beijing

March 1978

Inscribed: 通往铁路家属区 一九七八年三月

Heading towards the railway families' housing area

Pencil on paper

20.4 x 26.9 cm

In March 1978, during the spring festival holiday of his second year at the Central Academy of Fine Arts, Xu Bing visited for a second time the suburb of Fengtai in southwestern Beijing. Fengtai is the location of a depot for train repairs and he was visiting a friend who had been assigned to work there, having previously been with Xu Bing in the countryside at Shouliang Gou; the following year the friend went to study at Beijing Academy

of Broadcasting and later became a film director. The buildings in the distance at the left of the composition are the housing for the railway workers and their families. A small group of figures stands in the road just before the buildings.

The techniques and composition of this drawing are largely European; however, the lengths and layering of the pencil marks, and their variation in density, share some similarities with Chinese ink brushwork that

are particularly evident in the mountain rocks at the right of the composition.

The apparent emptiness of the landscape and the brevity of the human elements in this scene are typical of Xu Bing's preference for indirectness in depicting human presence. It is nonetheless more explicit than several other early works: he depicts the receding bus itself rather than tyre tracks alone, and an abbreviated group of railway workers in addition to their houses.

8

Forestry industry, Changbai, northeast China

June 1979

Inscribed: 七九年六月画于东方红林业局贮 木场 徐冰 *Drawn June 1979*
at the East is Red forestry department timber yard and mill Xu Bing

Pencil on paper

27.5 x 41.5 cm

In June 1979 Xu Bing travelled to Changbai in the far northeast of China. The trip was one of many organised by the Central Academy, in accordance with the current practice at higher education institutions throughout China of taking students to the countryside to experience the lives of ordinary people. There was a certain amount of participation in their labour, but mostly it was sharing in their daily lives – meeting working people, sleeping with their families and eating in their canteens.

By 1979 Xu Bing had spent two years at the Central Academy and had received further instruction in drawing. Two techniques employed here are not evident in his earlier drawings, though they are likely to have been used instinctively rather than taught: both were used to create white areas in the heavier shading. The broader white lines were produced by rubbing through pencil marks already made, while the thin reserved lines were created by first pressing a channel into the paper with a thumbnail or knife, and then shading lightly across it. This drawing can be said to anticipate two aspects of later works in the exhibition: the element of repetition in his 1987 print series (cat. no. 71), evident here in the stacked tree trunks, and the environmental and social concerns associated with the Forest Project (cat. nos. 91–3).

The Changbai mountain range comprises one of the great forest regions of China, the other being in the southwest. The northeastern forests remained pristine until around the seventeenth century but since around 1900 they have been logged excessively, first during the Russian and Japanese occupations of the first half of the twentieth century, and subsequently as part of a forestry policy that prioritised timber production, as shown here. This switched to one of sustainability in 1998 and the mountains are now a well-known tourist destination.

9

Forestry industry, Changbai, northeast China

1979
Signed 徐冰 80
Pencil on paper
27.0 x 41.7 cm

This drawing of forestry in northeast China, though dated 1980, was made by Xu Bing at the same time as cat. no. 8, when he travelled there on a Central Academy-organised student visit to experience everyday life. The signature and date were added later, and have the same appearance as those on cat. nos 10 and 11.

The two forestry industry drawings depict the same place and similar activities, with a central elevated figure in the same pose, yet are quite different in their approach to the subject. The present drawing shows industry at work with eight figures engaged in a variety of tasks. Cat. no. 8 is, by contrast, more pictorial, with the felled tree-trunks creating patterns and repetitions that are developed later in Xu Bing's landscape sketches of the early 1980s.

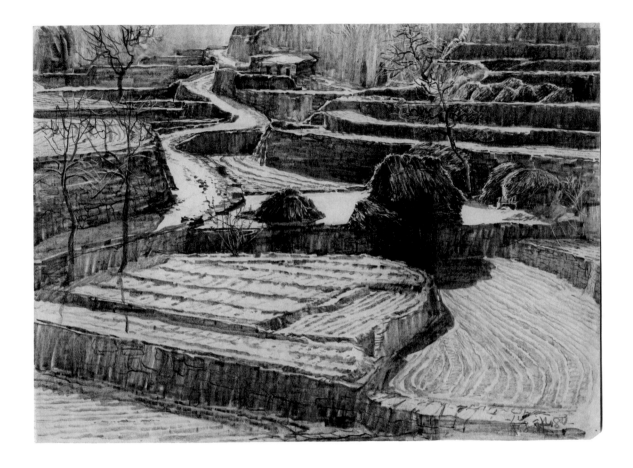

10

Terraced hillside, southern Hebei

1980
Signed 徐冰 80
Pencil and white crayon on paper
19.5 x 27.3 cm

This hillside is in the same southern Hebei region where Xu Bing produced his other landscape drawings of 1980 during an extended stay working on his degree project. The light areas reflect early morning sunlight in what is probably a late autumn scene. It is heavily worked, with erasures and highlights, in some places over many layers of drawing. It is again a landscape without people, though in addition to the land's cultivation there are also tracks on the path. The drawing is one of seven in the exhibition (along with cat. nos. 3, 5, 9, 11 and 15) that were unwrapped in autumn 2012 after having been stored in an outhouse in Beida before Xu Bing left China for the United States in 1990.

11

Nanmantuo village, southern Hebei

1980

Inscribed: 太行山 徐冰 80 *Taihang mountains Xu Bing 80*

Pencil and white crayon on paper

32 x 38.5 cm

Nanmantuo village is in Shexian in southern Hebei, where Xu Bing spent several months in 1980 preparing his degree project.

He has inscribed the scene on this drawing *Taihang mountains*, the only one of his drawings of this area to be titled with this name. The Taihang Mountains are a major range in central north China, running north–south and marking the eastern edge of the Loess Plateau. In the history of painting they are associated with two leading masters of the Northern Song dynasty (960–1127), the founding period of the landscape tradition. Fan Kuan famously wandered in them for ten years before producing his masterpiece *Travellers Amongst Streams and Mountains* and the leading court painter Guo Xi, painter of the similarly canonical work *Early Spring* (1072), grew up on their western slopes. Xu Bing was visiting friends and working on an institutional project, yet still drew much inspiration from the region, its daily family life as much as its scenery.

The village of Nanmantuo is itself ancient, as evidenced by the gated entrance, and even now retains a folk culture and legends of its own.

Xu Bing has captured the village's air of seclusion and mystery by painting it in the early morning light. The strong fold line near the lower edge is the result of the drawing having been stored, parcelled together with many more, in an outhouse at Peking University prior to Xu Bing's departure for the United States in 1990, and only being unwrapped again in autumn 2012. Though some white chalk was used in the drawing, other white areas are the result of excessive humidity sustained during that period.

12

Stable in a rural dwelling, Handan

1980
Signed 徐冰 *80*
Pencil on paper
25 x 40.5 cm

In 1980 Xu Bing spent several months in Handan, 450 kilometres southwest of Beijing, preparing his graduation project. In addition he made many drawings, and one sketchbook of the period includes a less detailed, less finished version of this subject.

The drawing depicts horse equipment – harnesses and bridles hang on the right above a saddle, while the large ceramic basin on the left, filled from the pan suspended above, contains drinking water. The exterior is still wet, showing that either the horses have just drunk or that it has just been filled, in another example of allusion to rather than the representation of activity. The characters on the gatepost are not an inscription but part of a couplet written on paper and pasted to the building, in accordance with widespread rural custom.

Handan is in southern Hebei province at the edge of the Taihang Mountain range marking the eastern edge of north China's Loess Plateau.

13

Cave dwelling, Handan

1980
Signed 徐冰 80
Pencil on paper
27.5 x 39 cm

This drawing was produced on the same 1980 visit to Handan in Hebei province as mentioned in cat. nos 10–12. It shows with clarity several of Xu Bing's concerns: the simplicity of daily life in its traces rather than in its activities, and the capturing of a moment. The baskets, tools, pumpkins and cotton shoes all appear as used, while the door cloth draped to one side shows that someone has just passed through the doorway. It was drawn in autumn, and the sharp shadow of the bare tree that falls across the front of the house to the left evokes the high clear skies of north China. He later made a larger lithograph print of this image.

The house itself is a cave dwelling of the type built and inhabited in north China for more than a thousand years. Most are located in northwest China where they are cut into the Loess earth; in this region of Hebei they are made of stone. Though rudimentary, buildings of this type are ecologically excellent, the natural insulation making them cool in summer and warm in winter. As such, in contemporary terms they are both outdated and sophisticated, falling short of and leading modern standards, and have been the subject of a certain amount of ecological debate.

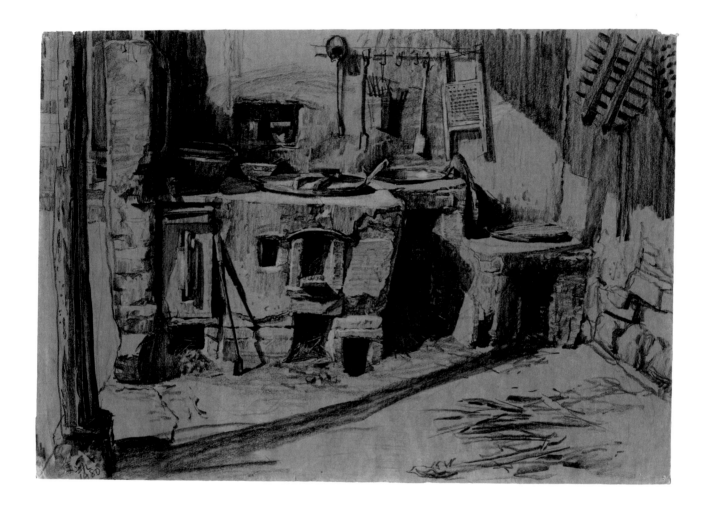

14

Kitchen, Handan

1980
Signed 徐冰 *1980*
Pencil on paper
27 x 38.6 cm

This sunlit kitchen in Handan shows the unchanging practical construction of living arrangments in rural north China.

The utensils, including cooking pots, a washboard and fire-stoking implements, as well as a painted ceramic bowl with chopsticks, all appear either ready for use or recently used. The earth floor, wooden pillar, and stone walls and range are all built of local materials, and together with the fact that the kitchen is outdoors emphasise the simplicity of life in the villages of Hebei.

Some of the artistic techniques, such as *sgraffito* for the straw fuel, were used instinctively as Xu Bing drew, similar to the detail in the drawing of logging at Changbai (cat. no. 8). This work, more than any other, shows similarities in its overall appearance with the drawings of the nineteenth-century French Barbizon school artists. The drawing was included in Xu Bing's degree project, 1981, and exhibited in Nuremberg in 1988.

15

Buddhist caves, Dunhuang

1984
Pencil and chalk on paper
37.4 x 46.6 cm

This drawing depicts the Buddhist caves known as the Thousand Buddha Caves 千佛洞 at Dunhuang, now in China's Gansu province but at the time of their excavation or construction around the fourth to fifth centuries AD, at the junction where the ancient Silk Road divided into northern and southern routes around the Tianshan Mountains and Taklamakan Desert. The myriad caves are painted with murals of Buddhist scenes and landscapes, and carved with Buddhist figures, in some cases with rows of small repeated sculptures across whole walls, giving the temple complex its name. The site was abandoned from the eleventh century until the early twentieth when European and Japanese scholars explored the caves, removing many treasures. In keeping with the site's position as one of east–west exchange, these are now the focus of an international collaborative research project between Dunhuang Research Institute and the many museums and libraries around the world that hold documents and works of art formerly housed there. It is now a protected site and major tourist destination. Visiting the caves and painting or drawing copies of the early murals within could be said to have

become a recognised practice, if not quite a convention, among artists since the mid-twentieth century.

Xu Bing visited Dunhuang in 1984, when access to the caves was still limited as much by the cliff formation as by the bureaucracy of heritage management, and in order to draw this work was seated just to the right of the main cave in the view shown. He was intrigued and excited by it as a drawing subject – by the irregularity and textures of the facade, as well as the opportunities the caves presented for light, shade and detail. Like the drawings of 1980, it is heavily worked and he has created thin white line details either by using a thumbnail to create a channel that he then shaded over, or by erasing with the unleaded end of his pencil, or a twig. He also used the environment to add his own texture to the drawing, by taking grains of the local Gobi Desert sand and placing them between his drawing board and the paper. The resulting granulation is visible in the centre of the drawing above the small black doorway. The entire drawing, in fact, rewards close inspection: wind-eroded Buddhist figures can be seen across the central sections, and two of the white apertures have lightly drawn details of

paintings of seated Buddhist figures and flying apsarases.

Some discoloured white areas are the result of exposure to excessive humidity. The drawing was wrapped up with others (including cat. nos.3, 5, 6, 9, 10 and 11) and left at Beida when Xu Bing left for America in 1990. The parcels were put in an outhouse where they were damaged by water, and only unwrapped for the first time in 2012. Together with this drawing were some small, coloured paintings copying figures from murals inside the caves.

When this was completed Xu Bing had already been teaching drawing at the Central Academy for several years, and his own methods had developed since the French- and Soviet-influenced styles of his schooldays and late teens (see cat. nos 1 and 2).

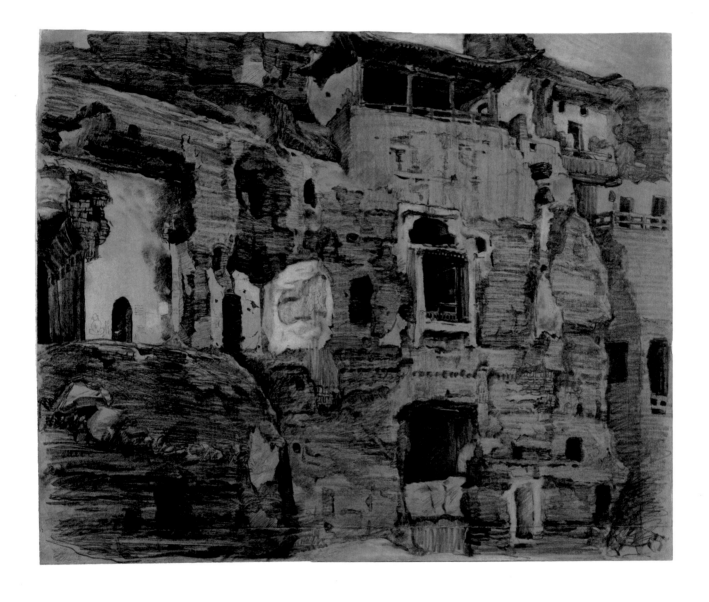

French Drawings

'My greatest feelings then were for the French artist Millet and the Chinese artist Gu Yuan. Both dealt with the peasantry. Looking at their work was like satisfying an addiction to some local speciality. The peasants Gu Yuan carved are nothing less than old Shouliang Gou itself.'

Xu Bing, from *Ignorance as a Form of Nourishment,* trans. Jesse Coffino

In March 1978 the National Gallery of China in central Beijing held an exhibition titled *French Nineteenth-century Rural Landscape Paintings.* It comprised more than eighty oil paintings by leading artists – Millet, Courbet, Monet, Corot, Pissarro and others – lent by the Louvre in Paris and local museums all around France, from Carcassonne to Lille to Le Havre. The exhibition was a cultural gesture from France to a newly opening China in the wake of the Cultural Revolution. Few exhibitions of art from outside China had been seen in Beijing for decades and the exhibition was a resounding success. Xu Bing, who was at that time studying at the Central Academy of Fine Arts just around the corner from the National Gallery, saw it and was deeply impressed. The paintings had been largely selected on the grounds of their portrayals of rural French landscapes and labour, and would have connected to the experiences of many visitors who, like him, had recently spent years in the countryside being re-educated. The drawings that follow have been selected from the Ashmolean collection in conjunction with Xu Bing, and many are by artists who were represented in that exhibition.

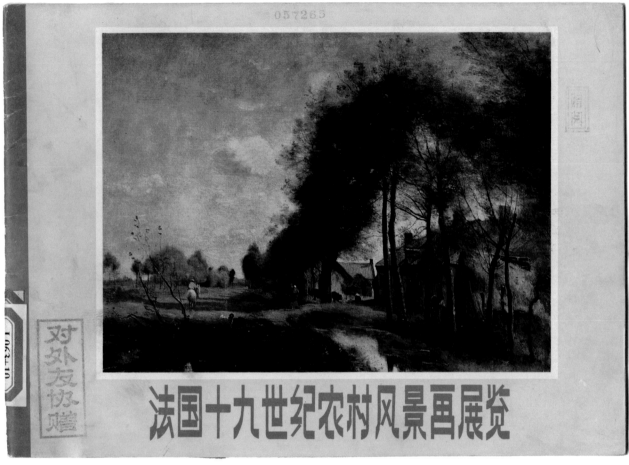

16a

16 a–c

Exhibition catalogue

法国十九世纪农村风景画展览 (16a)
(Exhibition of French 19th-century Rural
Landscape Paintings), n. pl., n.d. (Beijing,
1978), 25 pages, 6 colour plates, 18 black-
and-white illustrations
18.7 x 26.5 cm

The catalogue comprises a foreword by the
head of the French Foreign Ministry; a preface
by the head of the Parisian Municipal Board
of Culture and president of the exhibition
committee; an essay by an official from the
French Réunion des musées nationaux; and
a listing of eighty-eight paintings.

It is, however, only one of three
publications related to the exhibition.
At the time of the show the National
Gallery of China in addition produced a
small unillustrated booklet for restricted
circulation 编印为内部资料 as a 'learning
resource only for colleagues in the art
world'. It includes full catalogue descriptions
and discussions of each painting, as well
as artists' biographies and an afterword by
Jean-Paul Desroches of the Musée Guimet,
Paris (16b). A year later, in February 1979,
the People's Fine Art Publishing House
published a loose-leaf folder of twenty-
eight colour plates of paintings in the
exhibition, 法国十九世纪农村风景画, 'to
allow more readers to see these important
paintings, and to further the friendship
and understanding of the peoples of China
and France' (16c). The publications are
not consistent in the number of catalogue
entries though it is clear that between
eighty and ninety paintings were exhibited.

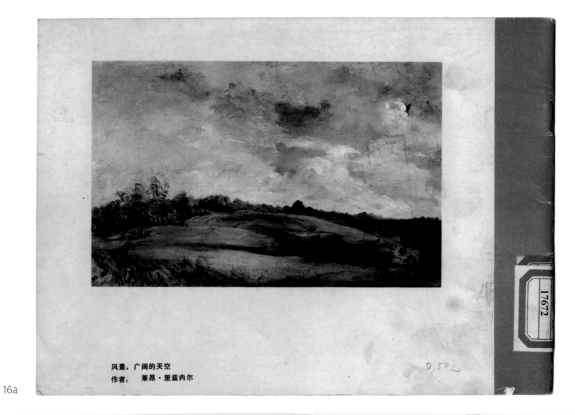

风景，广阔的天空
作者：莱昂·里兹内尔

16a

16a

16b

16b

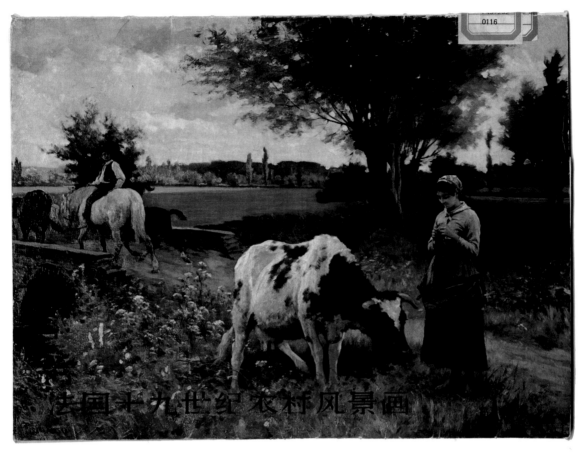

法国十九世纪农村风景画

16c

前 言

今年,《法国十九世纪农村风景画展览》在北京等地展出,受到我国美术界和各界观众的
欢迎。

法国在十九世纪曾出现古典主义、浪漫主义、现实主义、巴比仲画派、印象派等各种画
派,产生了许多杰出的画家。法国绘画艺术在近代世界艺坛上居有重要的地位。

十九世纪法国油画的写实技巧达到很高水平,不论在形象塑造、光和色的表现上都取得
了新的成就,在艺术风格上也更趋多样,值得我们研究和借鉴。

这次展出的油画大多是描绘法国农村自然风光的风景画,还有一部分是反映当时法国农
民生活的绘画。现从画展中选出二十九幅作品印成这套画辑,使更多的读者能见到这些绘画
的复制品,并以增进中法两国人民的了解和友谊。

人民美术出版社
一九七八年三月·北京

16c

17–21

Five drawings by Millet

Jean-François Millet (1814–75) was one of the leading artists of nineteenth-century France. He began with portraits (just as Xu Bing) and after 1849, when he settled in the village of Barbizon in the forests of Fontainebleau, rural life became his main theme and he came to be known as 'the peasant painter'. His works of the 1850s, in addition to being admired as fine paintings, are regarded as commentaries on the social history of that era.

Together with the other great painter of the period, Gustave Courbet (1819–77), Millet occupies a central position in the history of nineteenth-century painting, and their work exemplifies the Realist tradition. Courbet was also represented in the French landscape exhibition shown in Beijing in 1978. Millet's later works,

however, contrast with Courbet's forthright depictions of harsh rural life, both in their evident reverence for it and in an emphasis on the dignity or sublime qualities of peasant labour. This quality in Millet's work resonated in China a hundred years later with the 1940s woodcuts of Gu Yuan, produced in Yan'an as the then centre of the Communist-held region of north China. Gu Yuan was one of Xu Bing's teachers at the Central Academy of Fine Arts. His innovative use of the woodcut medium to capture the realities of everyday life exerted a profound influence on Xu Bing, and would have been recognised in Millet's works by him when he saw them exhibited in 1978 in Beijing.

Millet's position as a champion of labourers accorded with the official political stance on art in China in the late 1970s – a time when, for example, the most widely available works of foreign literature were the similarly sympathetic nineteenth-century novels of Charles Dickens. In the National Gallery of China's 1978 exhibition, Millet is represented more than any other artist, by four major paintings from the Louvre and the Musee Saint-Denis. Xu Bing's enduring admiration for the French painter is expressed together with his Buddhist stance in an exchange in an online interview with Blouin Artinfo on 30 September 2011:

'What work of art do you wish you owned?'
'A small sketch by the nineteenth-century French artist Millet.'
'What would you do to get it?'
'I wouldn't do anything.'

17

Man ploughing and another sowing

1849–52
Signed *J.-F. Millet*
Black crayon on off-white wove paper
14.5 x 21.2 cm
Ashmolean Museum, WA 1951.22; Whiteley (2000) 1363

The paintings by Millet exhibited in Beijing in 1978 did not include this particular subject. However, it is similar to a pencil drawing by Ilya Repin that may have been included in the book of Repin's work that Xu Bing was lent earlier in the 1970s by family friends in Beijing. Repin's drawing shows the writer Tolstoy ploughing and its composition compares closely with this work.

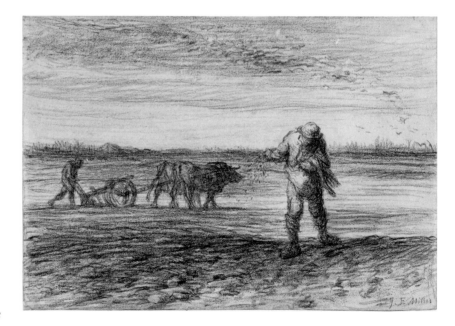

18

Path through woods to a thatched house

1866

Initialled *JFM*

Collector's mark Dyane

Graphite with pen and brown ink on warm off-white paper

17.4 x 23.5 cm

Ashmolean Museum, WA 1954.70.51;

Whiteley (2000) 1375

The composition of this drawing is similar to several of Xu Bing's early works (cat. no. 1, Xu Bing archive nos.13-1, 28-1), though Millet's trees and buildings are noticeably by a more mature artist, and more lightly drawn.

19

View of farm buildings across a field

6 August 1871

Inscribed: *Greville, endroit dit le Lieu Bailly 6 Aout 1871*

Stamped *JFM*

Graphite with black chalk or crayon, outlined in pen and brown ink, and touched with green, blue-green and red crayon on white wove paper

17.8 x 22.5 cm

Ashmolean Museum, WA 1951.25; Whiteley (2000) 1378

The proportions and content of this small drawing by Millet, with low buildings across open land, are very similar to a watercolour Xu Bing drew just over a century later, in 1974 (Xu Bing archive, 60-1). Xu Bing's watercolour depicts a scene near his home on the campus of Peking University.

20

Hillside with rocks and trees

Undated

Stamped *JFM*

Graphite, strengthened with pen and
brown ink, and touched with green and
yellow crayons on the verso of a page of
printed text

10.9 x 15.4 cm

Ashmolean Museum, WA 1954.70.33;

Whiteley (2000) 1374

This slight and simple drawing by Millet
has a similar composition to several of Xu
Bing's drawings of the impoverished village
of Shouliang Gou where he lived for three
years during the Cultural Revolution (cat.
no.5, Xu Bing archive 25-1). Coincidentally,
Xu Bing's Shouliang Gou landscapes and
Millet's view are equally executed on paper
made for other purposes: Millet's drawing
is on the reverse of some printed text
while Xu Bing's landscapes are drawn on
wrapping paper he was able to obtain from
the rural commune's office.

21

Three cottages against trees

Undated

Stamped *Millet*

Black chalk on off-white paper

17.6 x 26.6 cm

Ashmolean Museum, WA 1961.53.8;

Whiteley (2000) 1358

These rural cottages compare with Xu
Bing's drawings of low buildings in north
China. In Millet's drawing, the chalk lines
are of the style that Xu Bing used (cat. no.1)
as a result of the school teaching he had
received that was based on art instruction
in the Soviet Union, which was itself
modelled on French practices.

22

Camille Pissarro (1839–1903)

Nanterre

c. 1860
Titled *Nanterre* and initialled C.P.
Charcoal heightened with white chalk on
grey paper
24.3 x 30.9 cm
Ashmolean Museum, WA 1952.6.82

The composition of this drawing is
comparable to those Xu Bing used in
several of his sketches and drawings, and
especially those of Handan in southern
Hebei province. The techniques Pissarro
has used – in particular the long straight
strokes and the white chalk highlights - are
both techniques that Xu Bing used in early

landscapes that he drew before he entered
the Central Academy of Fine Arts.

The 1978 exhibition included one
painting by Pissarro, *Pommiers et peupliers
au soleil couchant (Apple Trees and Poplars
at Sunset)* of 1901, from the Musée Andre
Malraux, Le Havre.

23

Constant Troyon (1810–65)

Interior with a barrel, and woman working

Undated

Charcoal on brown cartridge paper

Initialled *C.T.*

24.0 x 32.0 cm

Ashmolean Museum, WA 1996.422;

Whiteley (2000) 1454

This interior scene, with its casually arranged household objects, resonates with many of Xu Bing's early drawings and his stated preference for depicting the simple things that are part of everyday life. Troyon similarly preferred landscapes to figure painting. In 1846–7 he travelled to Holland and became interested in Dutch seventeenth-century painting, as is evident in this scene.

Constant Troyon was associated with the Barbizon school. He is known as a painter of rural scenes and in particular of animals. The two paintings by him exhibited in Beijing in 1978 included a forestry scene, which is a rare subject in nineteenth-century French painting but one that Xu Bing himself depicted in a number of drawings; and a scene of a farmer on his cart from the collection of the Musée de Tesse, Le Mans.

24

Leon Augustin Lehrmitte (1844–1925)
View of Pont-en-Royan

Undated, probably after 1875
Signed *Lehrmitte*
Inscribed: Marly no. 13644
Charcoal with erasures on discoloured off-white paper
27.4 x 46.7 cm
Ashmolean Museum, WA 1952.57;
Whiteley (2000) 1475

Lehrmitte was a Realist painter well known for his rural scenes of peasant workers. There are several points of comparison between this view, and Xu Bing's early drawings of rural China. The foreground river is similar to that Xu Bing drew at Shouliang Gou, while the dark hillside and trees are seen in the drawing in cat. no. 7, and also in the heavily-worked southern Hebei drawings of terraced hillsides and Nanmantuo village (cat. nos. 10 and 11).

Two of Lehrmitte's paintings were included in the 1978 Beijing exhibition: *La Paye des Moissonneurs (Paying the Harvesters)*, acquired for the nation directly from the Salon of 1882 and now in the Musée d'Orsay in Paris; and a harvest scene from the Musée des Beaux-Arts, Carcassone.

25

Theodule-Augustin Ribot (1823–91)
Corner of a kitchen

Undated
Graphite on off-white paper
25.8 x 15.1 cm
Ashmolean Museum, WA 1974.103;
Whiteley (2000) 1425

Ribot is known for painting everyday objects in a realistic style and ordinary people engaged in everyday activities. This drawing may be a preparatory sketch for one of his kitchen scenes or still-life paintings. The subject matter here, and the artist's preference for themes from daily life, are similar to Xu Bing's own interests as shown in his view of an open-air kitchen in a house at a stone village in southern Hebei (see cat. no. 14).

26

François Boucher (1703–70)

Farmyard with tree

Undated

Black chalk heightened with white chalk,
on greenish blue paper

34.6 x 53.0 cm

Ashmolean Museum, WA 1950.14; Whiteley
(2000) 648

The French eighteenth-century painter
Boucher is associated with an opulent style
far from that of nineteenth-century rural
landscapes, and this eighteenth-century
drawing is distinguished from the style
adopted by art educators in China most
notably by the fine detail of the drawing,
though the tones are comparable. The

general appearance of the buildings,
however, and the detailed depiction of
what is evidently a functioning farm
coincide with the scenes that appealed to
Xu Bing in his early work.

27

Hyacinth-Eugène Meunier, called Murer
(1845–1906)

Cows at a watering place

Undated

Charcoal and stump with erasures on
white paper

24.3 x 35.5 cm

Ashmolean Museum, WA 1964.9.16;
Whiteley (2000) 1392

The trees and particularly the sky in this
drawing are similar in appearance to Xu
Bing's views across open fields in most of
his early landscape drawings (see p. 17 fig. 4).
These were executed in the European style
that was current in China when he drew
them in the late 1970s and early 1980s. A
small woodcut of a girl herding buffalo in
Xu Bing's *Shattered Jade* series (1978–83)
is one of very few works in which he takes
animals as his main subject.

28

Ernest Chevalier

**View across wasteland,
with buildings**

Undated

Black crayon touched with graphite on
smooth white paper

15.5 x 24.3 cm

Ashmolean Museum, WA 1950.178.45

Whiteley (2000) 1019

Ernest Chevalier is a relatively unknown
artist who was active in France in the first
half of the twentieth century. His subjects
are mostly rural landscapes; his drawings
share much of the subject matter and
sympathy of Xu Bing's early drawings
that he produced as an undergraduate
or earlier, when he was working in the
countryside during the Cultural Revolution.

Sketches and Sketchbooks

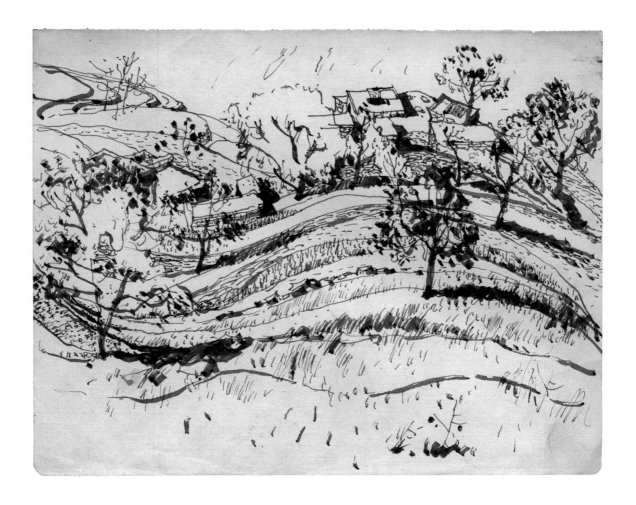

29

Apricot trees, southern Hebei

1980–81

Ink on paper

15.5 x 20.5 cm

This landscape in southern Hebei was drawn during Xu Bing's sojourn there while preparing his degree project. The apricot-covered hillside may be reminiscent of those he had spent so much time among in northern Hebei during the three years he worked in the countryside; the stone buildings imply a similar simplicity, though the land appears more fertile. The receding terraces at the upper left provide a sense of distance and completeness of composition that is not evident in most of Xu Bing's landscape sketches. The strong sunlight, leafy trees and sense of movement give the drawing a light, cheerful feel that is not seen in other generally more restrained landscapes.

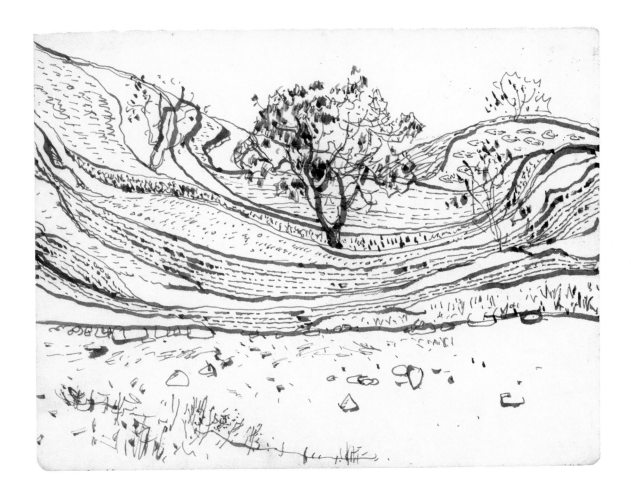

30

Apricot tree, southern Hebei

1980–81
Pen and ink on paper, with children's
water paint
15.5 x 20.5 cm

This landscape was drawn at the same
period as cat. no. 29. Xu Bing was seated
on a hill, looking down; the marks in the
foreground are flowers, while the groups
of marks that texture the clearly delineated
sections of the undulating landscape
anticipate the use of texture strokes in
some of his landscript prints and paintings.

31

Countryside, southern Hebei

1980
Pencil on paper
16 x 21 cm

This sketch of a house in a forest was drawn during Xu Bing's stay at Handan in southern Hebei province; during this time he also produced cat. nos. 29 and 30 which have the same carefree feel. The sketch was completed quickly, which accounts for the simplicity of the trees in the foreground. It is a happy depiction of rural life, showing livestock – two pigpens and pigs, a goat, a donkey and a pair of ducks – and grain stored on the rooftop.

A passage in the 1985 print *Ziran 1* 有山的地方 (cat. no. 58) appears to comprise a version of this scene, in the lower left corner in the shadow of the mountain. In the print its constituent elements – farmyard animals (two donkeys, two chickens and a sleeping dog), small buildings, viewed from the same raised point – are presented in a reduced, linear form which appears to have intellectualised the scene that was drawn freely and directly on the earlier occasion.

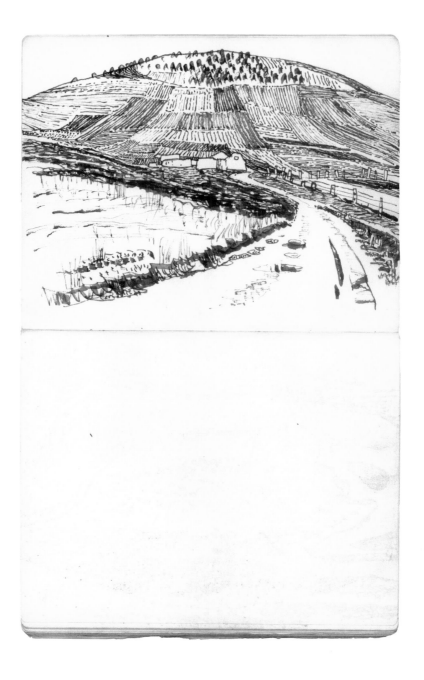

32

Landscape, southern Gansu

1979–80
Ink on paper
15.5 x 20.5 cm

Xu Bing travelled extensively throughout China in the early 1980s, always carrying a sketchbook, in common with other artists with whom he travelled.

This sketch is from a book he filled on a trip to southern Gansu province in the northwest. It presents a rare combination of two themes that occur independently in many of the sketches from this period: the tyre-marked road and the cultivated hillside. The cultivation, the buildings, the road and the fence alongside it all imply human occupation of the scene but, typically, no figures are depicted. The slightly calligraphic lines of the lower left of the sketch and the conventions he has created for depicting the trees at the top of the hill both refer to the ink landscape tradition in Chinese painting.

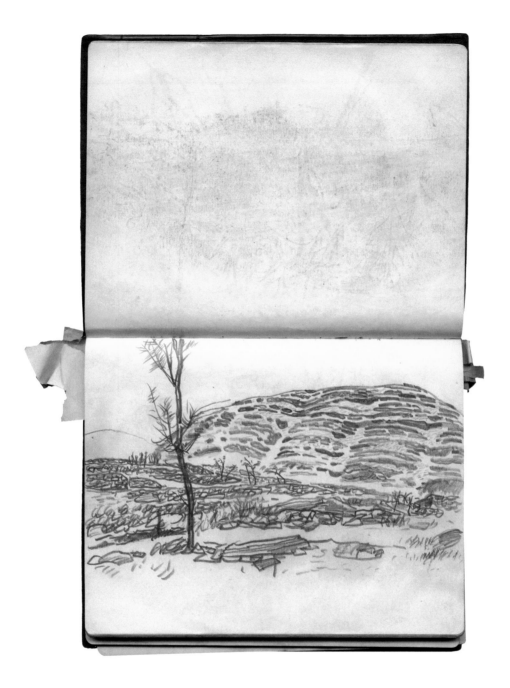

33

Landscape, Shaanxi

Early 1980s
Pencil on paper
16 x 21 cm

This sketch is one of a group in which hillsides are shown in quite solid rectangular sections, with the concept but not the detail seen in cat. nos 31 and 38; the tree is closer to the early pencil drawings of the 1970s. The stone and grasses in the foreground are also more heavily worked and cursive.

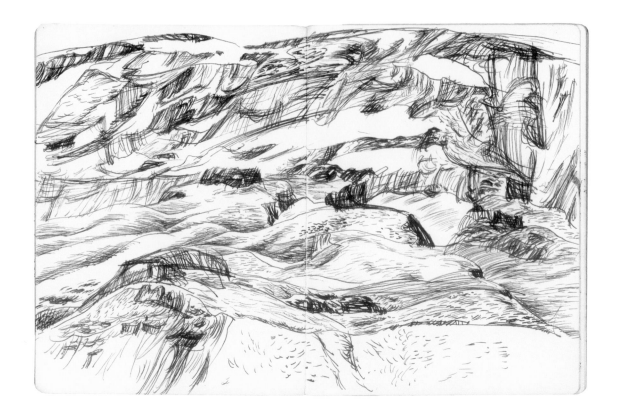

34

Mountainside, Qinghai province

Mid 1980s
Ink on paper
15.5 x 20.5 cm

This sketch was drawn on the trip that
Xu Bing made to the Longyang Gorge in
Qinghai, in China's northwest, in July 1986
and appears to be a preparatory sketch for
the copper plate engravings (cat. nos. 60
and 61) that he also created on the spot.
The lines are thinner than in most of his
drawings, in keeping with the needle-cut
lines of the engraving.

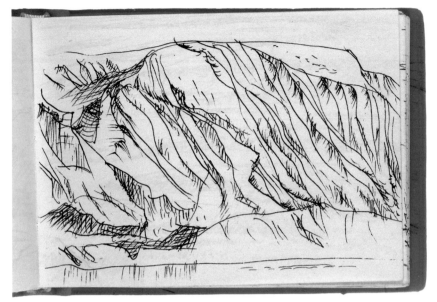

a

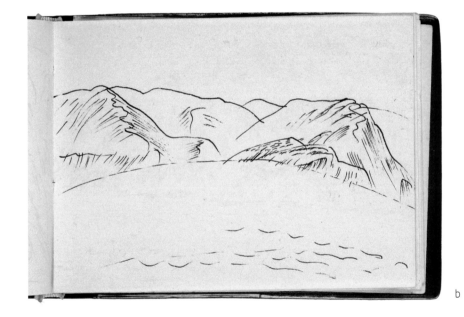

b

35 a and b

Two sketchbooks

1986
Ink on paper
Each 9.8 x 13.4 cm (closed)

These sketchbooks date from July 1986
when Xu Bing visited the Longyang Gorge
in Qinghai (cat. nos, 34, 43, 60 and 61). The
mountain slope in 35a compares with other
sketches, and the etchings, that he made
on that visit. Along with many of the small
sketchbooks Xu Bing filled while travelling in
the early 1980s, these include drawings made
on trains and buses. The view in 35b was
sketched from a boat on the Yellow River.

36

Hillside, Hunan province

Early 1980s
Ink on paper
16.5 x 23 cm

This landscape depicts Fenghuang in the southern province of Hunan, the birthplace of the famous painter and Central Academy professor Huang Yongyu (b.1924), whom Xu Bing was visiting when he drew this work. It includes more features that appear in the much later landscripts than almost any other early drawing or sketch. The repetition of a particular stroke or schematic form to represent the many small areas into which the land has been divided is similar to the use of brushwork convention in traditional painting. In addition, some of the grasses and small sprouting plants, while not depicted as written characters, are in some places visually similar to those in the landscripts, and the same may be said of the group of buildings on the left which, owing to their own repetition and simplicity, barely stand out from the natural forms surrounding them. The two figures in the foreground are similarly linked to the landscape, with conical hats and tapering baskets that are echoed in the nearby stacks of crops and their support structures. While these details may be said to anticipate the landscripts, the overall composition and its neat divisions also link it to the small woodcut series of 1978–83 (cat. nos. 44–57).

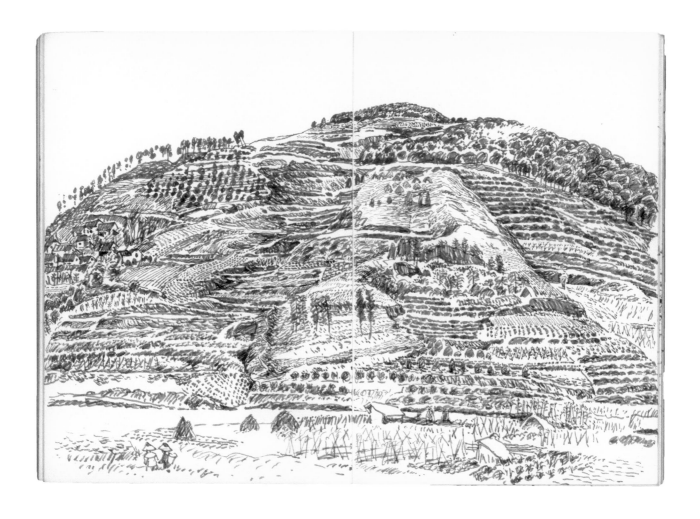

37

Landscape, Shaanxi

1984
Ink on paper
15.5 x 20.5 cm

In 1984 Xu Bing spent three months
in northern Shaanxi province, in the
northwest region of central China. At this
point he had already been teaching at
the Central Academy for three years and
was beginning a programme of Masters
study himself. It was the start of a phase in
which, he has said, he did 'less art making
and more reading', and in which he began
to experiment more in his printmaking.
This drawing, though apparently slight,
displays a considerable degree of
conceptualisation of the landscape,
despite having been sketched on the
spot. The central section in particular
seems concerned with patternmaking in
its variations on the sort of depiction of
cultivated land seen in cat. nos. 33 and 36.

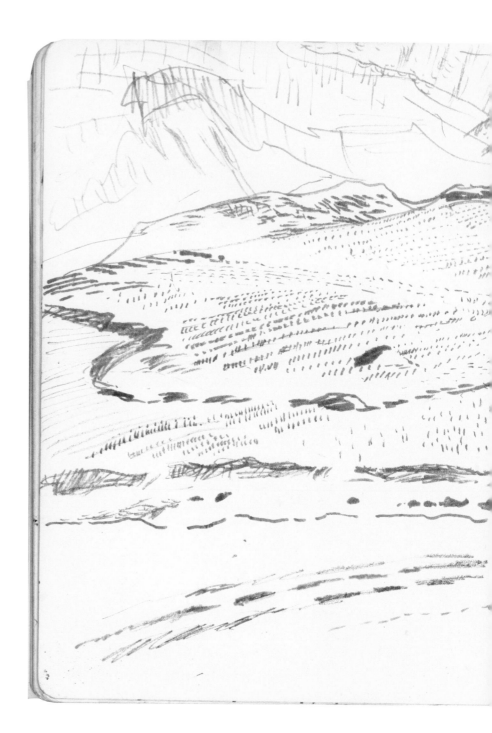

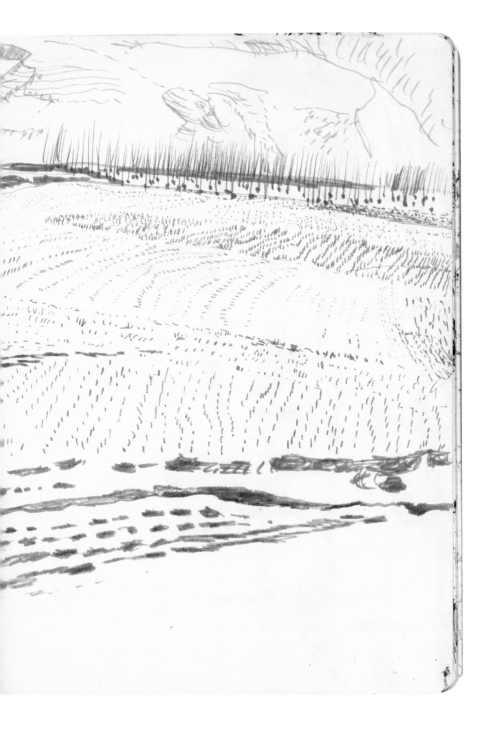

38

Three sketches

1980–85

Ink on paper

14.5 x 19.5 cm

These three small sketches combine the rural simplicity and circular compositions of the small woodcuts in the *Shattered Jade* series with the abbreviations and conventions for depicting crops and natural elements that are the subject of later prints. The stone in the centre of two of the drawings is for separating rice and corn, and is similar to those used in nineteenth-century France. The image on the right depicts a trench dug into loess earth and planted with rice, with a lump of manure at the centre.

1

39

Five sketches

1985
Ink on paper
25.5 x 18 cm

This group of sketches shows the processes of working out the techniques and concepts that appear in the *Ziliudi* print series (cat. no. 71):

1) At top left, the figure looking up towards the dark raincloud as he ploughs a field presents a relationship between man and nature, and the contrasts and inversions between black and white that are central to the print series. Similar themes appear in the small woodcuts of the early 1980s (cat. no. 55). The plots in front of him are shown, through simple variations in the stroke direction, to be planted with a range of different crops.

2) A comparably planted area borders a river with a tall crop growing on the opposite bank. The composition is close to the *Repetitions* print in cat. no. 62. Apart from that print, flowing water does not feature much in the eventual print series. However, the tall crop anticipates the repetition and the similarity to written characters that are key to the landscript series, though that did not begin until more than a decade after this sketch was drawn.

3) As a landscape, this is very much a schematic reduction, however the two motifs both appear in later works: the tadpoles in one of *Five Series of Repetitions*, and in cat. nos. 67 and 68, and the grasses in several other projects: they feature in the landscript prints cat. nos 77a-d and also in the *Mustard Seed Garden Scroll* (cat. nos 78 and 81), in which they are reproduced

from the famous painting manual first published in 1679.

4) The haystacks and pair of chickens appear in many of Xu Bing's drawings and sketches of this period, and in the small woodblock series. The roller at the lower left is also seen in cat. no. 38, and not only refers to the intervention of agriculture but, as a visual intrusion, compares with the print in cat. no.59.

5) This sketch works out in detail the privately cultivated plots – *ziliudi* 自留地 – that provide the subject for the major series of repetitions in cat. no. 71. The elements compare closely with those in the print *Nature 1 – Mountain Place* (cat. no. 58) and in cat. no. 36, which is itself a preparatory sketch for another print in the same *Nature* series.

None of the sketches was drawn from life.
Sketches 2-5 overleaf

2

3

4

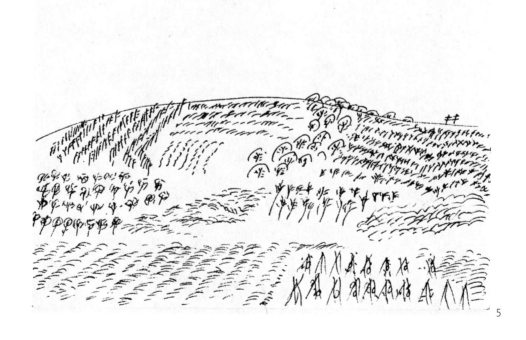

5

40

Two sketches

Early 1980s

Ink on paper

13.5 x 19.5

These two small sketches are not drawn from life but from the mind. The house beneath the hill appears in one of the small woodblock prints (cat. no. 55) in the series that Xu Bing produced between 1978 and 1983, and in several drawings.

The tree-lined road similarly appears in several works, including numerous small drawings, and is at its most developed in the print in cat. no. 59, where the patch of seeds on the road gives the print its title. The original road is the one depicted in cat. no. 41, and its exact location is now forgotten.

41

Road, north China

c. 1982
Children's pen on paper
15.0 x 20.0 cm

This tree-lined road was sketched from a bus while Xu Bing was travelling in north China, probably during a trip in 1982 when he took his students to the northwest. The image was subsequently used by him as a cerebral theme or motif in many works including the 1985 print *Nature 2: A Seed* (cat. no. 59). The

original location of the road, however, is no longer recalled.

A similar drawing (Xu Bing archive 93-1) in a small book of sketches from life shows a tree-lined road in open countryside and a small vehicle travelling along the middle, while a conceptualised version is depicted in cat. no. 32.

42

Three sketches of mountain sheep

1985
Ink on paper
27.1 x 38.8 cm

These three variations of the subject of sheep on a hillside explore a range of pictorial topics that occur in later prints by Xu Bing. The inversions of black and white are the most obvious. This appears quite clearly in the small woodcuts of the late 1970s and early 80s, and in the *Shattered Jade* series, though in the latter mostly as quite neat reflections or equivalent inversions. The sheep, as domesticated animals, appear in the Handan drawings of 1980–81 but seldom in later works; the single sheep with food at the lower left is particularly reminiscent of the animals in that group of drawings. The aspect that most clearly relates to prints also produced in 1985, and in the *Five Series of Repetitions* of 1987 onwards, is the row of trees on each hilltop. In each case they are similar to the crops depicted in other sketches and the *Repetitions* series prints, while those in the righthand sketch are close in appearance to characters used in the landscript paintings. The overall composition compares to that of an oil painting by Cao Liwei in the late 1984 exhibition of youth art and published in Xu Bing's review of that exhibition in *World Art* 世界美术 in 1985 (vol. 1).

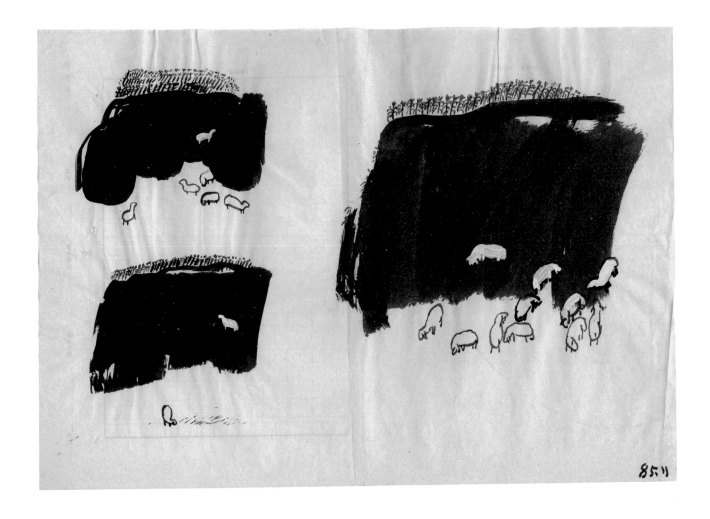

43

The Yellow River, Qinghai

1986
Ink on paper
15.8 x 21.0 cm

This sketch depicts the Yellow River at or near Longyang Gorge in Qinghai province, and was drawn on the same visit to the region during which Xu Bing produced the prints in cat. nos 60 and 61. The ink strokes that Xu Bing uses to form the rocks are similar to those in the earlier sketches but are less sharply grouped, and closer to the use of brushwork on mountains in traditional painting. The particular success of this sketch, however, lies in the depiction of the water, which is shown as fast-flowing over an uneven riverbed.

Longyang Gorge is the point where the Yellow River, with its source far to the west across the Qinghai plateau, first enters the Yellow River valley. The granite cliffs are around 200 metres high, and the river about 30 metres wide. The riverbed is uneven because of rocks or silting. The composition is similar to many mid-twentieth-century paintings of the Yangzi in Sichuan, with a level view across mountain tops above a mighty river. The river holds an iconic place in Chinese culture: the early settlements

in its Wei River valley region gave rise to its association with 'the cradle of Chinese civilisation', and its repeated floods and ensuing famines lent it the appellation 'China's sorrow'. During the Cultural Revolution the limited number of performance works endorsed by Jiang Qing (the wife of Chairman Mao) included the Yellow River Concerto, which was originally composed in a northern Shaanxi cave dwelling (see cat. no. 54) in Yan'an in 1939.

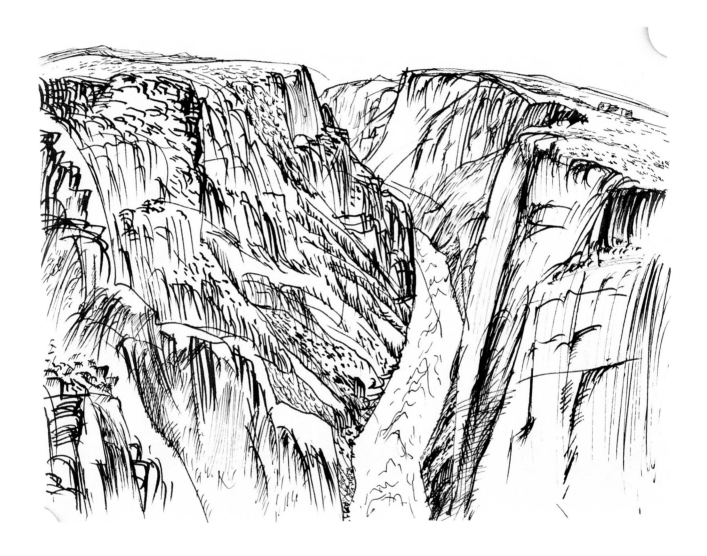

Small Woodcuts

Xu Bing was assigned to the printmaking department at the Central Academy of Fine Arts, Beijing, when he arrived there as a new student in 1977. Making small woodblock prints was part of the process of acquiring skills and learning about printmaking, yet he continued to produce woodcuts for more than five years and eventually gathered them together in the series that he named *Shattered Jade* 碎玉集. His teachers at the Central Academy included some who had been in Yan'an in the 1940s making woodcuts that took everyday life as subject matter in order to convey the communist message in rural or poor areas. Gu Yuan (1919–96), whose prints were singularly effective in capturing the dignity and simplicity of daily life, made a particularly deep impression on Xu Bing, and the woodblock prints here are very much influenced by him. Gu Yuan's subject matter also resonated with Xu Bing's experiences in the countryside, to which he refers in his article 'I picture things that I love' (1981) that included illustrations from the series. In 1985 parts of that article were repeated in the preface to a small book, *Xu Bing Small Woodcuts* 徐 冰 小木刻 published by Hunan Art Press, which gathered together 128 works.

Xu Bing's own attitude to the prints has changed over the years. He was initially pleased that he had achieved his aims in producing them and that they were appreciated by others. However, when he became aware of and involved with contemporary art beyond China he put the prints aside, viewing them as slightly parochial and old-fashioned, and unconnected with his current interests. He has since revised that attitude and indeed many of the woodcuts not only include motifs and styles that appear in his drawings throughout the 1980s, but also anticipate the conventions he uses in his *Repetitions* series of the late 1980s, and in the landscripts he began creating at the turn of the century. The exploration of black and white (cat. no. 44), agricultural activity (cat. nos 47–9), industry and environment (cat. no. 50), his conceptualisation of landscape (cat. nos 45, 51 and 55), his travels in north China (cat. nos 53, 54 and 57), rural life (cat. no. 46) and Beijing (cat. no. 56) all feature in other works, and similarly lack human figures, though their traces are often evident.

44

Fragrant Grasses 芳草地

1979
Signed
Woodblock print
8.4 x 7.9 cm

This print is more an exploration in the medium than a depiction of the subject in its title; as such it demonstrates that the ideas of the *Ziliudi* print (cat. no. 71) of 1985 had in fact been present in Xu Bing's work since very early in his woodblock practice.

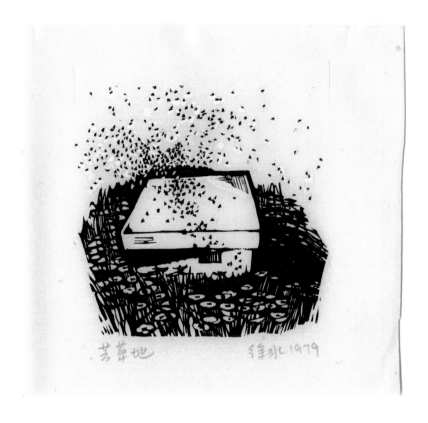

45

Field 田

1982
Signed
Woodblock print
7.4 x 9.8 cm

The direction of the planting in this image of a field gives it the appearance of the character for 'field'. Human intervention in the landscape is additionally shown through depicting the well at the field's edge.

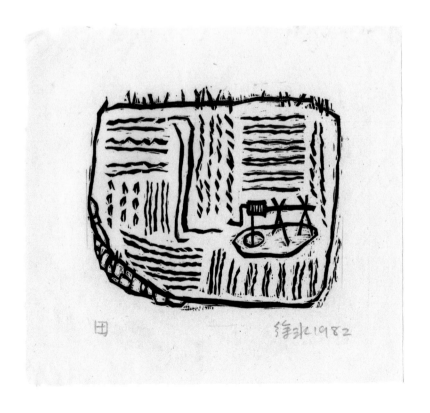

46

Warmth 暖

1980
Woodblock print
7.4 x 9.8 cm

The subject here is perhaps influenced
by the living space Xu Bing and his urban
companions were given when they arrived
in the countryside in 1974; it was adjacent
to sheds where pigs were housed, and they
looked after them (see p. 27).

47

Stone Roller 石碾子

1980
Woodblock print
9.0 x 10.4 cm

Several of Xu Bing's rural woodcuts show
agricultural equipment, though seldom in
use. It was one of his preferred ways for
referring to the interaction of people with
the landscape.

48

Threshing Ground 打谷场

1980
Woodblock print
7.7 x 9.4 cm

This type of threshing equipment is similar, as Xu Bing has pointed out, to that in use in nineteenth-century France.

49

Field's Edge 地头

1980
Woodblock print
9.5 x 10.5 cm

This small woodcut shares a theme with *Field* (cat. no. 45). The grasses or crops at the water's edge are a motif picked up in many subsequent works, perhaps most obviously the larger woodblock print *Big River* (1987; cat. no.62).

50

Forestry Scene 林区小景

1981
Signed
Woodblock print
8.4 x 8.1 cm

This forestry scene is not as considered as some of the woodcuts in the *Shattered Jade* series, but demonstrates Xu Bing's consistent interest in the management of natural resources (cat. nos.8, 9, 61).

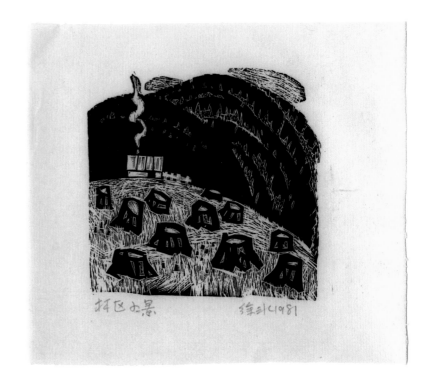

51

Garden Patch 园圃

1982
Signed
Woodblock print
7.0 x 7.5 cm

This print is similar to *Field* (cat. no. 45) in its composition, and the content is also seen in many of Xu Bing's sketches of the early 1980s. The clothes drying on the fence, and the chickens, refer to daily life in the same way that animals and objects do in his drawings of scenes in southern Hebei (cat. nos. 12-4).

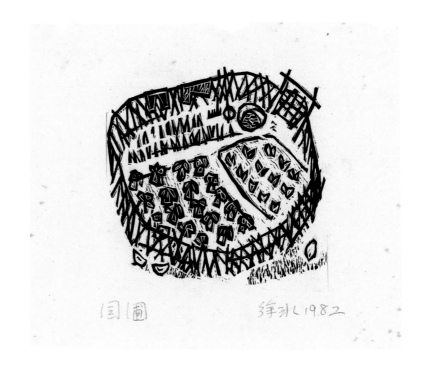

52

Backyard 屋后

1982
Signed
Woodblock print
7.4 x 9.8 cm

Like many of Xu Bing's small woodcuts,
the subject of this print is depicted within
an enclosure. The buildings are similar to
those in the *The Suzhou Landscripts* (纸抄纸)
(cat. no. 77a-d).

53

Winding Mountain Road 盘山路

1982
Signed
Woodblock print
8.7 x 7.9 cm

This apparently simple woodcut shares
many features with Xu Bing's early
drawings: the winding road, the bus,
the tracks on the road, and the white
highlights.

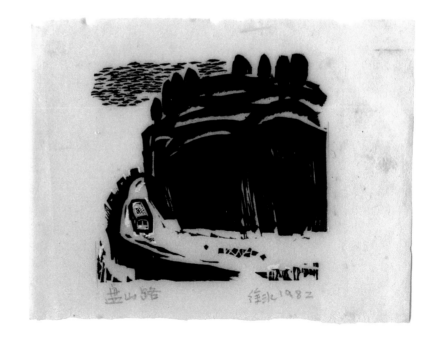

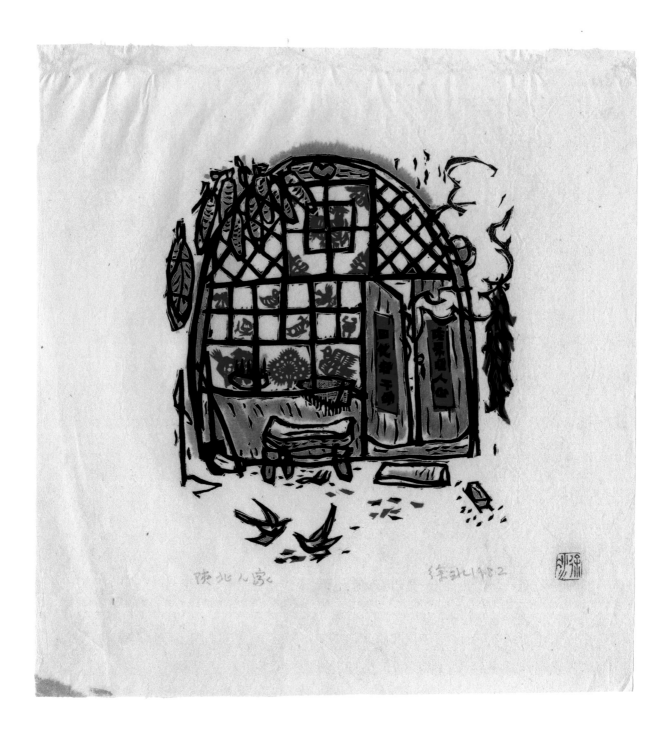

54

A Home in the Northwest 陕北人家

1982
Signed; one seal
Colour woodblock print
17.2 x 15.3 cm

This print depicts a typical cave dwelling
in northwest China, with papercuts on the
windows, a calligraphy couplet on the door,
and vegetables and household objects
around the exterior (see cat. no.13).

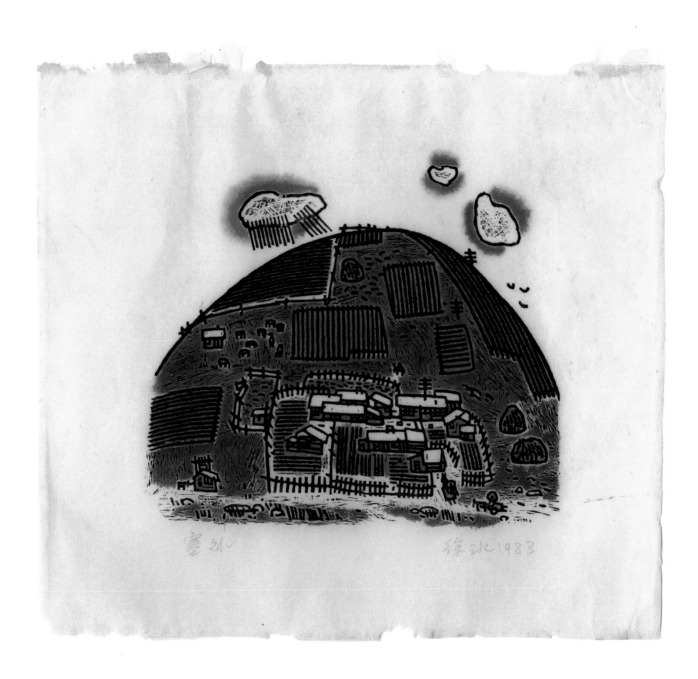

55

Beyond the Great Wall 塞外风光

1983
Signed
Colour woodblock print
16.7 x 15.0 cm

This print depicts a landscape in the far
north, the region where Xu Bing spent the
years 1974-7. The agriculture, the animals
and the cloudburst on the hilltop all recur
as motifs in his prints and drawings of the
early- and mid-1980s.

56

Houhai 后海

1983
Signed; one seal
Colour woodblock print
16.0 x 16.8 cm

Houhai is the name of an area in central
Beijing at the northwestern edge of the
Forbidden City, and refers to one of the
two imperial lakes there. It is a scenic
spot, crowded in summer and tranquil in
winter. Xu Bing used to pass through it
at weekends on his way home from the
Central Academy.

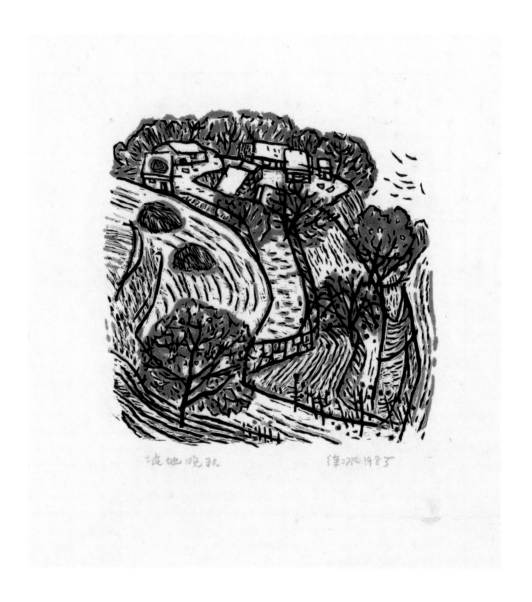

57

Late Autumn Hillside 坡地晚秋

1983
Signed
Woodblock print
15.1 x 15.6 cm

This hillside subject combines the view
seen in many of Xu Bing's landscape
sketches of the early 1980s, and the trees
of southern Hebei shown in cat. nos. 29
and 30.

Prints

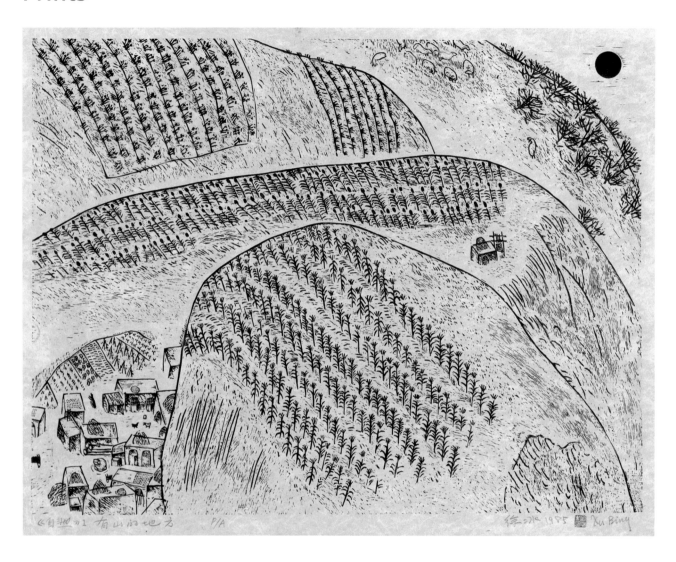

58

'Nature' 1 – Mountain Place '自然'
1 – 有山的地方

1985
Signed in pencil 徐冰 and Xu Bing
One seal: 徐冰木刻 (Xu Bing woodcut)
Woodblock print
46.0 x 61.0 cm

This print brings together in an imagined landscape elements from many of the drawings and sketches in this exhibition: the rounded hillsides of southern Gansu (cat. no. 32) and of Fenghuang in Hunan (cat. no. 36); as well as the threshing tools seen in small woodcuts (cat. no. 48); hillside sheep as drawn in the same year as this (cat. no. 42); and, in particular, the

group of farm buildings after the house in a forest in southern Hebei (cat. no. 31). These elements also appear in many of the small woodcuts. However the print also anticipates works of the late 1980s, which are similarly conceptual as landscapes and in which Xu Bing has used the same conventions for representing crops and other plants.

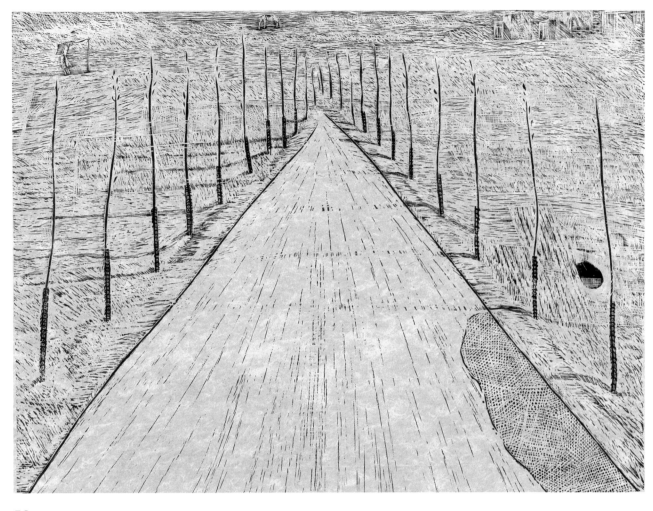

59

'Nature' 2 – A Seed '自然' 2一片种子

1985
Woodblock print
45.0 x 60.0 cm

In terms of content, both this print and *'Nature' 1 – Mountain Place* constitute versions of earlier drawings, on a larger scale and in more detail; and, of course, in a medium that demands more thinking out and preparation than the quick life sketches from which they derive.

The composition of a tree-lined road in an (apparently) empty landscape is as seen in sketches from the early 1980s (see cat.

no. 41), yet there are many more traces of human activity in these prints than in any of the earlier drawings. The most evident is the long patch on the right of the road, in the foreground, depicting a pile of seeds bearing the tyre marks of vehicles that have driven over it. The trees are just saplings, and are protected by hemp wrappings, in a further reference to cultivation. There are two horses in the print: one on the left, straining at a tether, and a second grazing in the distance. At the top right is a group of derelict farm buildings. The earth and the grass to the left of the road, and the earth to the right, are depicted by groups of short repeated marks in a variety of

lengths, thicknesses and directions, and in many places are crossing each other. The black area at the right comes from a knot in the woodblock, deliberately left largely unworked. The texture of the paper is likewise exposed in the relatively unworked area of the road itself.

The many reprisals in this print of aspects of Xu Bing's early drawings and sketches make it a pivotal work between those and the woodblock prints that followed, a number of which are slightly larger still, even further removed from the actual landscape scenery, and which use as conventions several of the marks seen in this particular print.

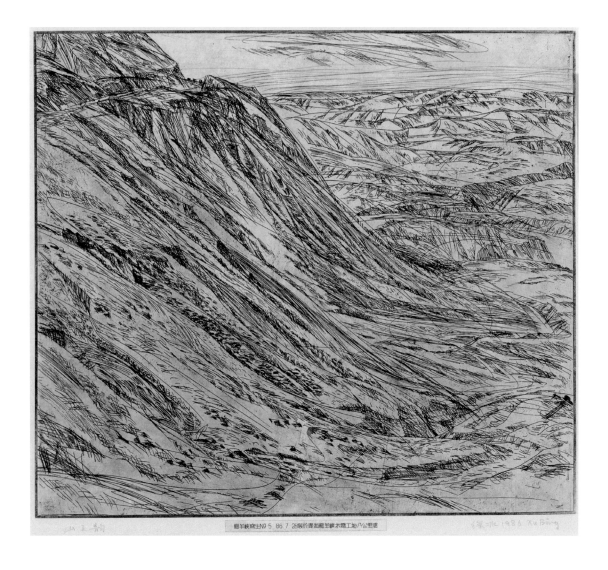

60

Mountain Rhythm 山之韵

28 July 1986

Signed 徐冰 *1986* and *Xu Bing*

Etching

44.0 x 50.9 cm

This etching was made in the open air and printed in a studio. It was produced during Xu Bing's travels in northwest China in 1986 and the precise spot is recorded on the mount: eight kilometres from the hydroelectric power station site on the Yellow River at Longyang Gorge in Qinghai province.

The process was unusual. Xu Bing took with him to Qinghai copper plates that had been waxed in Beijing. In the open air he scratched through the wax to create the image, using a needle from the travelling printmaking kit he customarily used for his peripatetic teaching. He added the acid in the evening on his return to the workers' housing where he was staying and the images were printed on his return to Beijing.

The Yellow River is over 5,000 kilometres long and the valley section in its upper reaches, beginning at the Longyang Gorge, is turbulent and fast due to the high cliffs and narrow riverbed – hence the siting of the power station. The river holds an iconic place in Chinese culture: the early settlements in its Wei River valley region gave rise to its association with 'the cradle of Chinese civilisation', and its repeated floods and ensuing famines lent it the appellation 'China's sorrow'.

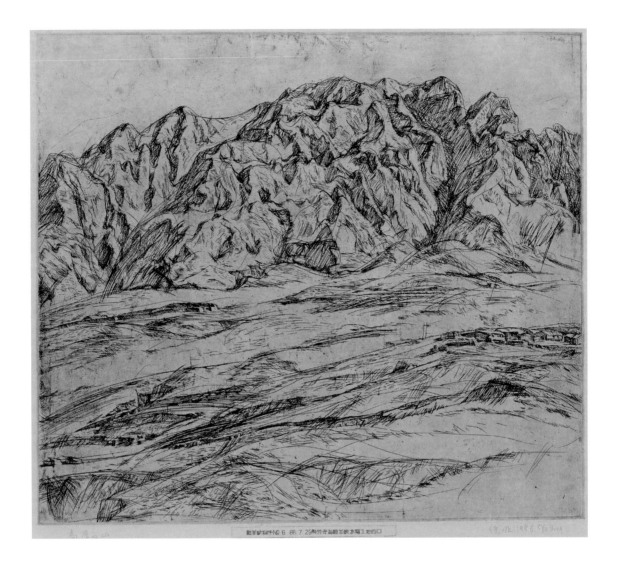

61

Mountain Plateau 29 July 1986

高原的山

29 July 1986
Signed 徐冰 1986 and *Xu Bing*
Etching
43.7 x 50.6 cm

This etching was made the day after *Mountain Rhythm* cat. no. 60), at the western entrance to the Longyang Gorge hydroelectric power station. The technique is the same (see above); the marks on the sky area are the result of acid leaking on the return journey to Beijing. Like the previous print, it depicts a mountain landscape, though the series to which both prints belong also includes images of the power station construction site .

The Longyang Gorge dam was designed as the westernmost of a succession of dams to be built along the length of the Yellow River. Water control has always held an important position in Chinese rulership, beginning with the legend of Yu controlling the floods and founding the first dynasty around four thousand years ago. Historically, government departments managing water systems have been centres of power and many major officials have had backgrounds in hydraulic engineering. Mao Zedong believed that 'humans should conquer and harness nature'. Environmental degradation, however, has meant that the Longyang Gorge power station, the construction of which Xu Bing depicted, produces only a fraction of the energy anticipated at that time.

62–70

Nine prints from the Repetitions series, 1987–8

Xu Bing began experimenting with his printmaking during the mid-1980s. It was a decade during which Western literature, philosophy and history were newly available following the end of the Cultural Revolution. Xu Bing encountered the work of Marcel Duchamp and Andy Warhol at a time when he had already become deeply interested in repetition and the possibilities of print as a medium. The result was a series of five works that involved repetition, produced as long horizontal scrolls printed from a number of blocks; the nine prints included here are individual sections from those series. Cat. no. 71, which follows, is a complete work. In these prints Xu Bing experiments with different techniques for carving the woodblocks and with inversions, repetitions and patternmaking in the designs. Pattern and technique are foremost, but the prints are not entirely unrepresentational. The subject matter all comes from the natural world and some compositions are legible as landscapes. Most of the elements can be found in the small woodcuts from the *Shattered Jade* series (1978–83), or in earlier drawings and prints; the forms he uses for representing crops, fields, haystacks, hillsides and water are all evident in other works, and mostly within the displays in this exhibition. The *Repetitions* series was submitted by Xu Bing for his Masters exam, and he continued to work on it for some time afterwards.

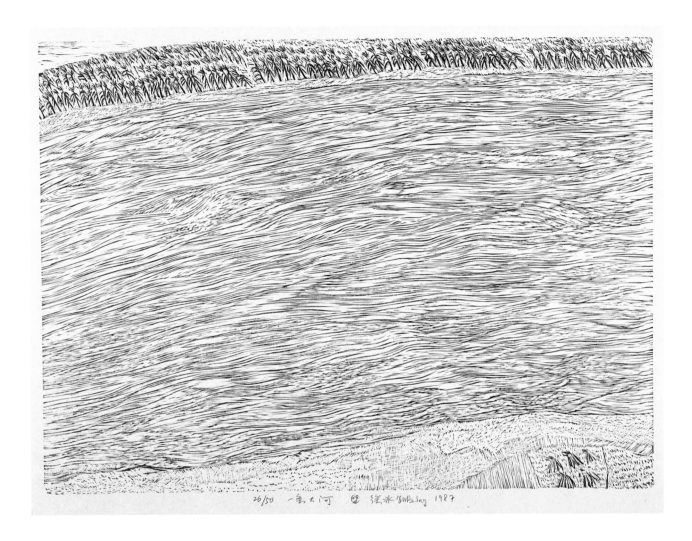

62

Big River 一条大河

1987
Signed 徐冰 and *Xu Bing*
One seal: 冰
Woodblock print, 26/50
53.0 x 73.5 cm

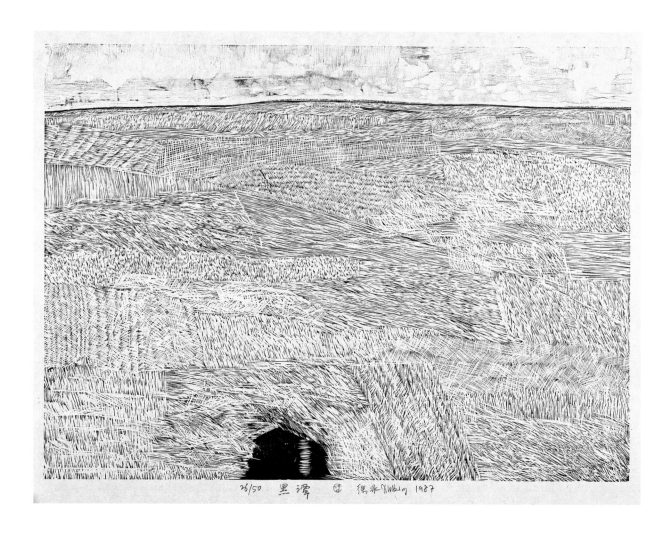

63

Black Pond 黑潭

1987
Signed 徐冰 and *Xu Bing*
One seal: 冰
Woodblock print, 26/50
50.5 x 71.0 cm

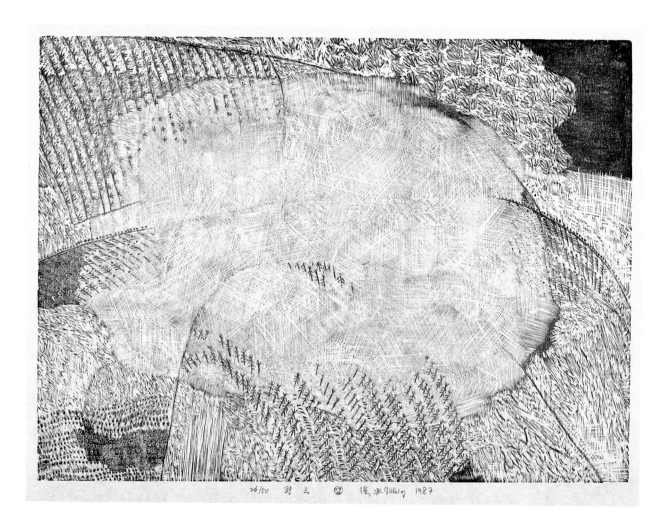

64

Moving Cloud 移云

1987
Signed 徐冰 and *Xu Bing*
One seal: 冰
Woodblock print, 26/50
51.5 x 72.0 cm

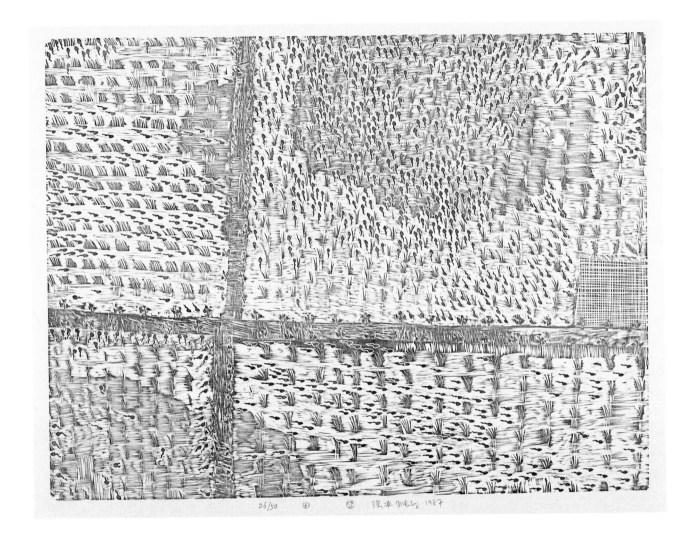

65

Field 田

1987

Signed 徐冰 and *Xu Bing*

One seal: 冰

Woodblock print, 26/50

55.0 x 67.0 cm

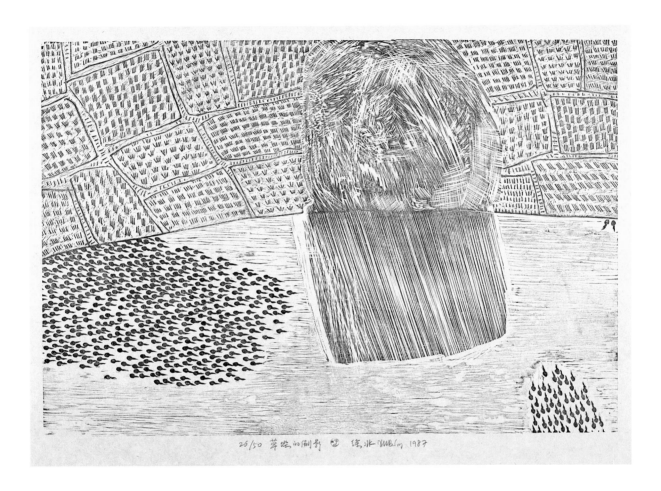

66

Haystack Reflection 草垛的倒影

1987

Signed 徐冰 and *Xu Bing*

One seal: 冰

Woodblock print, 26/50

47.4 x 71.7 cm

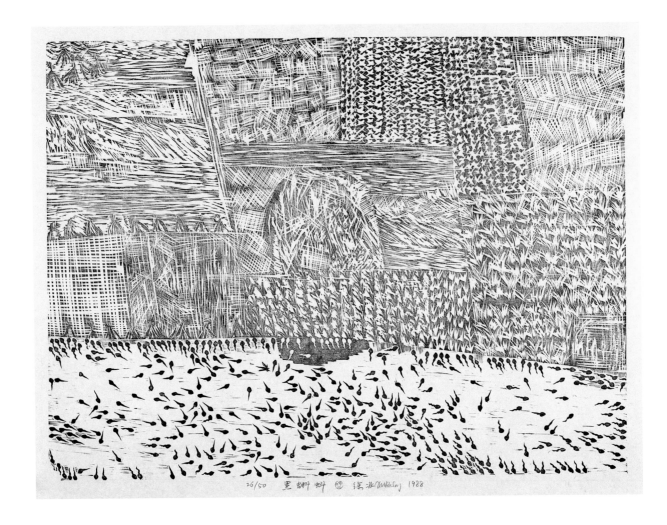

67

Black Tadpoles 黑蝌蚪

1988
Signed 徐冰 and *Xu Bing*
One seal: 冰
Woodblock print, 26/50
50.5 x 71.0 cm

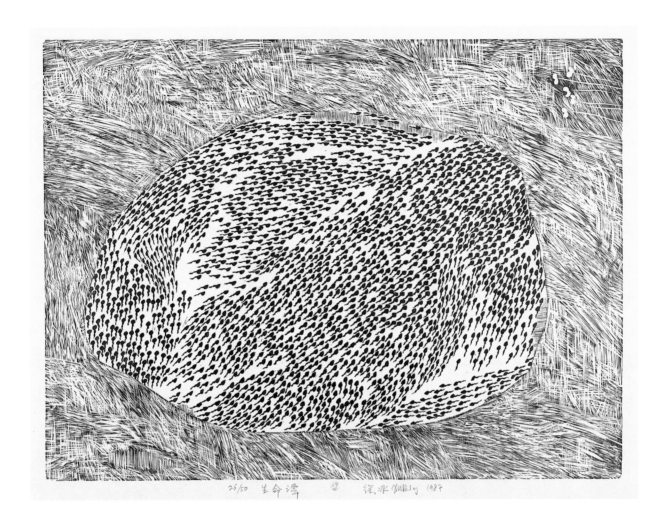

68

Life Pond 生命潭

1987
Signed 徐冰 and *Xu Bing*
One seal: 冰
Woodblock print, 26/50
50.4 x 68.2 cm

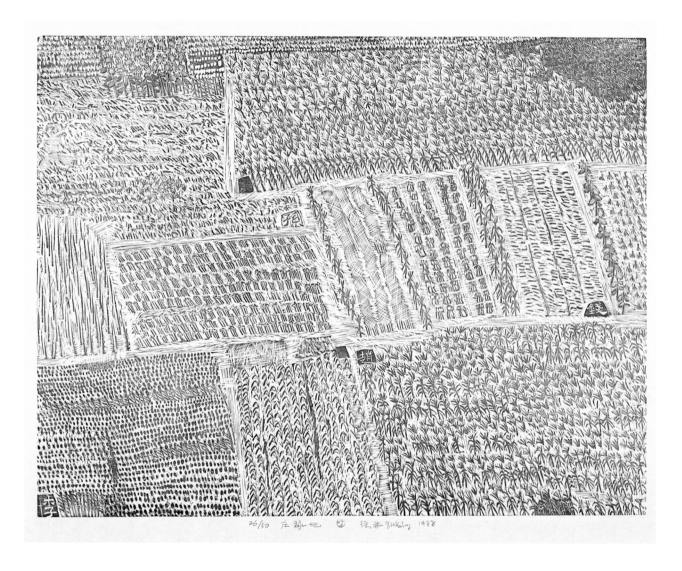

69

Family Plots 庄稼地

1988

Signed 徐冰 and *Xu Bing*

One seal: 冰

Woodblock print, 26/50

55.0 x 72.0 cm

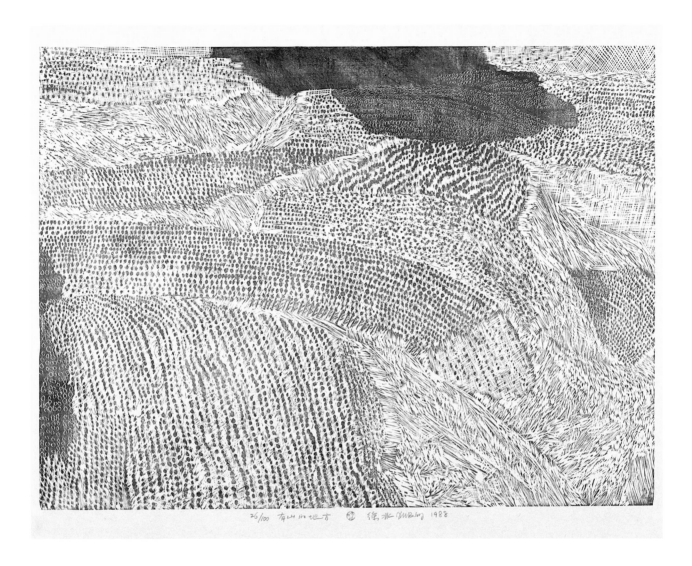

70

Mountain Place 有山的地方

1988
Signed 徐冰 and *Xu Bing*
One seal: 冰
Woodblock print, 26/50
53.0 x 72.5 cm

71

Series of Repetitions: Ziliudi

复数系列:自留地

1987
Signed and titled in pencil 复数系列 徐冰 *Xu Bing 1987*
Woodblock print
54.5 x 864.0 cm

Xu Bing's *Repetitions* series explores and exposes the processes of woodblock printing. The scroll has been printed eleven times in sequence from a single block at different stages in its carving. It begins therefore as black print from an uncarved block and ends with almost white print from the same block after the raised surface has been almost completely carved away. The medium as well as the process is exposed: in the two black sections to the left, the wood grain is clearly visible, while further on knots in the wood can be seen.

The print explores not only the medium and its processes but also something that is inherent in it: repetition. The possibilities of repetition that print

affords, together with its way of 'fixing' an image, are aspects of printmaking that Xu Bing had been considering at length during the mid-1980s. The standardisations that the medium requires or produces were also a source of interest for him, most particularly in their relation to the standardisations surrounding everyone in modern life, in the design of everyday equipment or goods. His interest in these things coincided with the opening of China to foreign ideas and the new availability of information about Western art. Xu Bing was interested in Duchamp's questionings and in Warhol's use of repetition. Andy Warhol had visited China in 1982, as a tourist, but it was the publication of his work in Chinese art

journals that caught Xu Bing's attention. Exposure to these ideas and an urge to make art that moved away from the socialist thinking of his early training resulted in the *Repetitions* series – the works that represent Xu Bing's first contemporary pieces in that they engage with modern art beyond his own local sphere, both technically and conceptually.

The subject matter may therefore be said to be secondary to the ideas and processes in this work. The motifs employed, however, have close links to Xu Bing's early artistic experiences, to the images in his early drawings, and to the concepts he used later and in particular in the new landscript works (cat. no 77 a–d). The title *Ziliudi*, 'family plots',

refers to a landownership arrangement instituted in the 1950s whereby families who worked on state-owned communes were allowed an individual plot whose produce they could retain for private consumption or sale. The system was abolished in the 1960s as the 'tail-end of capitalism', to be revived in the reforms of the 1980s. The characters that Xu Bing has placed in the corners of some of the rectangles (family plots) in the central sections of the print are family names, in reference to this system. The names used appear in the order Zhao, Qian, Li, Sun, as the first four listed in the Song dynasty (960–1279) compilation of one hundred family names, representing the four most important families of that time.

The phrase 'old one hundred names' now refers informally to the common people. The crops shown in these family plots use the forms that Xu Bing has drawn in many of his earlier sketches (for example cat. no. 36), and the arrangement of the rectangles is not dissimilar to his depictions of distant hills and landscapes in earlier drawings and prints. However, there is a more significant reference in the composition – its association with newspapers. The plots of land are shaped and arranged as blocks of printed text. Xu Bing was involved with the production of public text from a young age, in his schooldays for the school's political office and in the countryside for the commune's journal, where he designed the layout as

well as the typography. The 'content' of the 'newspapers' in this print uses the plants as writing, creating an equation between the pictorial conventions used in language and in landscape painting; he has described the *Repetitions* series as containing much of the groundwork for *Book from the Sky*.

The *Ziliudi* print thus connects to socialist rural planning; Song dynasty categorisation systems; the relationship between text and nature; the processes of its own medium; contemporary China; repetition and convention in Chinese art and language; modern Western art; and also to Buddhism, for in moving from nothing to something and back to nothing, it hints at the cycle of life.

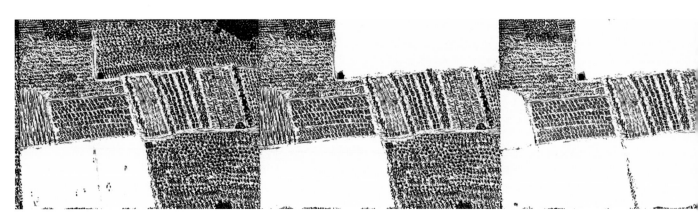

(repeated)

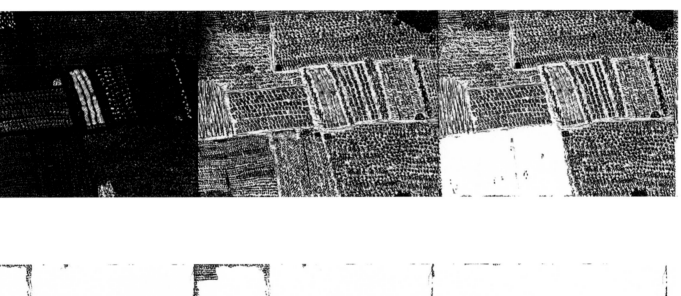

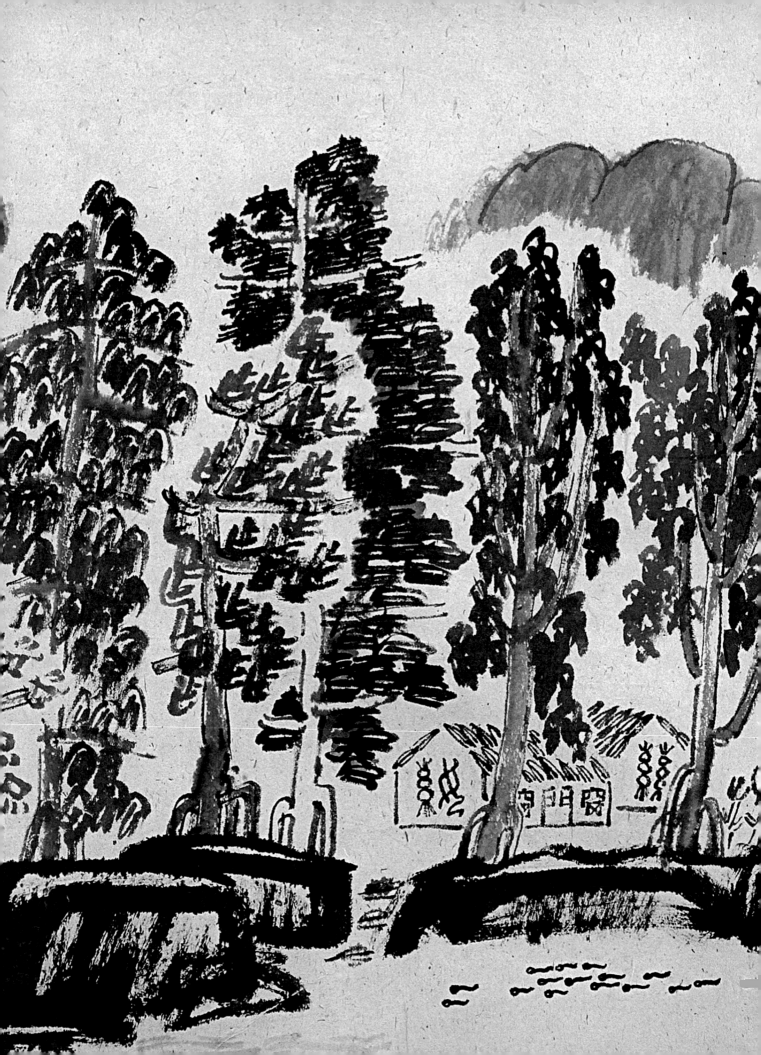

Landscript

Shelagh Vainker

anguage and nature are the subject of many of Xu Bing's works (see p. 184–99), including some very recent pieces. His first animation, *The Character of Characters* 汉字的性格 (2012), opens with birdsong to which a man calls in response. The landscape they occupy is that of Zhao Mengfu's fourteenth-century *Autumn Colours in the Qiao and Hua Mountains*, and their communication through sound swiftly transforms into written words in the form of pictorial characters sucked out of the trees and rocks. In this animation, language and nature interact within one of China's most famous landscape paintings. In Xu Bing's landscript works on the other hand, language and nature are combined to create a painting: the character for 'tree', 木, is used to depict a tree, the character for 'mountain', 山, to depict a mountain, the character for 'water', 水, to depict water, and so on. This is possible because the origins of the Chinese script lie in pictographs. For example, the writing used on early ritual objects such as bones and turtle shells for divination, or bronze vessels for sacrifices, includes symbols that are essentially pictures of the sun or moon or trees and other parts of the natural world. These symbols still appear in modern characters, though they have long since been combined with phonetic elements.

Xu Bing describes in the essay that follows (pp. 120–8) how his use of characters to make paintings came about when he visited the Himalayas. Some of the sketches he drew on that occasion are included in the exhibition (cat. nos. 72–3a–f). The sketchbook in cat. no. 72 (fig. 1)

Fig 1 Cat. no. 72, Helsinki sketchbook, drawn in the Himalayas, 1999, ink on Nepalese paper, 20 x 12.7 cm (closed).

shows clearly his initial consideration of the idea: the character for 'stone', 石, is drawn in an archaic form that emphasises its similarity to a stone or rockface. The image opposite it shows a fast-flowing river with a cliff to one side and trees and stones to the other, creating a small composition of its own. The loose-leaf Himalayan drawings explore the use of the method for larger compositions, and as scenes they are clearly recognisable – a house, an airport amongst mountains, an enclosure and so forth. The 'brushstrokes' that depict the scenes are all characters, but they are a mixture of characters that are pictorial images themselves, and characters that are the word for that part of the picture. The latter have no visual connection

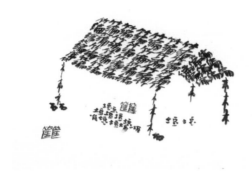

Fig 2 Cat. no. 73c, Sketch of a thatched pavilion on wooden pillars and a stone base for storing potatoes, 1999, ink on Nepalese paper, 21.4 x 28.0 cm.

Fig 3 Cat. no. 73a, Sketch of Kathmandu airport, 1999, ink on Nepalese paper, 21.4 x 28.0 cm.

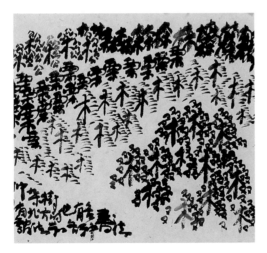

Fig 4 Cat. no. 74 (detail), Landscript, 2002, ink on Nepalese paper. Khoan and Michael Sullivan Collection.

with the things they represent, so function more as notes, as in 土豆 for the potatoes beneath the shelter in cat. no. 73c (fig. 2). In the drawing of the airport (fig. 3) the runway markings are depicted with the character for 'white', 白, which describes the look of the markings but does not itself look similar to runway markings. These verbal representations do not appear in the larger scale landscript paintings that Xu Bing began making the following year (fig. 4). These are composed entirely of characters, and as such depict almost pure landscape: the man-made elements in them – buildings, stone walls – are themselves made of natural materials, and are things so fundamental that the characters for them have clear pictographic origins, as in 'door', 门, or 'window', 窗, for example.

In his landscript essay Xu Bing explores the influences that pictographic writing has had on Chinese culture, and discusses installation works that he has developed from the pictographic quality of Chinese characters. The main part of his discussion, though, concerns calligraphy. What he discovered in doing landscripts was a new dimension to the relationship between calligraphy and painting. That relationship has long been understood and discussed in terms of brushwork style. Xu Bing discovered a relationship in terms of symbols; in using characters, repeated, to depict a group of trees or a group of stones – in other words a forest, or a mountainside – they were made to function in the same way as the brushstrokes that make a forest or a mountainside in painted landscapes. He likens this function to that of the elements of painting published in 1679 in the instruction book *The Mustard Seed Garden Manual of Painting* (p. 151, cat. nos 78–90). He refers to this manual in the long inscription that runs across all four parts of the new work at the centre of the exhibition (cat. no. 77) where he writes: '"the mustard seed garden manual of painting", china's most famous work of art instruction, combines the brushstroke – mountain strokes, tree strokes, rock strokes – from the paintings of old, it is a dictionary.

Students need only memorise the "radicals" [the basic character components] to express everything existing in this world.' The manual was the first to be printed and widely circulated, though in fact it was similar to manuals that painters had used in private for centuries previously. Each page reproduces sample methods of painting a particular subject – rocks, buildings, grasses, trees and so on – and includes short texts labelling the subjects. Many of these include the names of the particular artist whose method of painting is being reproduced: 'Guo Xi's method of painting trees' (cat. no. 85) or 'Mi Fu's method of painting rocks', for example. Most of the painters referred to in this way, including the two mentioned above, were active in the Song dynasty (960–1279), though a few earlier and some later painters are also named.

The brushstrokes, Xu Bing's characters and model methods for painting landscape elements are thus all, in this understanding, conventions or symbols that the artist combines together to make a picture. The concept of using such symbols to describe things applies to other art forms as well: words in poetry, for example, or syllables in opera (fig. 5). Producing the symbols is a skill that can be learnt, as *The Mustard Seed Garden Manual* demonstrates, and the symbols themselves

convey widely recognised meaning. The creativity of poets, opera performers or artists resides not then in the accurate production or appropriate use of symbols, but in how the artist combines or arranges the symbols to make new expressions or meanings. In a landscape painting this might mean the way in which the mountains, rocks, water or, indeed, empty space relate to one another within a composition, or the use of ink wash to add tone overall. Xu Bing summarises this in the inscription on the four landscript lithographs: 'good poetry emphasises the use of the "canon", the brilliant poetry of earlier generations. if a good painting possesses "classical" qualities, it must reflect the brushwork of the ancients. Chinese painting emphasises "paper copying paper" and through these symbolised brushstrokes it is passed on from generation to generation.'

This is a view of painting that lies at the core of the Chinese scholarly culture. It was most powerfully articulated by the Ming dynasty painter, calligrapher, official, connoisseur and writer Dong Qichang (1555–1636). Dong developed a new theory of landscape painting that emphasised the styles of old masters and that looked to earlier painting as models for an artist to work from: 'If one considers the wonders of nature, then painting cannot rival landscape. But if one considers the wonders of brushwork, then landscape cannot equal painting.' He identified a lineage in the scholarly painting tradition, a succession of painting masters whose works might be regarded as the ideal standard to follow. Many of those painters are included in *The Mustard Seed Garden Manual*, for example Mi Fu and Mi Youren of the Song dynasty (960–1279), and Huang Gongwang and Ni Zan of the Yuan dynasty (see cat. no. 89). The influence of Dong Qichang's theories was profound and endured well beyond China's last imperial dynasty, the Qing (1644–1911). The ideas were adopted as court practice in the early Qing, and the most renowned painters of that period are a group known as the Orthodox

Fig 5 Sketch of an outdoor opera performance, north China, early 1980s, ink on paper.

Masters. The leading Orthodox Masters were four painters all surnamed Wang: Wang Shimin, Wang Jian, Wang Hui and Wang Yuanqi. The closest to Dong Qichang was Wang Shimin (1592–1680), whose painting *Morning Brightness over Autumn Mountain* Xu Bing takes as a model in the fourth of the landscript lithographs (cat. no. 77d). The Orthodox painters aimed to advance the scholarly painting tradition while reflecting and building on the achievements of past masters. As such, the inscriptions on their works often state a debt to earlier artists and follow the form 'painted in the style of …' or 'imitating the brushwork of …'. This is what is meant by 'paper copying paper'.

This theory of painting, dependent on past masters, has been called a referential or art historical method. Just as *The Mustard Seed Garden Manual of Painting* has been dismissed as cliché and criticised as opposing creativity, so have Dong Qichang's theories been repudiated and questioned. Their most forceful interrogator is Shi Tao (c. 1642– c. 1707). Shi Tao was born a member of the Ming royal family and, following the establishment of the new dynasty, spent years wandering, as an itinerant artist and a Buddhist. He was as formidable a theorist as he was a painter and his 'theory of a single line' 一画论 remains one of the most complex and discussed in the history of Chinese painting; he is recognised as the leading 'Individualist' painter of the Ming and early Qing periods, and his work is acknowledged by many early to mid-twentieth-century painters as an inspiration. He criticised a theory of painting from the ancients, advocating that such an idea was more suitably addressed by looking directly at the methods of the Song dynasty (960–1279) painters at the head of the landscape tradition. These were painters whose methods included spending long periods walking in mountain landscapes before representing them in ink on paper (cat. no. 85). He also held the view that creativity in ink should, like nature, be spontaneous.

When Xu Bing writes in his landscript essay of eliminating the influence of the Cao Quan stele

and the Tang (618–906) master Yan Zhenqing's methods, that facing a mountain and drawing a mountain bypasses the weight of the calligraphic tradition, he is writing of the contrast between Dong Qichang's art historical methods and Shi Tao's natural ones. Shi Tao's criticism of Dong's methods goes beyond a refutation of his theories and on to a clearly stated distinction from his own work, for the comment by which he is best known for questioning art historically based Orthodox painting methods is 'I use my (own) method' 我用我法. This is the phrase with which Xu Bing opens the inscription on the four landscript lithographs. He not only opens the inscription by citing Shi Tao, he concludes it on his own version of a landscape by Dong Qichang's foremost disciple Wang Shimin.

The method that Xu Bing uses is, of course, landscript. It might be argued that by citing Shi Tao, Xu Bing has drafted him into the lineage of masters whose work is contributing to his own creative act, in the process he outlines in the middle part of his inscription on the four lithographs. The 'paper copying paper' lithographs certainly breathe new life into the landscape tradition on those terms, and are all the more venerable for being based on calligraphy. Yet the innovative method by which they do so depends on an approach to nature, language and art that is close to that expressed by Shi Tao in his paintings and in his writings. It really is Xu Bing's own method.

Judith Goldman notes in her essay: 'Once he said they were not like anything he had done before. Another time, after studying the proofs, he found them uproariously funny.' To read the words of one of historical China's greatest individualist painters on an apparently traditional work by one of contemporary China's leading artists, and moreover to see them written in English on a landscape copying one of the most conventional of painters, is indeed uproariously funny. It is also a great deal more, as a close reading of Xu Bing's following essay reveals. |**sv**

《文字寫生》系列

徐冰

1999年，我開始用文字畫「寫生」，由此有關象形文字方面的思維活躍起來。我發現，從此處入手，可以觸到寫漢字的中國人文化本源的部分，並把許多糾結已久的疑問打通起來，弄清很多問題。中國人的性格、思維、看事情的方法，審美態度和藝術的核心部分甚至生理節奏，幾乎所有方面，其實都和「漢字的方式」有關。

1999年的尼泊爾之行讓我又重新拿起「寫生本」做寫生。這些畫可是真正的「寫生」，因為它們是用文字寫出來的。我坐在山上，面對真的山寫「山」（也是畫山，中國人寫山與畫山是一回事）fig 1。在河水的地方寫「水」字。雲在移動、山色變化、風吹草動、生靈出沒；我興奮地「描寫」（記錄）它們，此刻，文字與筆觸都是被動的。但這被動地跟著跑，卻讓我開始懂得了動詞的「書」是怎麼回事。這時，我可以把書法和繪畫史上有關風格和筆法的討論通通忘掉，完全讓位於此刻的感受。我感覺，我似乎摸到了一種東西，回到了這些問題的原起點，直接觸碰我們文化中最核心，也是最特殊的那一部分。我們談到動詞的「書」，如果「書寫」作為「記帳」這類功用目的的動作，**結果是沒有差別**。但是，一旦摻進了別的目的，書法的「法」或「書法藝術」的「藝」就出現了，事情就變得複雜起來；充滿了文化、歷史、風格劃分等等這些屬於「學問」的內容。坐在山上，最強烈地感到的問題是：我的書寫總是帶著書法；不是顏真卿就是曹全碑的干擾。你想想，你面對著鮮活的山，卻總帶著顏真卿的「法」多難受。其實最好的是，你像是從來不知有「書法」這回事，坦然對著真山來寫這個「山」字。好的字應該是寫到沒有任何他人痕跡的時候才叫好，這是很有本事的人才能做到的。上面一段抒發一下我當時的心情，這涉及的其實是中國藝術中核心的內容。

「書畫同源」的道理誰都懂，但多是從筆法風格上談兩者的關係，而我在這兩者之間體會到的卻是符號學上的聯繫。我用文字組成山水；一座山、一片水，一棵樹。我發現，這些字元連起來就是一片皴法或點法 fig 2。這和《芥子園畫傳》上的「竹个點」、

「松柏點」等類同。在我看來《芥子園畫傳》就是一本字典，都是從名家畫作裡整理出來的「偏旁部首」。學生學畫如學寫字，死記硬背，熟記在心。之後，即可用這些符號去「寫」心中萬物，世間萬物。萬物皆可歸為各種符號，就像漢字記述世界萬象的方法一樣，這是中國文化核心的部分。所以，中國繪畫講臨摹，不講寫生，就是因為皴法、點法都是符號，符號是靠記的，不是靠「描」的。這也是為什麼中國繪畫承傳，始終是靠「紙抄紙」的辦法。**我們的文化是沿著這麼一個線索傳下來的。**

東方傳統戲劇中的「生旦淨末丑」，格律詩中的「用典」，水墨畫的「梅蘭竹菊」都是通過符號概念來表達的，技法即符號的組織法，在「規定動作」上發揮，組成意境。境界的高低取決於處理符號的能力和藝術家本人的品質。

下面再從漢語寫作與水墨畫使用符號的關係上多談一點。漢語寫作使用文字與水墨畫的皴法、點法類似，這在古本戲文裡最明顯，這也是傳統戲劇對我的魅力所在，享受唱詞中字與字營造的立體的美感。一段唱詞下來，句中只有三、五字是描述用的實字，大部分則是虛字，起渲染氣氛、調節意味的作用，這些字不表示具體的內容，更多是字「面」的資訊。類似於水墨畫中渲染氣氛的留白和苔點，與所畫內容綜合成意境 fig 3。漢字有很多渲染的方法，文字的「意」和「韻」之外還可加上「形」，為營造氣氛做補充，如讀「日、月、雲、山」這些字時，字形所補充的那部分意境也在起作用，這是拼音文字沒有的，是中國文字營造氣氛的特殊之處。文字的功夫可以說是「碼字」的技術，每一個字、詞是一個意境場，它與另一個意境場組合，又構成新的意境場，寫作是搭配這些意境場的技術。這和國畫中使用皴法、點法調節出意境的效果是一樣的。中國傳統文學的「碼字」法與拼音文字不同，卻與中國水墨畫筆法一脈相承，因為中國人寫字畫畫本來就是一個動作。

可以說，中國人的文化方式都與象形文字的源起有極大關係。為什麼這麼說？因為中文的閱讀與英文

Fig 1

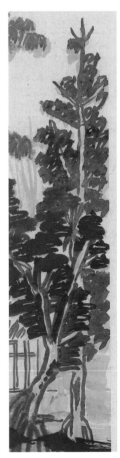

Fig 2

Fig 3

Fig 4

Fig 5

Fig 6

也是不同的，雖然漢字已經從象形演變成了現代漢字，但核心部分的圖像邏輯依然存在，並與平日的閱讀、思維、觀看構成一種奇妙的關係，並起著作用。比如說，中國的建築、傢俱設計，結構那麼特殊，簡約又豐富，這都與我們研習漢字結構有關。再說中國窗戶的設計，到底是中國窗花造型影響了「窗」這個字的形成呢？還是「窗」這個字影響了中國窗花的設計呢？fig 4 我想一定是互為作用的。中國人對結構的理解有自己的一套，因為有自己的一套文字體系。每一個接受教育的人都要花上幾年時間牢記幾千個字型，每寫一個字，就完成了一張結構圖，就畫了一幅小畫。祖祖輩輩幾千年，中國人畫了多少幅圖，讀了多少幅圖，怎麼能沒有影響。再比如，每一個漢字都是一個故事，甚至是有情節的故事，這故事是由幾個小符號（偏旁部首）構成。比如「寒」字，「𡨄」講的是：很冷的天氣裡，一個人蜷縮在家中，用草取暖，地上都是冰。讀一個「寒」字這麼多資訊。另外，中國人對關係的把握也有自己的一套，因為漢字有自己的一套間架、筆順體系。寫漢字講一筆生成下一筆，每一筆根據前一筆的位置，最後一筆是關鍵，調整全字的缺陷與平衡，有扭轉乾坤的作用。字的間架結構簡直就是一種哲學，這哲學潛移默化被使用在生活中。我的一位西方朋友來中國，他最不可思議的是：從不同方向來的兩大群自行車，在沒有指揮之下，在「亂成一團」之後，各走各的方向。這奇妙的「運行法」與調配了一輩子筆劃關係的經驗，一定有關。因為漢字筆劃、間架搭配的高境界即是「相安無事」、「化險為夷」。

我的創作是我思考問題的手段；中國書法是怎麼回事；中國藝術的實質是什麼；這個文化的根本處在哪 fig 5；中國人的性格為什麼是這樣子，通過象形文字的線索，弄清了許多。

中國文人都以藝術中的詩、書、畫、印為一體而自豪，我的這些《文字寫生》，結果是把這幾者真的融合為了一體。你可以稱它們為書法，也可稱為繪畫，又可稱為一篇文字。在中國文化中筆墨和書寫真的是可以遊戲的。

我在漢字象形性的基礎上，還發展出一些裝置作品，有一件叫《鳥飛了》。此作品由近五百多個不同書體制成的「鳥」字組成。展廳中央地面上有一篇文字；取自於字典上關於「鳥」的解釋，是這樣寫的：「鳥（鳥）niǎo 脊椎動物的一綱，溫血卵生，全身有羽毛，後肢能行走，前肢變為翅，一般能飛。」（我想，鳥們是不會喜歡這樣的對它們的描述的。它們一定想離開它，回到自然之中。）從這篇文字為起點，「鳥」字開始飛起來，從簡體印刷體向繁體印刷體、楷書、隸書、小篆一路演變，最後追溯到遠古象形文字的「鳥」；成群地飛向窗外。這件裝置色彩

豔麗，給人一種童話般燦爛和魔術變換的感覺。作品引導觀眾在文字、概念、符號及形象之間展開思維運動的空間。作品用東方的象形文字體系與自然之間的關係與西方觀念藝術的代表作《三把椅子》做一種有趣的對比。庫索斯的作品《三把椅子》是：「真實的椅子」、「照片的椅子」和「英文解釋的椅子」一字排開的對比，也只能形成這種對比。因為英文與所表達的物象間沒有視覺上的直接聯繫 fig 6。但是在漢字中，「鳥」字與鳥的造型在視覺上，是分界不明的關係，不知道在哪就被轉換了。這個比較讓我們看到，不同文化在基本元素上的區別。

另外一件裝置叫《文字的花園》，是由上千個塑膠板材刻製的象形文字，如 木、川、鳥、山 等，類比出美術館窗外的風景，在視線上與窗外的風景銜接。展廳中仍然掛著美術館的油畫藏品，我用文字，將畫面內容延伸出來，畫中的鳥變為一串象形文字的鳥從畫面中出來。觀眾在這個五彩的文字花園中漫步，試讀著這些誰都認識的象形文字。我那時的作品開始表現出較強的體驗性及參與性的傾向。很多家長帶著孩子來到這個展廳「看圖識字」。為此，我特意在展廳牆上做了一張英文與中文象形字對照表。家長問孩子：「水在哪兒？」孩子就在「花園」裡去找，他們能找到，因為「水」就是水的形象，在湖水的位

Fig 7

置上；而「草」這個字就長在草地上⋯⋯。這時的中文變得很簡單，已不再是一種需要學習才能掌握的文字。文字符號又回到了與自然關係的原點上，在這原點上，是超越語種界限的。

通過這個系列，我們可以看到，帶有種子性質的想法是可以發展、變異、深化的。甚至是可以探索一輩子的。我的一位老師說：「人一輩子就一句話，齊白石就是「似與不似」之間，一輩子也做不完。」因為這句話有一個深不見底的內容。這和不少藝術家一個符號重複一輩子是兩回事，嚴格講這些人是一輩子只畫了一張畫。

別人都說我是搞當代藝術的，其實我琢磨的事多是陳舊的東西 fig 7。這些「舊」裡面藏著最本質的東西、核心的東西。就那些多被說煩了的老話，永遠是有道理的、有用的、甚至是最新的東西。|XB

Landscript Series

Xu Bing

In 1999, I began using characters to paint 'drawings from life', and from this I became excited by the thinking surrounding the pictographic aspect of Chinese characters. I discovered that in taking this as a point of departure, it's possible to touch on something of the origin of the Chinese character-writing culture, cutting through many longstanding complex problems and explaining many issues. For in fact, the nature, the thinking, the way of looking at things, the aesthetic appreciation, artistic core and even the physiological rhythm – indeed almost every aspect of the Chinese people – is connected with the 'pattern of Chinese characters'.

My travels in 1999 allowed me to take up my 'drawing from life' sketchbook once more and paint from nature. These paintings can actually be considered 'drawn from life' since they are described using writing. I sat on a mountain and, facing a real mountain, I wrote 'mountain' (you might also say I painted a mountain, as for Chinese people to write a mountain and to paint a

mountain are the same thing) (fig. 1). Where there was river water I wrote the character for 'water'. The clouds shifted, the mountain colours changed, the wind blew and the grasses moved, the life around me appeared and disappeared; with a feeling of excitement, I 'described 描写' (recorded 记录) it all, and at that moment the characters and the brushstrokes were a passive thing. But this passivity raced to keep up (with the fast-changing richness of nature) and in fact allowed me to start understanding what kind of thing the verb 'to write' (shu, 书) is. At this point I could set aside completely the historical theories of style and brushstroke in calligraphy and painting, and allow myself to be entirely in the feeling of that moment. I felt as though I had touched upon something: I had returned to the point of origin of these problems, and had encountered directly the most essential and particular constituent of our culture. We talk of shu (书) as a verb; if 'writing' were an act with the same function as 'keeping accounts', *then there would be no difference between the two*. But as soon as we add another objective into the mix, the 'method' in 'writing method' (shufa), or the 'art' in 'art of calligraphy' (shufa yishu), things become more complicated: they become imbued with culture, history, stylistic difference and other sorts of content related to 'learning'. Sitting on the mountain, the issue I felt most keenly was this: my written words always have a calligraphic content; if it's not (the Tang dynasty calligrapher) Yan Zhenqing's intervention then it's the (Han dynasty) Cao Quan stele. Imagine it, you are sitting in front of a real actual

Fig 1

Fig 2

mountain, yet still you feel the weight of Yan Zhenqing's 'method'. In fact, the best thing about it is it's as though you never knew about this thing called 'calligraphy' and, unperturbed, you face the mountain and draw the character 山, 'mountain'. Well-written characters should only be called well-written when they are executed without a trace of any other person's writing, and this can only be achieved by someone particularly skilful. The above goes some way towards expressing my frame of mind at that time, and what it touches upon is in fact the content at the very core of Chinese art.

The principle 'calligraphy and painting share a common origin' is well known. The relationship between the two is mostly discussed in terms of brushwork style, yet what I had discovered about them is their relationship in terms of symbolism. I use characters to compose a landscape – a mountain, a stretch of water, a tree (fig. 2). I discovered that where these characters are marked down in sequence then they function as a brushwork method or brushstroke method (in a painting). It's the same as the 'bamboo strokes' or the 'pine and cypress strokes' in *The Mustard Seed Garden Manual of Painting* (see cat. 78). In my view, *The Mustard Seed Garden Manual* is a dictionary, it's all radicals and character components organised from within the paintings of famous artists. Students learn painting as they learn characters, memorising it all to death until it's engraved on their hearts. Once that has been accomplished, these few symbols can be used to 'write' everything that is in the mind and everything that is in the world. Absolutely everything can be traced back to

a type of symbol, it's the same as the way in which Chinese characters record every phenomenon on earth; this is the core of Chinese culture. Therefore, when Chinese painting is termed copying as opposed to drawing from life, it is precisely because the brushwork, the brushstrokes, are all symbols, and symbols rely on noting, and not on 'describing'. This is also why the continuity of Chinese painting depends from start to finish on the practice of 'paper copying paper'. *It is along a thread such as this that our culture has been handed down.*

The 'five classes of actors' In traditional Eastern theatre, the 'allusion' in classical poetry composition, the 'plum orchid bamboo chrysanthemum' of ink painting are all expressed through the concept of the symbol; the skill is in the arrangement of the symbols, brought into play by the 'set piece' to compose the artistic concept. The achievement of the artistic concept is determined by the skill with which the symbols are handled and the quality of the artist himself.

Let's now talk some more about the relationship between Chinese writing and the utilisation of symbol in ink painting. The use of characters in Chinese writing is like the use of brushwork and brushstrokes in ink painting. This is most evident in early drama scripts and for me, it is where the magic of traditional theatre lies: I enjoy the words of the songs and the solid aesthetic sense that these words create. In a libretto a line has only three or five solid, descriptive words; most are empty words placed there to provide the atmosphere of an ink wash regulating the overtone. These words have no concrete meaning, most are 'surface' information. They are like the white spaces and moss strokes in the wash areas of ink painting that work with the painted areas to create the artistic concept (fig. 3). Chinese characters have many wash methods: in addition to the 'meaning' and 'resonance' of the character, you can add the 'form' that supplements the constructed atmosphere. For example, when you read 'sun, moon, cloud, mountain', the shape of the characters supplements the artistic concept in a

Fig 3

Fig 4

way that also serves a purpose. This is something that is lacking in alphabetic writing. It is here that Chinese characters' particular quality of creating atmosphere lies. The achievement of Chinese characters can be likened to a code-making skill: each and every character or word is a conceptual field that combines with another to construct a new conceptual field, and writing is the art of collating these fields of conception. This is the same as the use of brushwork and brushstrokes in ink painting to regulate the effect of the artistic concept. The 'code-making' method in traditional Chinese texts differs from alphabetic writing, yet its origins can be traced back to the brushwork of Chinese ink painting because, for Chinese people, writing characters and painting paintings are the same act.

You could say that the mode of culture of Chinese people is extremely closely related to the origins of pictographic characters. Why say this? Because reading Chinese also differs from English, for although Chinese characters have already evolved from pictograms into their modern forms, the core element of pictorial logic is still there; this combines with everyday reading, thinking and viewpoints to create an intriguing connection, and

function. For example, the structure of Chinese architecture and furniture design is exceptional, so concise and rich, and this is connected with our study of the structure of Chinese characters. Chinese window design is an example: in the final analysis, did the construction pattern of Chinese windows influence the form of the character? Or did the character 'window' influence the design of Chinese windows (fig. 4)? I think it definitely functions both ways. Chinese people have their own set of understandings about construction, because they have their own set of character systems. Every educated person has to spend several years laboriously memorising the forms of several thousand characters; each time they write a character they have completed a design and painted a small painting. Across generations spanning thousands of years, Chinese people have painted countless paintings, have read countless diagrams; how can there not be an influence? A further example: every Chinese character is a story, and even when it is a story with a plot, the story is constructed from several symbols. For example, the character for 'cold', 寒, relates the following (through its combination of components and brushstrokes): in very cold weather, someone curls up indoors, using grass to keep warm, and the floor is covered in ice. So much information is conveyed in reading a character for 'cold'. Furthermore, Chinese people have their own grasp of connections because Chinese characters have their own set of systems for character structure and stroke order. When writing Chinese characters, one brushstroke follows another, with every brushstroke placed according to the one before; the final stroke is the heart of the matter, regulating the whole character's imbalances, with a function akin to the pivot of the universe. The form and structure of characters is really a kind of philosophy, and the subtle influence that this philosophy exerts has an effect on our lives. When a Western friend of mine came to China, the thing that puzzled him most

Fig 5

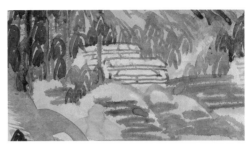

Fig 6

was when two large groups of bicycles coming from opposite directions, with no signposting, formed a chaotic group and then each went their own way. This amazing 'method of moving' is without doubt connected to a lifetime's experience of brushstrokes, because the elevated realms of the brushwork and internal structure of Chinese characters are precisely 'living in peace with each other' and 'turning danger into safety'.

My creative work is my means of thinking over problems – what is Chinese calligraphy; what is the essence of Chinese art; what is the original source of this culture; why the nature of Chinese people is as it is – through the thread of pictographic characters, a lot is made clear (fig. 5).

Educated Chinese people all take pride in the fact that the arts of poetry, calligraphy and painting are one system; and in these 'landscripts' of mine the result is that these arts really are melded together. You can call them calligraphy, you can also call them paintings, you can even call them a text. Brush and ink, script and writing can really be played with in Chinese culture.

I have developed several installation works on the basis of the pictographic quality of Chinese

characters, and there is one called *The Bird Has Flown*. This work was composed of some 500 'bird' characters made in different forms of script. On the floor in the centre of the gallery was a text, taken from a dictionary definition of 'bird', which says: '鸟 *niao*, a class of vertebrate animal, warm-blooded and oviparous, the whole body covered in feathers, the forelegs developed into wings, can mostly fly'. (I can't think that birds would like this description very much. They would certainly think of escaping it and returning to nature.) With this text as a starting point, the 'bird' character begins to take flight, transforming from simplified printed form to long printed form, regular script, clerical script, small seal script and finally reassuming the ancient pictographic character 'bird'. In a flock they fly towards the window and beyond. This installation was very colourful and gorgeous, and gave people a sense of magical fairytale splendour. The work led the viewer to develop a space for thinking between its characters, concepts, symbols and form. It used the relationship between the Eastern pictographic character system and nature to make a very interesting comparison with 'One and Three Chairs', by Joseph Kosuth, a representative work of Western conceptual art. Kosuth's work comprises an actual chair, a photograph of a chair and an English dictionary definition of a chair, all set out for comparison; and this is the only kind of comparison it can create. This is because there is no direct visual relationship between English and the phenomena it expresses (fig. 6). But in Chinese characters, the relationship between the

character 'bird' and the visual form of a bird is an indistinct boundary, and one doesn't know at what point it transforms. This comparison enables us to see the distinction between different cultures at a fundamental level.

Another of my installations, called *Garden of Letters*, used more than a thousand pictographic characters cut from plastic, such as 'tree', 'water', 'cloud', 'grass' and so on, to simulate the scenery outside the gallery window, connecting the line of vision with the scenery outside. Inside the gallery, oil paintings from the museum's collection were still on display and I used characters to allow the subject of a painting to extend out, the bird in the picture changing into a string of pictographic characters emerging from the painting surface. The visitors walked around this colourful garden of characters, reading these pictographic characters that they all recognised. My work at that time began to express a fairly strong tendency towards learning experience and participation. Many parents and grandparents brought their children to this gallery to 'see pictures and recognise characters'. For this reason I specifically made a comparison chart of Chinese pictographic characters and English on the gallery wall. The adults would ask the children 'Where is the water?'. The children would then go looking for it in the 'garden' and were able to find it because 'water' was in the form of water, and was placed in the

lake; likewise, the character for 'grass' was growing on the lawn. On this occasion the Chinese writing transformed very simply: it wasn't something that required learning in order to understand. The written symbol had returned to its original point of connection with nature and at this original point it transcended the boundaries of language.

Through this series we can see that a way of thinking that contains a seed within it can develop, modify and become more profound, to the point that you could spend a lifetime exploring it. One of my teachers said, 'A person only needs one phrase for their entire life; Qi Baishi's was "between likeness and non-likeness"- which you couldn't exhaust in a lifetime.' That is because this sentence contains unfathomable depths. This is a different thing from many artists' lifelong repetition of a symbol; strictly speaking these people have only painted one painting in their lifetime.

Other people all say I am a practitioner of contemporary art; in fact, what I have polished and refined are mostly obsolete things. These 'obsoletes' contain within them the most fundamental things, core things. These old sayings that we have gone over again and again always have significance, always serve a purpose, just as if they are brand new things. |XB

Translated by Shelagh Vainker

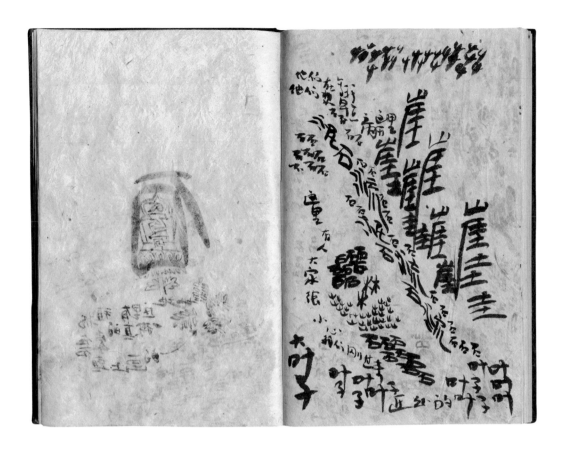

72

Helsinki sketchbook

1999
Ink on Nepalese paper
20 x 12.7 cm (closed)

This is one of the sketchbooks in which Xu Bing drew during his month-long stay in the Himalayas as one of six artists participating in a project initiated and organised by the Kiasma Museum of Contemporary Art in Finland. The trip was important in two ways. It was the first occasion on which Xu Bing used Chinese characters to draw landscapes – the origin of his landscripts and the system at the root of the new works in cat. nos 77a–d. Secondly, his unexpected feelings about the rural poverty he encountered there prompted a re-examination of his role as a contemporary artist.

This opening shows characters that Xu Bing has drawn to represent landscape elements. On the left is the character 石, meaning 'stone' or 'rock', which becomes a standard component in landscript works for mountains, rocky promontories or wall edgings and so forth. Within it he has drawn a small Buddhist dagoba or stone stupa of the type seen in Tibetan and Himalayan temples. On the right is a small landscape composition with the character 水, meaning 'water' at its centre, repeated to create a river. Its form here is close to its appearance in seal script and other ancient writing, and Xu Bing uses it in landscripts for rivers and waterfalls. To its right is a cliff, and to the left stones and plants, all represented by the relevant characters. Each character is written on the reverse of the thin paper page shown. It is a characteristic of all Xu Bing's landscript paintings that they are drawn on Nepalese paper.

Xu Bing was surprised by his feelings about life in the mountains of Nepal. Having spent years of his youth in rural poverty he had not anticipated that visiting such a region after decades of a successful international career would put him in the position of an outside onlooker. As a result, the following year he wrote a short essay on the artistic attitudes promoted by Mao Zedong and inculcated in him in the 1970s, titled 'This is called entering deeply into life' 這就叫深入生活. More immediately, he acquired a donation box in an Himalayan mountain village and included it in the gallery in Finland when his work was exhibited. Small reproductions of his works were printed on Nepalese paper and available to visitors in exchange for a donation. The $5,000 raised was used to construct a school building in an impoverished Nepalese village, and created a cycle of exchange between art and education.

73 a–f

Six Himalayan sketches

a. Kathmandu airport, with white runway markings

b. Stone enclosure around various plants, with a river beyond trees and a lavatory, and more trees in the foreground

c. Thatched pavilion with wooden pillars on stone bases for storing potatoes

d. Stone enclosure with grass inside and further piles of stones

e. Scene with rocks, grass and timber supplies

f. Landscape study

1999
Ink on Nepalese paper
21.4 x 28.0 cm

These small sketches use less pictographic words to describe the scenes in addition to characters that have a strong link with the natural forms they represent.

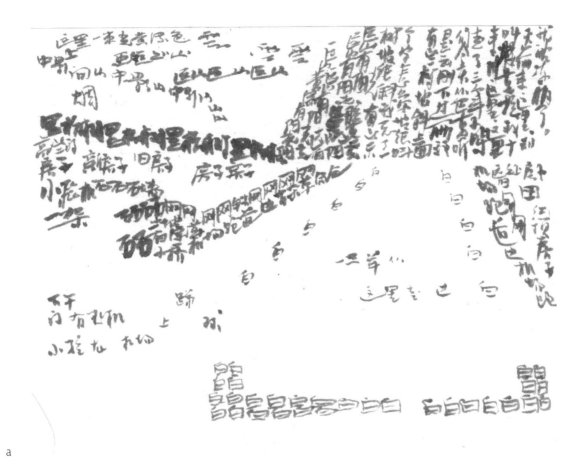

a

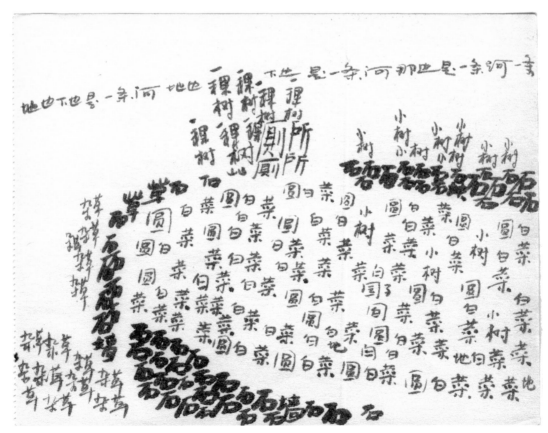

b

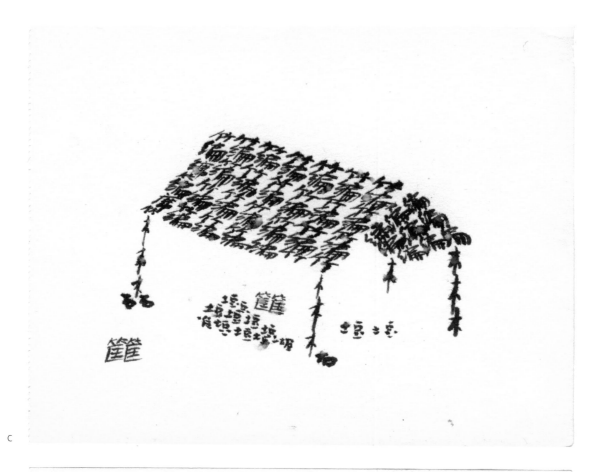

c

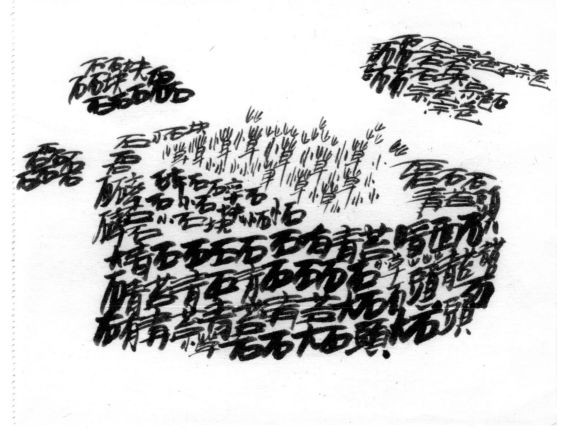

d

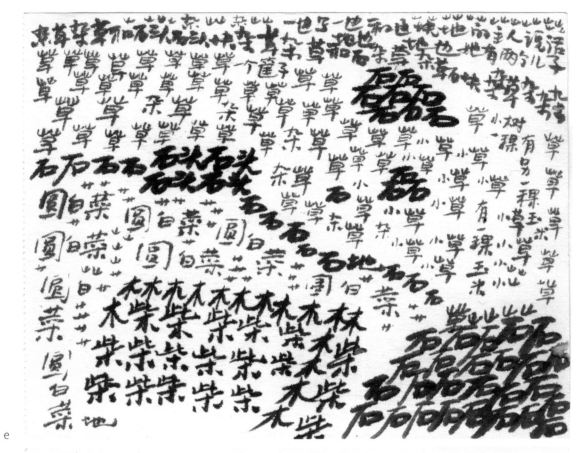

e

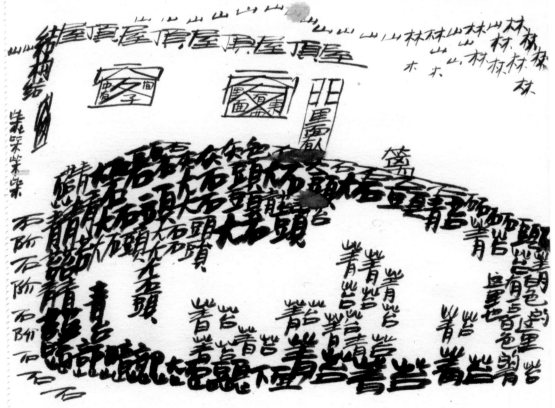

f

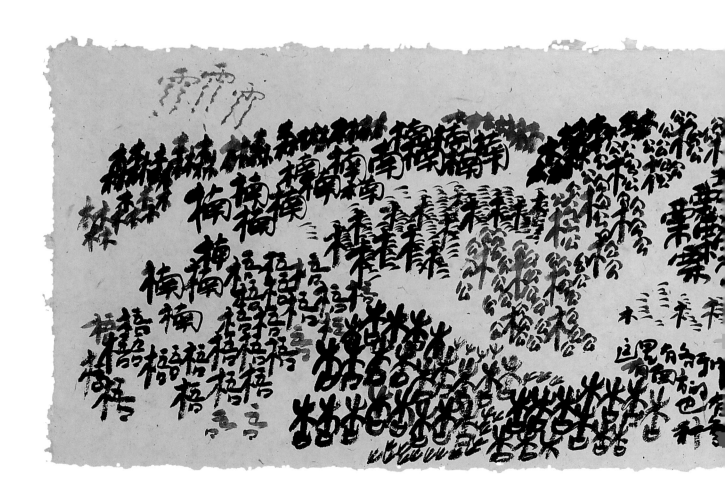

74

Landscript

2002
Ink on Nepalese paper
Signed *Xu Bing*
One seal: Xu Bing
50.0 x 173.0 cm
On loan from the Khoan and
Michael Sullivan Collection

This is one of Xu Bing's earlier landscript paintings and the forms of the characters are very clear. Rocks, rain and various trees, including apricot and pine, are easily distinguished; their repetitions and groupings make the composition legible regardless of knowledge of Chinese. The fact that every part of the landscape is written with a character resembling its meaning represents a progression from the small sketches (cat. no. 73), in which characters with only slight pictorial content function as labels rather than visual representations. The centre foreground section however comprises a sentence of descriptive text, or could perhaps be said to conceal an inscription. It begins 'here there are all kinds of trees....' and continues with a list that takes up all of that section of the composition.

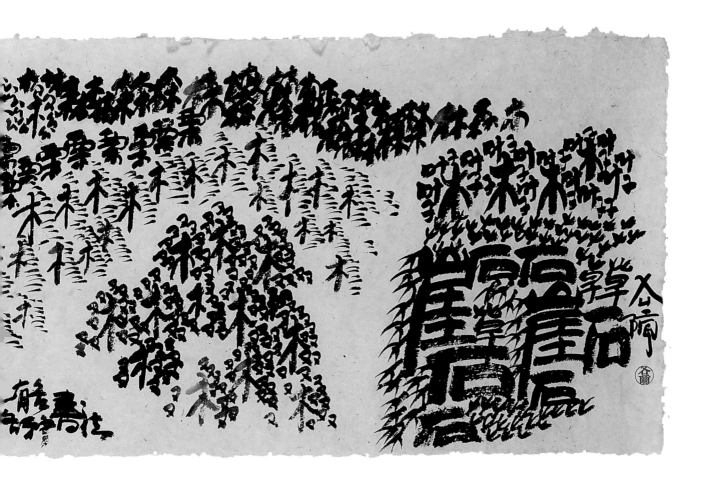

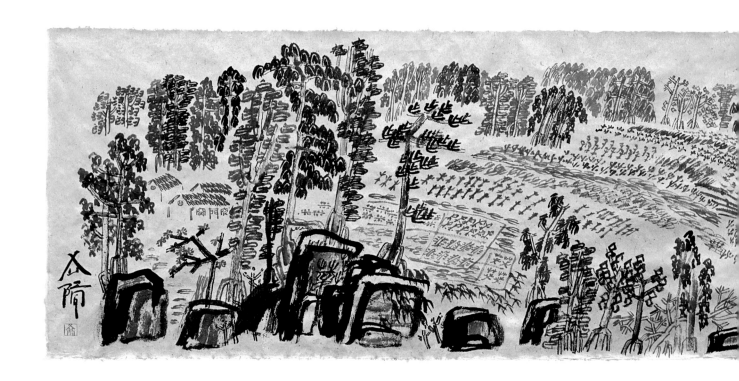

75

2013 Landscript 1

2013
Signed *Xu Bing*; one seal
Ink on Chinese paper
80 x 367 cm

This painting, together with cat. no. 76, was painted for the current exhibition. The two works are a pair in terms of size, medium, and subject; both are landscripts, yet they develop landscript in different ways.

This painting represents a view of a hillside, and the fact that a large area of the hillside is shown planted with a variety of different crops distinguishes it from earlier landscript paintings with

more traditional, imagined landscapes. It may in fact be compared with sketches Xu Bing drew in the 1980s (cat. nos. 33, 36). Many of the characters are familiar from earlier landscripts: 石rock, 杏apricot, 米rice, 门door, 窗window, and there are several additions: 韭leek, and 茴fennel, for example. Aspects of the very recent Suzhou Landscripts（纸抄纸）(cat. No.77a–d) are also evident. In the

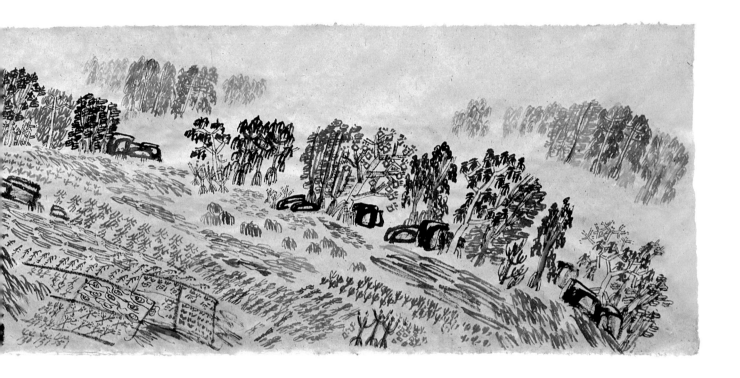

centre foreground, areas of crops are planted to form a quartered square or rectangle, in the same way as the fields in cat. no. 77a that have been highlighted with an overlay in red of the character for 'field'. To the right of the fields in this painting, and also in the foreground, a group of three saplings includes strokes in heavier ink that comprise the early form of the character 木 tree. In cat. no.77, the trees show in broken red lines the same early form of the character for tree.

The use of these early forms is developed further in this painting, in new ways that are even more pictorial. For example, the pair of trees in the centre foreground show foliage in the form of linked double squares, creating an image similar to one of the characters used for silk or mulberry on oracle bones inscribed for divination in the Shang dynasty (c.1600–c.1050 BC). Oracle bone characters are the earliest form of identified script in China. They are often described as pictograms. In a purely pictorial way, four trees that appear on the far side of the hill in this painting use a single square in what appears to be an entirely pictographic reference to persimmon.

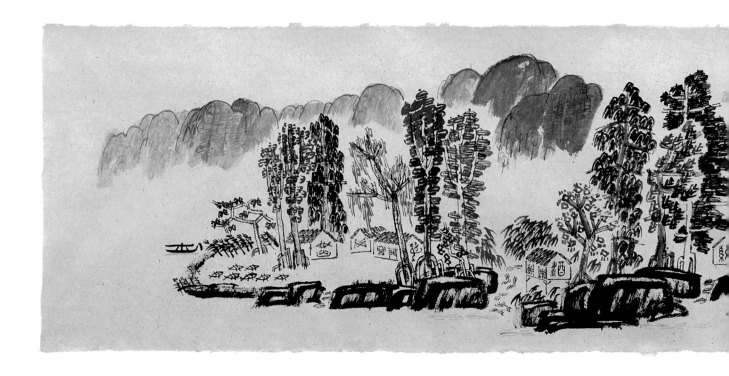

76

2013 Landscript 2

2013

Signed *Xu Bing*; one seal

Ink on Chinese paper

80 x 367 cm

The composition of this painting is at once that of a typical landscape handscroll and of a traditional genre scene. Some of the landscript character forms are familiar - 水water, 石 rock, 门door, 窗window and various types of trees. Others depict features using forms altered from previous landscripts, for example the gate between the large stones around the duck pen.

This is closer to oracle bone or seal script characters than to modern writing, and its pictorial quality is such that it is hardly noticeable as a form of writing at all.

The appearance of oracle bone script, bronze script and seal script distinguishes this work from Xu Bing's previous landscripts and marks a new depth in his understanding of the relationship between painting and writing. Script on oracle bones and tortoise shells or plastrons was incised for divination during China's first historical dynasty, the Shang (*c.*1600–*c.*1050 BC); in the following dynasty, the Zhou (*c.*1050–221 BC), inscriptions were cast on bronzes. Writing in ink began on silk and bamboo

before paper was widely used in the first centuries AD. Characters were also cast or carved onto bronze and hardstone seals in script - seal script - that was manipulated to fit the shape of the seal and therefore varied widely. The characters that appear on the buildings in this landscript are examples of this range of pictographic scripts, and they function in the painting as labels rather than depictions of natural or built forms.

These labels associate the buildings with, for example, fish, wine, silk, farming and hunting. The characters announcing these associations include seal script, oracle bone script, bronze script, Xu Bing's versions of the scripts, and images that he

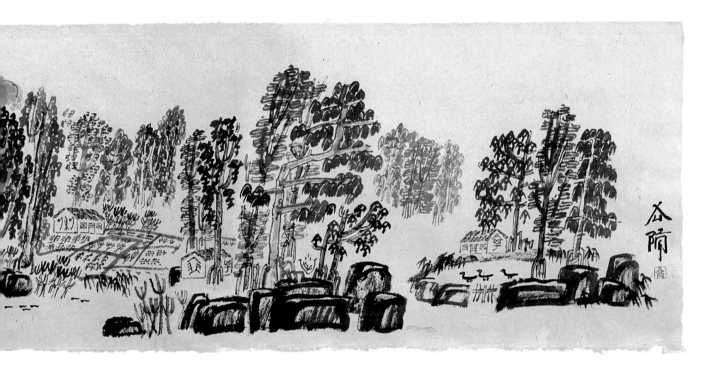

has invented that have the appearance of script. His own versions of the scripts are not however without a sort of authenticity, for what he discovered in researching early pictographic scripts was that they had no standard forms, and were current in many versions. The character for 'wine' on the building by the stream is a straightforward seal script form, for example, while the animal skin and butterfly net on the hunting lodge are perhaps not. The fish laid out at the left of the composition in fact replicate the graph on a particular bronze tripod vessel known as the *Xi bo ding*; and the 'face' amongst the rocks and trees is closest to the version of the character with the modern meaning 'imperial robe' as it appears on the Zhou dynasty ritual bronze vessel known as the 'tripod of the Duke of Lu'. By moving from using the pictorial qualities of modern Chinese characters to making small pictures that look like ancient writing, Xu Bing draws attention to the blurred nature of the boundary between writing and painting.

Each of the buildings stands within a discrete area devoted to a particular industry. At the centre of the painting are two buildings marked with characters relating to silk - one for rearing silkworms, the other for making silk fabrics – and they stand among mulberry trees; to their right is a building marked with farming implements, by a cultivated plot with various crops. The depiction of so many industries emphasises the relationship between nature and people that Xu Bing's landscript method itself addresses. The whole creates an agricultural landscape, lacking human figures but with many traces of people's lives. In this and in its simplicity it recaptures some of the spirit of Xu Bing's early small woodcuts, while the timelessness and the proximity to nature suggested by the implied activities, and most particularly by the lone fishing boat, hint at a timeless idyll that has been an iconic theme in Chinese literature for more than a thousand years.

77a–d

The Suzhou Landscripts (纸抄纸)

2004–12

A landscript lithograph consisting of four separate panels, after four seventeenth-century landscape paintings in Suzhou Museum. Printed in two colours from 35 plates on Entrada Natural Rag 300 gram paper, each panel measures 231.1 x 96.5 cm and is hand stamped with Xu Bing's seals in red. Published by Deuce II Editions, Inc., New York, the lithographs were printed in an edition of 30 by Jason Miller at Universal Limited Art Editions, Bay Shore, New York .The colour and texture of each sheet was digitally created by Jill Czarnowski.

Inscribed in Square Word Calligraphy individually and with a single inscription running across all four panels, which reads:

I used my method to copy four hanging scrolls from the su zhou museum. the four paintings that I chose are themselves works based on earlier paintings, something that is made apparent in their titles. "plagiarism" does not exist in traditional Chinese culture. good poetry emphasizes use of the "canon," the brilliant poetry of earlier generations. if a good painting possesses "classical" qualities, it must reflect the brushwork of the ancients. chinese painting emphasizes "paper copying paper," and through these symbolized brushstrokes it is passed on from generation to generation. "the mustard seed garden manual of painting,china's most famous work of art instruction, compiles the brushstrokes – mountain strokes, tree strokes, rock strokes – from the paintings of old. it is a

dictionary. students need only memorize the "radicals" to express everything existing in this world. in china, calligraphy and painting are a single action. painting a mountain is writing the character "mountain". the character "mountain" is the concept of "mountain", and the pith of a mountain and also a copy of the image of "mountain" and how it has evolved. these four works nakedly exhibit and explore this tradition. works of the Chinese literati are born from feelings that develop between friends, over time, at gatherings, and outings. this group of prints, drafted over a period of ten years, are a record of a friendship.

september third, two thousand and eleven, chang chun xu bing

Followed by two square seals: 徐 (Xu) in relief, 冰 (Bing) in intaglio

All four scrolls are versions of paintings in the collection of Suzhou Museum 苏州博物馆 in Jiangsu province, not far from Shanghai. The museum, established in a courtyard house and garden in 1960, was rebuilt in the early twenty-first century to a design by the architect I.M. Pei. For the opening of the building in 2006, I.M. Pei invited Xu Bing to create a work in his *Background Story* series. This series creates backlit landscape installations that from the front appear as illuminated landscape paintings, with many of the subtleties of brush and ink; from behind, however – and they are usually installed so that

visitors can walk behind – the shadows are revealed to be made by branches, twigs, leaves and other decaying forms of the plants of which real landscapes are composed.

Xu Bing spent around a week at the museum constructing the installation, and noticed that many of the paintings in the collection there were copies of earlier paintings and bore inscriptions stating the fact, along with the titles of the original works on which they were based. This accounts for the form of the individual inscriptions on each of the four prints. Seeing copies that themselves dated to the seventeenth century – the great era of convention in Chinese painting, from the writings of the painter and theorist Dong Qichang to the publication of *The Mustard Seed Garden Manual of Painting* that Xu Bing mentions in the main inscription here – coincided with Xu Bing's longstanding interests in repetition and standardisation, and with the then evolving project that Judith Goldman's essay describes (see p. 4–9). The result is *The Suzhou Landscripts* (纸抄纸).Each of the four images is composed largely, but not entirely, of Chinese characters. Xu Bing's earlier landscripts are painted exclusively with characters, but they are his own compositions and not reworkings of classical landscapes. A more significant departure from the earlier landscripts is the subtlety of the forms of the characters used here; they are identifiable but assimilated to a much greater degree into the

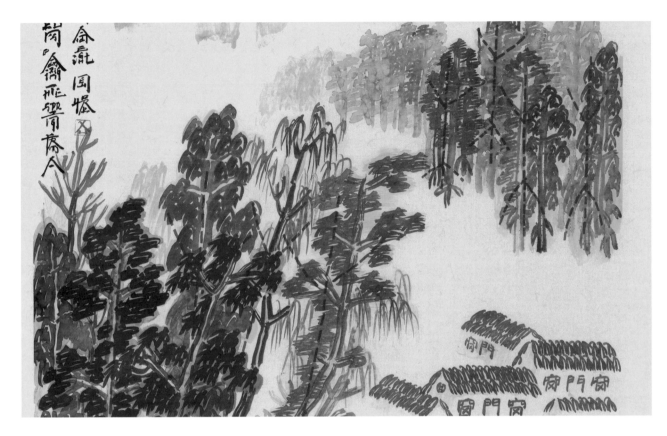

elements they represent, a difference particularly evident in the trees. By tying this new way of making landscripts to the traditions of Chinese painting (a landscape view, a reworking of an existing painting, a new 'brushwork' method) he engages with the historical tradition and updates it, in accordance with, or as a comment on, one of the major principles of literati painting since the Yuan dynasty (1279–1368). His use of the pictorial conventions of the Chinese language to achieve this highlights not only the conventions of Chinese painting itself, but also the relationship between language and nature that is a particularity of Chinese culture, as he outlines in his essay 'Landscript Series' (see p. 120–8).

There are two further, more visible, ways in which the prints depart from the tradition that Xu Bing reinvigorates

in these works. First is the imposition of large characters in red on areas of each landscape. These are characters that describe the landscape elements beneath, written in forms that are close to the pictographs from which the modern characters have evolved, as they appear on oracle bones or bronzes of the Shang (c. 1600–c. 1050 BC) or Zhou (c. 1050–221 BC) dynasties. They draw attention to the pictorial origins of the Chinese language and their source in the natural world, and provide a visual relief from the austerities of the monochrome ink that dominates the literati tradition.

The second departure is in the use of Square Word Calligraphy, Xu Bing's own invention, for the inscriptions. The fact that his own calligraphy looks like Chinese characters but comprises letters of the Roman alphabet is itself a

statement on the times in which Xu Bing has lived, for it represents an inescapable thread running through all his work – the mixing of a Western education with an attitude to the natural world that is entirely Chinese.

Finally, Xu Bing's decision to create *Landscripts* (纸抄 纸) as prints at once furthers the method in which he has a lifetime's skill and affords an extension of the aims discussed above. The medium of multiples and repetition is singularly appropriate to a work that is itself a comment on copying and standardisation, and in addition places the landscape tradition more comfortably within the era of mass communication with which he, as a contemporary artist, is indefatigably engaged.

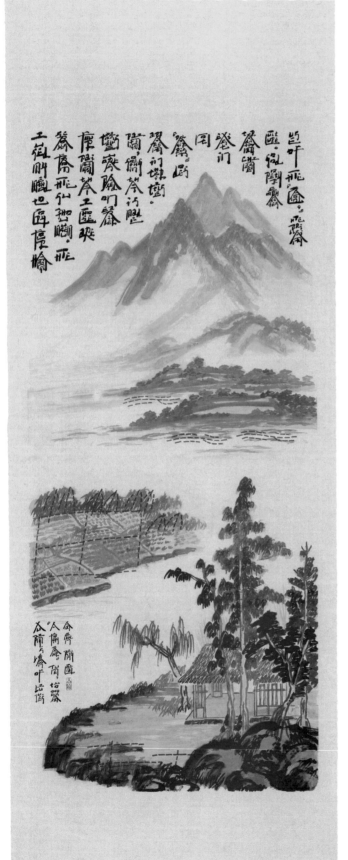

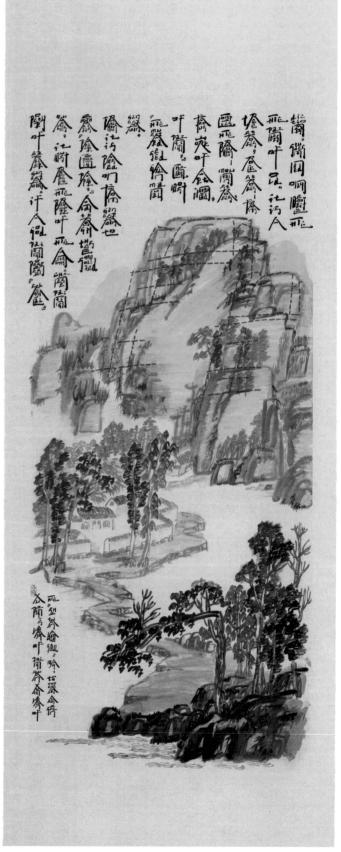

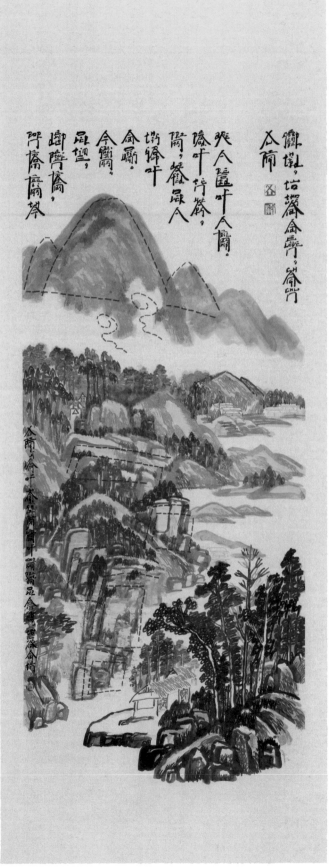

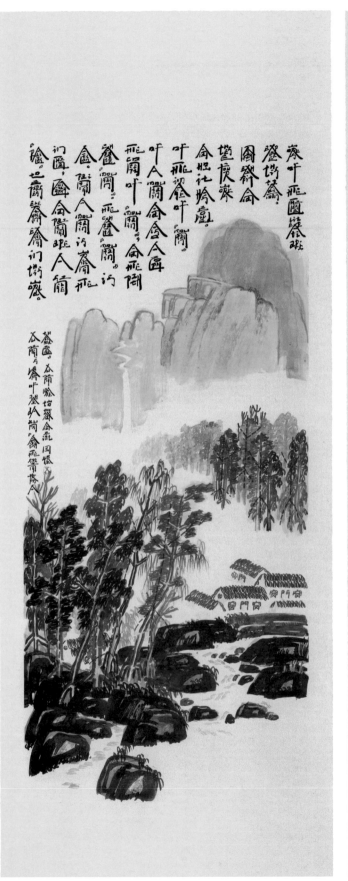

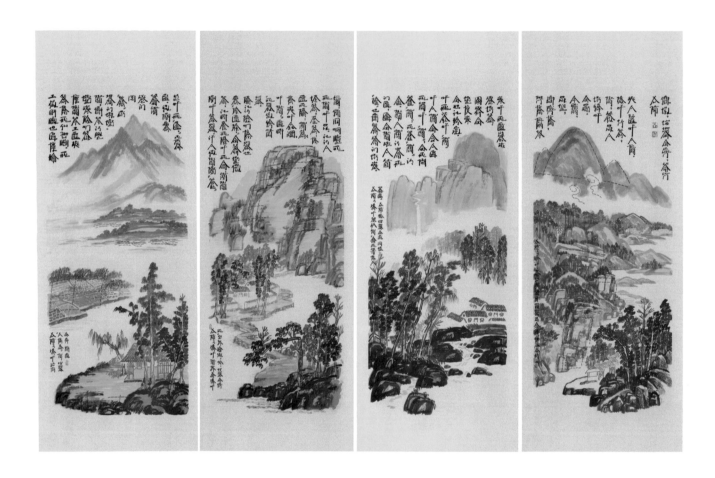

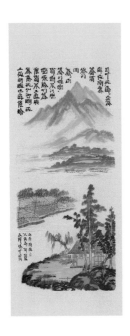

A

Inscribed in Square Word Calligraphy: *Xu Bing's version of Liu Jue's 'A Foggy River' June, two thousand and eleven Beijing China*

Followed by one seal: 徐冰 (Xu Bing), in relief

231.1 x 96.5 cm

The image incorporates the Chinese characters 松 ('pine'), 白 ('poplar'), 石 ('stone'), 水 ('water'), 竹 ('bamboo'), 叶 ('leaf'), 苗 ('sprouts'), 草 ('grass') and 册 ('lashed wooden poles').

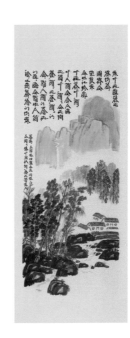

C

Inscribed in Square Word Calligraphy: *Xu Bing's version of Zhai Da Kun's 'Admiring the Spring From a Thatched Cottage' Xu Bing March two thousand and eight New York*

Followed by one seal: 徐 (Xu), in relief

231.1 x 96.5 cm

The image incorporates the Chinese characters 松 ('pine'), 山 ('mountain'), 石 ('rock'), 梨 ('pine'), 柳 ('willow'), 春 ('spring tree'?), 白 ('poplar'), 草 ('grass'), 门 ('door'), 窗 ('window'), 竹 ('bamboo'), 水 ('water') and, in red, 木 ('tree').

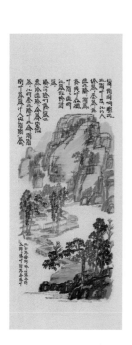

B

Inscribed in Square Word Calligraphy: *Xu Bing's version of Zheng Yuan Xun's version of the 'Shi Tian Landscape Scroll' May, two thousand and seven*

One seal: 徐冰 (Xu Bing), in relief

231.1 x 96.5 cm

The image incorporates the Chinese characters 白 ('poplar'), 松 ('pine') 草 ('grass'), 石 ('rock'), 木 ('tree'), 磊 ('stones'), 森 ('forest'), 叶 ('leaf'), 杏 ('apricot'), 水 ('water') and 崖 ('cliff').

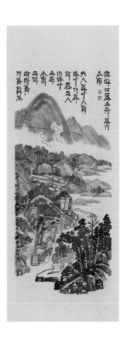

D

Inscribed in Square Word Calligraphy: *Xu Bing's version of Wang Shi Min's 'Landscape of Morning Brightness Over Autumn Mountain' two thousand and ten*

Followed by one seal: 冰 (Xu), in relief

231.1 x 96.5 cm

The image incorporates the Chinese characters 松 ('pine'), 白 ('poplar'), 草 ('grass'), 山 ('mountain'), 石 ('rock'), 屋 ('residence'), 水 ('water'), 春 ('spring tree'?), 叶 ('leaf'), 虫 (worm), 窗 ('window'), and, in red, 山 ('mountain'), 云 ('cloud') and 石 ('rock').

ENVIRONMENT

IVEUSEC | EUCAIYPTUS
FEATURE | PLANTS
FLOWRS | HINFOREST
ANOAKE | FEATURES
KEY | LEDHANS
SIN AVES | OJAVDS

yellow

white
yellow

Landscape and Learning

Shelagh Vainker

Xu Bing's dedication to art as a means of exploring problems and benefiting society goes hand in hand with his commitment to teaching. He writes in the essay at the end of this catalogue that his artistic thinking was defined by the socialist policies that prevailed in his youth. A key part of this thinking was the conviction that art should connect with society. Elsewhere he has said that art is in the things and circumstances of daily life, and that where there are problems there is art. These convictions translate not only into the artworks he produces, which may themselves have positive social outcomes or dimensions, but also into wider communication through involvement with educational projects, and directly through his own university teaching.

Xu Bing began teaching immediately after his graduation in 1981 from the Central Academy of Fine Arts, where he was retained as a member of the teaching staff with responsibility for drawing instruction (fig. 1). The Academy's teaching methods at that time, not so long after the Cultural Revolution (1966–76), still followed a Soviet model and he re-invigorated them with new approaches. He also, along with other members of the teaching staff, organised study trips for the students and it was during these that many of the sketches in the first part of this exhibition were drawn. Neither his teaching nor his travelling, however, were limited to his responsibilities at the Central Academy. He also visited the Renqiu Oilfield in central Hebei to give art classes for the workers, as well as teaching a small student art group at Beida.

In addition to the educational benefits of all this activity, there were concrete outcomes to his

Fig 1 Xu Bing teaching in the early 1980s

teaching practice. Prompted by his experience at the Central Academy he began writing about drawing instruction, eventually producing a 100,000-word treatise titled *Notes on Sketching Education* (see p. 20). Together with his outreach work for people who had never had the opportunity to receive any instruction in art, this writing and his university teaching earned him the prestigious Huo Yingdong Education Foundation Award. The prize, awarded by the Hong Kong-based Huo Yingdong Foundation in conjunction with the State Committee for Education, is given for the most outstanding achievement by a young teacher in higher education across the whole country. Xu Bing was awarded it in 1989, one year after the first exhibition, in Beijing, of his groundbreaking work *Book from the Sky* at the National Gallery of China, and one year before the controversy surrounding that work contributed to his departure from China. He went to the United States, where he was subsequently based for

nearly two decades. It was also in 1989 that the 4 June incident took place in Tiananmen following student demonstrations and occupation of the square. Xu Bing was there with his students, supporting them as their class teacher.

In the United States Xu Bing held no formal teaching appointments but continued his involvement with education by participating in workshops and giving lectures at museums and universities across the country, and often by invitation in Europe, Australia and other parts of the Americas as well. He also wrote prefaces to various catalogues and edited volumes. His most influential piece of writing was his reply to a young artist who wrote to him for advice on whether it is possible to maintain one's integrity and freedom of thought while at the same time participating in the art world. In fact, eleven other artists had received the same fictitious letter, and their replies were published in *Art on Paper Magazine* in 2006, and also in the expanded book form compilation *Letters to a Young Artist* (Darte, New York, 2006), in which Xu Bing's reply was the opening piece.

His greatest educational activity at the time however was an artwork rather than a pedagogical event: Square Word Calligraphy, also known as

New English Calligraphy – which is used for the inscriptions on Xu Bing's new landscript prints (cat. nos 77a–d) – is a way of presenting English or other Western words as Chinese characters. The appearance of the writing is thus very close to that of a Chinese text; yet closer inspection shows each 'character' to be composed not of brushstroke components representing the radical or phonetic elements of a Chinese character, but letters of the Roman alphabet organised in a way that resembles the shape and proportions of Chinese characters. Square Word Calligraphy forces viewers to readjust their reading, and raises questions about cultural assumptions regarding language. Seeing it gives the feeling of learning to read again, and in 1994 Xu Bing developed this aspect of it into an installation set up as a classroom, with desks where visitors could read the calligraphy, practise writing it, or try it out on a computer screen (fig. 2). This participatory aspect of his work – combining an artistic concept with the literacy that is part of everyday life in most parts of the world – is in keeping with his earlier enthusiasm to engage as wide a number of people as possible in art. *The Square Word Calligraphy Classroom* has been installed in exhibitions in a number of countries, including at the Johannesburg Biennale in 1997.

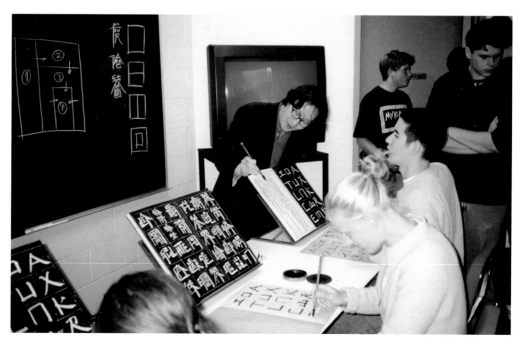

Fig 2 Classroom Calligraphy, Daryl Reich Rubenstein Gallery, Sidwell Friends School, Washington, D. C., 2002

Since 2008 Xu Bing has encouraged young artists from one of the most influential positions in art education in China, as vice president of the Central Academy of Fine Arts in Beijing. His teaching has resumed a formal role, in his supervision of graduate students, yet his involvement in education extends much further. He regularly organises and participates in workshops and conferences, in China and elsewhere, and often gives lectures which, in Beijing, are attended not just by students at the Central Academy but also Peking and Qinghua and other universities and art colleges. Some, such as one he delivered in August 2012, are associated with exhibitions he has curated: the Art Gallery of the Central Academy of Fine Arts holds one exhibition each year of work by recent graduates, alternating between those selected from all over China and those exclusively from the Central Academy itself. In addition to his own public lectures for students, he invites speakers from elsewhere to address them. These are not always fellow visual artists – for example in 2009 the American television writer and director Rene Balcer gave an enormously popular lecture, which can be read online, that shares the inspirational quality of Xu Bing's own writing for young people in its candour without self-regard, and encouragement without condescension.

The writing, lecturing and direct teaching in which Xu Bing continues to be involved, both within China and abroad, demonstrate his commitment to young artists. His current projects, editing two multi-author books of teaching materials, extend this dedication to school-age and university students. One of these, a textbook for junior and middle schools, is a joint project with the Department of Education, while the second is for older students at university level, both those specialising in art or art history and those studying art alongside other subjects. It includes essays by artists, art teachers, art critics and art historians, of whom several have experience in more than one of those categories, and also has a strong emphasis on the technical skills associated with art. The purpose is to demystify art for non-specialists, identifying as sources of alienation the fact that art exists because it expresses things that words cannot; that the terms in which it is commonly discussed have been influenced by Western methods; and that contemporary art is full of all kinds of strange expressions. The difficulty with Western methods is quite specific: the terminologies used in Western art history and theory are not in themselves straightforward to non-specialists; when translated into Chinese, they require terms as well as ideas that are not in the Chinese vocabulary. These are, moreover, sometimes mistranslated and so become particularly challenging for those not already familiar with discussions around art. Xu Bing is in addition keenly aware of the sensitivity of young people, likening them to snails with antennae outstretched, receptive to everything, but also easily damaged and quick to retreat into their shells. For this reason it is of the utmost importance, he believes, that the information they receive is as reliable as possible: correct, simple and exact. From this follows his conviction that of all the kinds of books in print, it is textbooks that are the most important.

Fig 3 *Tree*, by Megan Thomas (age 8), Kenya, 2009

Fig 4 'Guo Xi's method of painting trees', *The Mustard Seed Garden Manual of Painting*, early twentieth-century edition, Bodleian Library, Sinica 3937/2, juan 2, p. 22. Presented by Dr Arthur Waley, 1963 (cat. no. 85)

Fig 5 Title page of *The Mustard Seed Garden Manual of Painting* 芥子园画传 (1679), from a reprint of an edition probably printed in Kyoto 1812–17, Bodleian Library, Sinica 3938/1 (cat. no.79)

Artists and textbooks

It was a textbook that inspired one of the two projects that comprise the final section of the exhibition, the *Mustard Seed Garden Landscape Scroll* (cat. no. 78). This is a reworking of a famous seventeenth-century painting manual – *The Mustard Seed Garden Manual of Painting* (see cat. nos 79–90) – used by beginners and the self-taught from that time down to the present day. Xu Bing's scroll is paired with the Forest Project (cat. nos 91–3), which involves teaching children to draw and while so doing to think about language and the environment (fig. 3). The resulting drawings are then sold online to buy trees to plant in whichever region the children are from: so far, Kenya, south China and Brazil. The *Mustard Seed Garden Landscape Scroll* is an examination of a student teaching resource within the Chinese painting tradition; the Forest Project uses landscape painting to engage with educational, environmental and economic issues across the globe.

The *Mustard Seed Garden Manual of Painting* has been said to be limited by its reflection of contemporary practice around Nanjing, where it was published, yet as a textbook, it nonetheless could certainly be argued as meeting Xu Bing's requirements of correctness, exactness and simplicity. The model examples of mountains, rocks, trees, grasses and other landscape components that it reproduces page by page are taken from paintings by acknowledged masters of the landscape tradition; while the figures – which as a category have a less nuanced and more anonymous history – are linked to lines of verse by great poets (see cat. no. 87). The landscape elements are accompanied by texts, mostly quite short, identifying the painter whose work has been taken as a model for that image, and sometimes expanding into a short discussion of the artist or the genre represented. The poems and poets cited date mostly to the Tang dynasty (616–906), the golden age of Chinese poetry, and the painters mainly to the Northern Song dynasty (960–1127), the canonical period of Chinese landscape painting. (fig. 4)

The *Mustard Seed Garden Manual of Painting* was first published in 1679, in Nanjing, by the famous impresario Li Yu (Li Liweng), after whose garden it is named, and was compiled principally by Wang Gai. (fig. 5) It wasn't the first manual of its kind – most of the earliest printed books, all of which date to the Song dynasty (960–1279), had a taxonomic dimension and include a manual on painting plums printed in 1238 – but it was the most successful. Second and third parts devoted to birds and plants were added in 1701, and it seems to have been in use, if not necessarily in print, ever since (various Qing dynasty [1644–1911] and Republican period [1911–1949] editions are included in the exhibition). The most widespread edition since the founding of the People's Republic of China in 1949 is that edited by the artists Yu Fei'an and Hu Peiheng, and published by the People's Fine Art Press in 1957, with reprints including new prefaces in 1978 and 2012. Hu Peiheng's 1957 preface states that its publication was part of the re-establishment of painting practice in the new society. A much smaller painting manual, limited to flowers and plants, and titled *The Flower and Plant Painting Manual* (*Huahui huapu*), was published in 1962 by the Shanghai People's Art Press. The editorial board's preface comments that its publication follows the successful economic and cultural developments of socialism with the aim of providing workers, peasants and amateur painters with opportunities to study art; the preface to the 1972 reprint mentions only the amateur painters. Currently available editions vary from a high-quality facsimile of an early Kangxi (1662–1722) edition (Jiangxi Art Press, 2011, printings priced at RMB 780 or 580 depending on the weight of the paper) to the simple four-volume edition mentioned above (price RMB 29-38 per volume), and editions published in Beijing (1998), Hangzhou (2009) and Changchun (2010). It is used not just by aspiring painters but also by those who for relaxation are practising mastering just one genre, for example bamboo or birds.

A compilation of iconic artistic examples has thus, over three hundred years of circulation, become an icon in itself, or at the very least a standard reference. Works that are so well known become conventions: everyone understands the associations they hold and they can thus provide

Fig 6 'Guo Xi's method of painting trees' (detail), from *The Mustard seed Garden Manual of Painting*. See Fig. 4.

good material for an artist (or writer), either as shorthand for those associations or by playing with these possibilities, if not the object itself. In the *Mustard Seed Garden Landscape Scroll* Xu Bing has done both.

In the Square Word Calligraphy inscription on cat. no. 77b Xu Bing refers to the manual as a dictionary that provides all the components for a painting. His scroll is at first glance a standard landscape scroll – which is, of course, exactly how it should appear, as it is a composition of generic elements taken from a textbook on landscape painting. Xu Bing has composed it by selecting elements from different pages of the volume first published in 1679 and rearranging them as a handscroll. He has retained the lines of text that accompany the images, limiting them to the title line where convenient for the composition. In his essay on landscript (see p. 120–8), Xu Bing refers to the use of symbols in Chinese art with the example of theatrical performance using symbols or conventions, transformed into works of art by the artists' creative skills in rearranging them. The *Mustard Seed Garden Landscape Scroll* uses the conventions of traditional painting practice and rearranges them into the set piece of a landscape scroll (the technical aspects of which are outlined in the catalogue entry). At the simplest level, it succeeds as a coherent and convincing arrangement, which, given the decision to retain the original size of the images, was itself an achievement.

Aside, however, from retaining the accompanying text and image size, Xu Bing introduces two new concepts: one addresses the manual's role as an instruction book, the other the matter of narrative. This narrative concept has extended associations of its own that bring the scroll back to its origins among the canonical works in the history of painting in China.

Scroll paintings that include columns of text other than inscriptions at the edges are generally either cartographical landscapes or didactic figure paintings. In the former, the texts are mostly simple place names, either of mountains or temples. In the latter, they are usually extracts from didactic texts, a famous example being the scroll that over centuries moved in and out of the imperial collection, and for more than a hundred years has been in the British Museum, Gu Kaizhi's (attr.) *Admonitions of the Court Instructress*. It is an early figure painting comprising a succession of figure scenes separated by lines from a Han dynasty (206 BC–AD 220) treatise on behaviour for ladies about to enter court. Another example is a scroll in the Metropolitan Museum of Art, New York, by Li Gonglin (c. 1041–1106) that illustrates a classical text on filial piety composed between 350 and 200 BC. By including the instructional text of *The Mustard Seed Garden Manual of Painting* in his contrived landscape, Xu Bing adds an allusion to the function of scrolls as teaching resources themselves (fig. 6).

The very format of handscroll paintings, which are unrolled and viewed in a sequence, creates a narrative dimension. Disregarding the texts, the *Mustard Seed Garden Landscape Scroll* has the appearance of a traditional landscape including trees, water, mountains and figures, which Xu Bing describes as moving in typical fashion from the countryside to the town or human activity, and returning to the countryside. Such a composition is generic, yet there are details of his scroll that suggest an allusion to Bianliang (modern Kaifeng, Henan province), as depicted in the scroll *Qingming Festival on the River* by the Northern Song dynasty (960–1127) painter Zhang Zeduan. The *Qingming Festival* scroll is commonly referred to as the most famous Chinese painting. Notable versions of it were produced in the Ming

dynasty (by Qiu Ying, 1494?–1552) and at the Qing court (1644–1911), and it is printed on silk scarves sold at outlets from Taipei airport to the boutiques of north Oxford. The scroll illustrates the river running through the Northern Song capital as it may have looked at the major festival of Qingming one year in the eleventh century AD. It begins in the countryside, with a view at the right-hand end very similar to the one Xu Bing has used at the right-hand end of his scroll, though his unrolls, contrary to practice, from left to right rather than right to left. A river is implied throughout the length of Xu Bing's scroll by the placing of mountains and foreground, and the positioning of waterbirds and bridges. Had he wished to reproduce it accurately, the limitations of the available images would have been insurmountable. For example, the bustling activity and the large rainbow bridge that dominate the Song scroll are not reproducible from *The Mustard Seed Garden Manual* in the correct dimensions, though a city wall at the left is of just the same design and position as that in the early painting. The *Mustard Seed Garden Landscape Scroll* has been described as a work that takes images from paintings that have been extracted into a manual and returns them to a 'painting'; it is also a work that places iconic images from a compilation, which has itself become an icon, to refer to an iconic painting, moreover one from the period in which many of the images originate: the tenth- to twelfth-century painters Guo Xi, Fan Kuan and Mi Fu are all artists of the Song dynasty period whose seventeenth-century printed versions are used by Xu Bing.

This is itself a gesture of repetition, as Xu Bing has used the Qingming Festival in a previous work – part of his *Tobacco Project* (1999, 2000, 2004, 2011) where, to imply the passage of time, he used a reproduction of Zhang Zeduan's work to support a slow-burning 10-metre long cigarette. He writes:

> The Song painting describes a scene of ordinary life among the people in the period when capitalism was sprouting. The long river gives people a sense of time. The lit cigarette makes us uncomfortable and at a loss: as the cigarette goes, when it's gone it's gone. The

nothingness of the cigarette is a sort of fate. (5 January 2006)

By his definition, the scroll is a depiction of ordinary life. In associating it with the manual that made China's most elite cultural practice available to ordinary people, Xu Bing brings his own landscape scroll into the purview of his principles of art connecting with society, while at the same time bringing new life to traditional Chinese art.

Artists and the environment

Xu Bing, as he states in the essay at the end of this catalogue, is a Chinese person through and through. Yet his engagement with contemporary life wherever he finds himself nonetheless means that many of his projects, and most clearly, of course, those undertaken while he lived in the United States, have an intercultural dimension (see p. 196–8). Other projects, because they address issues common to humanity, have no apparent cultural origin or affiliation at all – *Book from the Ground*, for example (see p. 2; p. 193–195). The Forest Project (cat. nos 91–3) is a work that is international and humanitarian, above or outside any national culture, but engaging locally wherever it takes place.

The Forest Project resulted from Xu Bing's participation in *Human/Nature: Artists Respond to a Changing Planet*, which was organised in 2005 by the international conservation organisation Rare, in conjunction with the Museum of Contemporary Art, San Diego, the University of California, Berkeley Art Museum and Pacific Film Archive. It sought eight artists to visit UNESCO-designated sites and create locally relevant artworks that would promote environmental awareness and improvement. This remit coincided with ideas Xu Bing was already considering and so he chose to go to Kenya, with the expectation that it would provide another dimension to his work with animals (see p. 184–99). On arrival however he discovered that the most pressing local issue was forestry, which affected the subsistence of people and animals, the water system and social planning, but which, due to shortcomings in both government policy and Western aid systems, was threatened with lack of sustainability. Descending Mount Kenya

in the clear air while discussing this with his assistants and the guide, Xu Bing had the germ of the idea that grew into the Forest Project, which is outlined as follows on its website www.forestproject.net:

> Through art, culture, education, the involvement of local folks, and the internet, Xu Bing's Forest Project creates a system to facilitate the automatic and uninterrupted flow of funds from developed countries to Kenya, China and Brazil, earmarked for the planting of new trees.

> Forest Project seeks to establish a self-sustaining system linking these two worlds symbiotically through auctions of artwork created by students from primary schools in the Mount Kenya National Park area; Shenzhen, China; Hong Kong and Brazil.

> The educational component – embodied in an instructional book and workshops led by artist Xu Bing – connects the written word, calligraphy and art into one process. Students from local primary schools create drawings of trees using forms of writing from a variety of cultures and historical periods, spanning ancient Chinese pictographs, Egyptian hieroglyphs, Cuneiform script, Arabic, English and more.

> The income and price disparities between more developed nations and rural areas in Kenya, China and Brazil form the basis for the success of this project. Two dollars is a pittance for many in the West, just enough for a one-way ride on the subway, but when used to purchase a piece of art created by a student, it can be converted into many newly planted seedlings.

> The success of this project depends on you. Please visit the gallery of student work, register for an account and bid! (fig. 7)

The Forest Project is a large international undertaking, yet Xu Bing has initiated several smaller projects since the 1990s in which he has used trees, branches, leaves or other plant matter directly as materials, either for art objects or installations, and which speak to audiences outside China. His *American Silkworm*

series (1994–) raised questions about language using live silkworms that spun their silk over dictionaries, computers and other reference sources. The worms needed constant supplies of mulberry leaves and, in fact, some of the installations were in the form of arrangements of branches with silkworms crawling amongst them. The *Tobacco Project* (1999, 2000, 2004, 2011) used not just rolled cigarettes (to create, among other things, a tiger-skin rug), but large tobacco leaves made into a book, as well as a sculpture of compressed tobacco. In so doing he introduced an extra sensory dimension to the exhibition, for the tobacco smell was strong and particularly challenging for visitors who had quit smoking. The project looked at the relationship between tobacco and people, and at the Virginia exhibition (2011) particularly in terms of the local tobacco-growing industry.

The plant material project that connects most directly with landscape, however, is the *Background Story* series (2004–) that takes dried or decaying branches, twigs, leaves and so on to build a landscape behind an illuminated panel, which viewed from the other side has the appearance of a landscape painting. To date there have been eleven *Background Story* installations across the world . They have been extremely well received as contemporary installations that are attractive and contain an element of surprise. When shown outside China they are also an effective introduction to Chinese landscape art, particularly when the image relates closely to a specific painting, as at the British Museum in 2011 and Massachussetts Museum of Contemporary Art in 2013. These installations and many of Xu Bing's other projects have been developed with the assistance of workshop teams and require teamwork to construct: the *Mustard Seed Garden Landscape Scroll*, for instance, the animation *The Character of Characters* (2012) and, perhaps more than any other, *Phoenix*.

Phoenix (2008–10) is a large-scale suspended sculpture of a pair of 27- and 28-metre long phoenixes that recycles industrial rather than natural waste, for it is built from construction debris and embellished with light-emitting diodes. Exhibited first in central Beijing outside the Today

Fig 7 Xu Bing teaching in Kenya, 2009

Art Museum and then at the Expo 2010 Shanghai China, it is at the time of this exhibition on display in the Massachusetts Museum of Contemporary Art. In its use of the detritus created by construction sites, the *Phoenix* project is concerned with China's growing urban environment. This growth brings into question the relationship of Chinese artists to the world around them, which has historically been essentially one of mountains and rivers, natural countryside, cultivated fields, parkland or gardens, and buildings of wood and stone within towns designed to relate more or less to their natural surroundings. In the 1950s artists still wrote about the enduring, age-old closeness of the natural world to the Chinese people's hearts and daily lives. Industrial development since then has changed the presence of the environment in people's daily lives, removing many from contact with the natural world and bringing about a reconsideration of artists' attitudes to landscape, which one might summarise as polarised between new styles of ink painting, and urban landscape photography in which buildings and roads replace the mountains and rivers of tradition. In either case they represent a disruption of an ancient relationship between artist and nature.

Issues of development are of course worldwide. Another international project in addition to the Forest Project, in which Xu Bing has used his art to enlist the help of the public in support of an

underdeveloped region, is the Helsinki-Himalaya Exchange. In the exhibition at the Kiasma Museum of Contemporary Art in Helsinki that was the outcome of his Himalayan trip in 1999, from which the first landscripts emerged (see cat. nos 72–3), Xu Bing included a donation box. Visitors made a donation in exchange for a postcard image of the works he was exhibiting. The images were printed on Nepalese paper and the donations were passed to a Nepalese educational fund that was then able to construct a schoolhouse in a mountain village. Xu Bing has written about the deep impression that his visit to Nepal made on him, finding himself unexpectedly in the position of the privileged onlooker and becoming newly aware of the imbalances between rural and urban, educated and ignorant, local resident and foreign visitor. This also reflects a change in the possibilities of connections between cultures. At the time when Xu Bing had recently moved from an uneducated rural community, the international art available to view was limited, if nonetheless powerful in its impact (see the French drawings and early works by Xu Bing in Part One). In the twenty-first century China is no longer so separated from the rest of the world, and it is possible for Xu Bing to produce, from Beijing, work that addresses both Chinese traditions and current concerns elsewhere.

Xu Bing regards as a growing responsibility of contemporary artists the use of art as a means of redressing the kind of imbalances that he observed in Kenya and Nepal. Where there are problems there is art. Environmental issues affect everyone and in China they are particularly pressing; artists in China have an especially longstanding and close relationship with landscape and nature, and it has traditionally been a solitary one. Xu Bing has shown the part that language plays in that relationship and, separately, what can be achieved through participatory projects and especially those with an educational dimension. He implements his creativity with the involvement of others, and presents the final artwork in ways that communicate with individuals and address communities. His work looks to the history of his own culture and to the humanitarian in any culture, and persistently connects to the times in which he happens to be. |SV

On Painting and Teaching

Xu Bing

From *About The Mustard Seed Garden Landscape Scroll,* Written Message from Xu Bing delivered at Boston Museum of Fine Arts, 4 December 2010

I believe that a core characteristic of Chinese painting is its semiotic nature, which is directly related to Chinese writing. Chinese thought, perceptions of the world, and aesthetic attitudes are all related to pictographic characters. That is to say, the beginnings of Chinese culture affect its subsequent unfolding. Chinese perceptions of the world are always based in signs and concepts. This is evident in China's religious, philosophical, literary traditions and even in its modern mottos and slogans, among other things. The Chinese dislike lengthy discourses and elaborate logical inferences, preferring instead to represent things with signs and concepts.

The *Mustard Seed Garden Manual of Painting* illustrates this connection (between semiotics and visuality) most clearly. For me, it is a dictionary of signs for representing the myriad things of the world. Take for example the character 竹, for 'bamboo'. It is composed of two 个 characters, themselves more or less identical to one codified rendition of bamboo leaves. Writing and painting are one – are signs alike. Through my *Landscript series*, I realized that a texture stroke is a repetition of a sign. This is why I call the *Mustard Seed Garden Manual of Painting* a dictionary of signs. It gathers various prototypes. The depiction of human figures and even their activities

are predetermined in such configurations as 'lone sitter viewing flowers', 'paired sitters viewing clouds', 'three figures standing facing one another', and 'four seated figures drinking'. An artist needs only to memorize these 'radicals' as one recites a dictionary and then to piece them together into a world. The Chinese painting tradition is thus based on copying rather than sketching. In the Qing Dynasty, the tradition was summarized, organized, and atomized in a book. This is why the *Mustard Seed Garden Manual of Painting* is a condensation of the core methods and attitudes of Chinese painting. It is also why the 'classics', so often accused of being mired in the past, have remained timelessly resonant. A good textbook conveys what is central and essential.

Although we use modern Chinese now, its pictographic nature still profoundly informs our reading. When we read the characters 山水 (landscape, lit. 'mountain and water'), how do the shape of the mountain in 山 and the patterns of water in 水 affect our thinking? People all say this is the age of reading images. The Chinese have been reading images for thousands of years. Ultimately, all this cannot but affect a people's ways of thinking about and knowing the world.

Translated by Alan Yeung

The essence of what we call 'teaching' is: how to help them preserve what adults have already lost, and to find an

appropriate connection to adult culture and ways – in fact how to look upon, understand and absorb adults' skills, experience and ways of doing things. It is not to make them quickly and precociously become 'standard artists'. The aim is not to 'teach them to paint pictures'; rather it is to provide them with the space and nurturing they need at every stage in their growth. If they develop every aspect of their potential adequately, they will automatically be able to begin to discover other parts of their latent ability, and these could be in any field. We just need to tend them painstakingly like a gardener, and wait. They will always be able to find a suitable way of looking at things and thinking things over.

From the preface to *Highlights of Chinese Children's Painting* (2012)

In my opinion, restrictions can also be helpful. When I was teaching the children (during the Forest Project), I set them some limits, asking them to make a picture of a tree by using primitive symbols for 'tree' to compose it, and this made them paint more interesting pictures. Rather than limiting them, it stimulated their thinking. Artists in the West have no restrictions but if you don't know how to use it, the lack of limits can leave you with nothing to pursue. Socialist artists on the other hand, working within such tight constraints, advance to an extreme degree.

From *The Benefits of a Socialist Background,* interview in *People Magazine Weekly* |XB

好好学习 天天向上

Xu Bing with students participating in The Forest Project, Hong Kong, 2009 (above)
Xu Bing with students participating in The Forest Project, Kenya, 2008 (below)

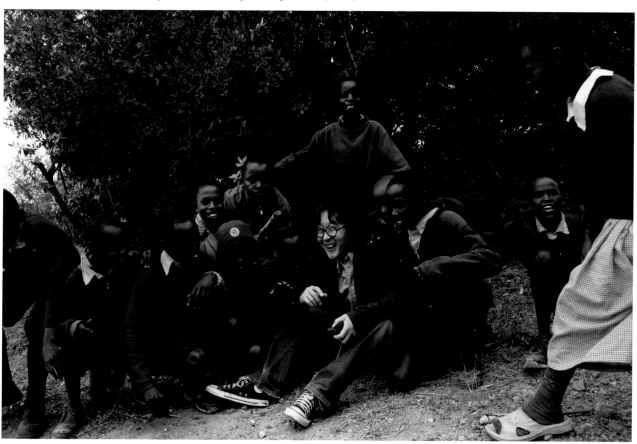

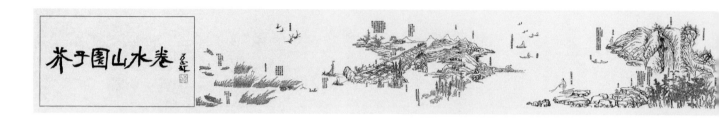

78

The Mustard Seed Garden Landscape Scroll 芥子园山水卷

2010

Title written and signed by Zhu Naizheng, and again in Square Word Calligraphy

With a colophon by Qianshen Bai

Woodblock print mounted as a handscroll, ink on paper

32.3 x 847 cm

Published editions: Hao Sheng, *Fresh Ink: Ten Takes on Chinese Tradition*, Boston (Boston Museum of Fine Arts), 2010, pp. 184–91; Anne Farrer, 'Xu Bing's *Mustard Seed Garden Landscape Scroll*', in Xiaobing Tang, *Multiple Impressions: Contemporary Chinese Woodblock Prints*, Ann Arbor (University of Michigan Museum of Art), 2011, pp. 22–5.

The *Mustard Seed Garden Landscape Scroll* represents Xu Bing's participation in the exhibition *Fresh Ink: Ten Takes on Chinese Tradition* at Boston Museum of Fine Arts in 2010, in which ten artists were invited to create pieces that responded to works in the museum's collection. The Museum of Fine Arts holds one of the most prestigious collections of Chinese paintings outside China, including works by famous masters of the Song, Yuan and Ming dynasties. The project provided Xu Bing with an opportunity to effect an idea that he had been considering for some time, and he selected an early twentieth-century edition of the seventeenth-century printed book *The Mustard Seed Garden Manual of Painting* 芥子园 画转. He discusses the painting manual and the project on p. 156, and also refers to it in the main inscription on *The Suzhou Landscripts:* (纸抄纸) in cat. no. 77:

if a good painting possesses "classical" qualities, it must reflect the brushwork of the ancients. chinese painting emphasizes "paper copying paper," and through these symbolized brushstrokes it is passed on from generation to generation. "the mustard seed garden manual of painting," china's most famous work of art instruction, combines the brushstrokes – mountain strokes, tree strokes, rock strokes – from the paintings of old. it is a dictionary. students need only memorize the "radicals" to express everything existing in this world.

First published in 1679, *The Mustard Seed Garden Manual of Painting* made publicly available in print form the sort of manual that painters had been using for centuries. It was very successful and remains in print and in quite wide use today. By atomising

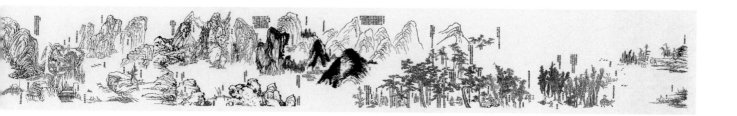

the conventions of the brushwork and motifs in Chinese painting it opened possibilities for amateurs to master painting skills in a methodical way and to contrive their own compositions. The manual has also been dismissed as discouraging to creativity, but it has nonetheless also been used as a first introduction to painting by many leading twentieth-century artists including Qi Baishi, Huang Binhong, Fu Baoshi and Xu Bing himself. At the Central Academy it was regarded as outdated and clichéd. Xu Bing came across it when visiting the famous Rongbaozhai print studio to buy materials and found it in fact to be full of interest. He has since identified it as a quintessential example of Chinese perceptions and codifications of the world around (see Hao Sheng, p. 188).

The scroll was produced by photocopying the manual onto polyester sheets which Xu Bing then assembled into a landscape composition. It was then carved, along with two frontispieces, into pearwood blocks by two print artists, Wang Wenda and Lu Baogui, and printed and mounted. Neither is named on the scroll and it is not signed, though the use of Square Word Calligraphy associates the work with Xu Bing. Anne Farrer regards this detachment of Xu Bing's identity from the landscape image as the most important aspect of the project: it negates the first of the Six Principles of painting as defined by Xie He (sixth century AD), one of the founding theoreticians of Chinese landscape painting, and denies the modern printmaker's identity as a creative artist, established only since the 1930s with the assumption of every part of the woodblock process from design to printing (Anne Farrer, p. 25).

The scroll takes images that have been transferred from early paintings into a printed book and rearranges them into a landscape, thereby returning them to the painting tradition. By doing so two new associations are introduced: the columns of text suggest early didactic paintings produced as illustrations of classical texts, and the unfolding scene suggests narrative, some elements of which appear to relate to the famous Song dynasty (960–1279) scroll *Qingming Festival on the River* 清明上河图 that Xu Bing has used in previous projects. It is not necessarily clear from which end the scroll unrolls; however, on this edition the addition of a colophon indicates the end of the print. It is written by Qianshen Bai, professor of Chinese art at Boston University and formerly a member of the 1980s Beida student art group with which Xu Bing was also involved (see p. 48).

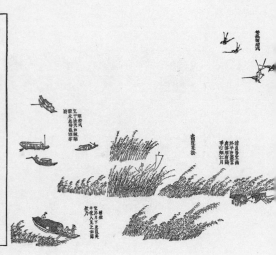

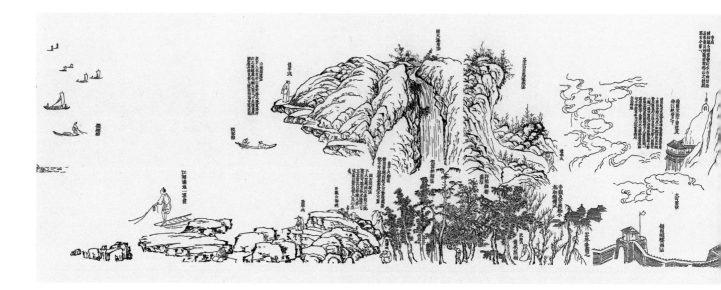

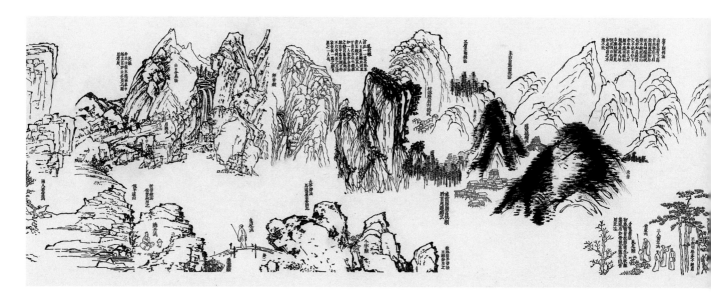

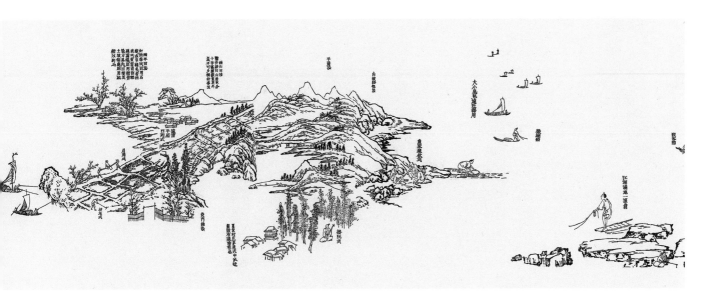

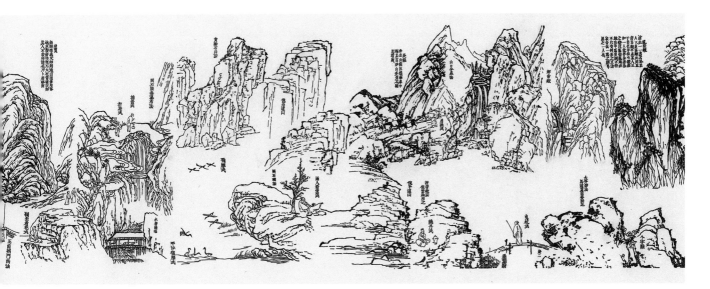

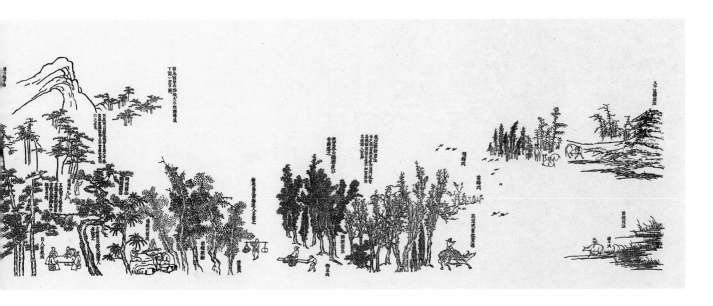

79

Title page of *The Mustard Seed Garden Manual of Painting* 芥子园画传 (1679), compiled by Wang Gai in conjunction with Wang Shi, Wang Nie and Zhu Sheng

Vol. 1 of an edition of 23 vols, probably a reprint of an edition printed in Kyoto

1812–17

H 27.0 cm

Bodleian Library, Sinica 3938/1

The use of green on this title page suggests that it may be a trial printing, as proofs were customarily produced in colour before a work was printed in its entirety in black ink.

The large characters of the title are preceded on the right by a column giving the name of the editor/compiler Wang Anjie (a style name of Wang Gai): Wang Anjie of Xiushui copying the ancients 绣水王安节摹古. The characters are written in the form used for seals and inscriptions from

the Zhou dynasty (c. 1050–221 bc) onwards. The second character – 水 shui – in the place name 绣水 has a similar form to that used by Xu Bing for the rivers and streams in the landscript paintings and prints. The line across the top, outside the border, reads *Edited by Mr Li Liweng* (李笠翁先生论定). Liweng is an alternative name of Li Yu (1610–80), the famous playwright, novelist, publisher and entrepreneur who published and wrote the preface to *The Mustard Seed Garden Manual.*

80

Title page of *The Mustard Seed Garden Manual of Painting* 芥子园画传 (1679), compiled by Wang Gai and others

Vol. 1 of 3 remaining from a 5-volume edition, Qing dynasty, undated
H 27.0 cm
Bodleian Library, Sinica 899/1

The first line of the text on the facing page reads: *People of today love real landscapes in the same way as they love painted landscapes.*

The title is printed on a pink or red paper. It is not unusual for editions to have coloured title pages, though on early editions, as seen in the Nelson-Atkins Gallery, Kansas, and in another Bodleian copy (Sinica 3059), a rich dark yellow seems to be the most usual. The printing of the title here reproduces the calligraphy technique known as 'flying white' 飞白, in which a dry or unevenly loaded brush leaves areas unmarked (white) as it moves across the page.

The righthand column of seal script reads exactly as the title page in cat. no. 79: *Wang Anjie of Xiushui copying the ancients* 绣水王 安节 摹古, Wang Anjie being an alternative name of the compiler of the manual, Wang Gai. The line across the top, outside the border, similarly reads *Edited by Mr Li Liweng* 李笠翁先生论定. On this copy, however, there is an additional line of text in seal script, to the left of the title. It reads *Property of this (government) office* (本衙藏板, and may be regarded as a more assertive version of the stamps of the Bodleian Library and the Oriental Institute, Oxford, that appear on the title page printed in green (see cat. no. 79).

81

Methods for painting reeds and rushes

Vol. 2 of 3 remaining from a 5-volume edition, Qing dynasty, undated
H 27.0 cm
Bodleian Library, Sinica 899/2, juan 2, p. 40

The text discusses Song (960–1279) and Yuan (1279–368) paintings titled *The Pleasures of Fishing* as an explanation of why this example of reeds and rushes appears in the section of *The Mustard Seed Garden Manual* devoted to trees. The reason is that fishing paintings are largely composed of water and mist, typically so lightly painted that reeds and grasses provide the main focus of the picture. In most paintings it is trees that are the focus, meaning that reeds and grasses serve an equal function.

Xu Bing uses only the four-character title of this passage, positioned above the two groups of reeds he has reproduced; however, he has placed those adjacent to a fisherman among more reeds. In fact, Xu Bing has placed the title in precisely the position that the title occupies in the image of the fisherman among reeds, taken from the 'mountains and rocks' section further on in the original manual.

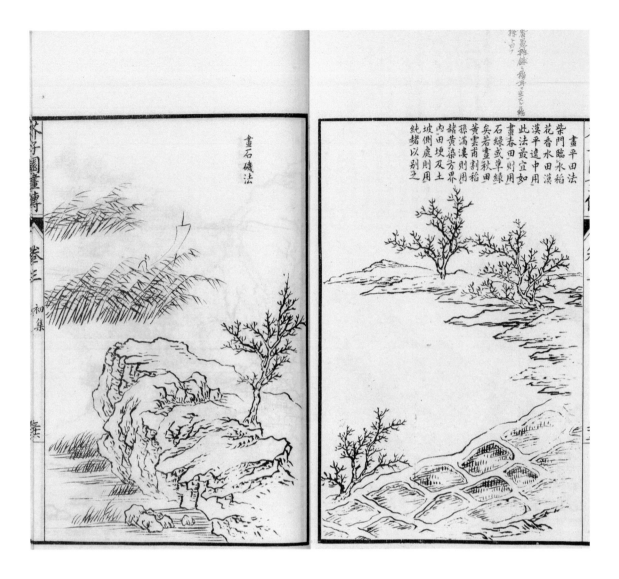

82

Method for painting rock, and method for painting level views of fields

Vol. 2 of 4 from a photolithographic edition, 1921
H 26.0 cm
Bodleian Library, Sinica 3939/2, juan 3, p. 36 (left) and p. 35 (right)

The page on the left is titled with a method for painting rocks; however, it also depicts the fisherman among reeds shown next to the grasses (cat. no. 81) in Xu Bing's scroll.

The text on the righthand page discusses the correct seasonal colours to use for depicting fragrant rice fields – green in spring, yellow in autumn. The arrangement of the text shows that this is not the edition that Xu Bing used as his model, though that was also one dating from the 1920s. The figures in the scroll are his own introduction to the scene, taken from elsewhere in *The Mustard Seed Garden Manual*. The composition of the rice fields has some resonance in Xu Bing's early landscape sketches, but more closely in his landscript print after Liu Jue's seventeenth-

century scroll *A Foggy River* (cat. no. 77a). Both Xu Bing's print and Liu Jue's painting include a spit of land rising from left to right near the foot of the composition, and divided into small fields, as in this illustration from the manual.

This edition of *The Mustard Seed Garden Manual*, produced by photolithography, a technique then in its relatively early stages in China, is not the finest printing but demonstrates the continuity in the book's production and the different ways in which readers and owners used it: the manuscript annotation in red ink is written in Japanese.

83

Thatched dwellings for villages in summer landscapes. The windows can be shaded

Vol. 19 of a 23-volume edition, probably a reprint of an edition printed in Kyoto

1812–17

H 27.0 cm

Bodleian Library, Sinica 3938/19, juan xia 卷下 (second part), p. 11

The group of buildings that Xu Bing has used in his scroll, complete with the associated text, is the central group on this page, below the buildings suitable for high ground and above those prescribed for mountain scenes in Sichuan, by rivers. Thatched huts appear in the landscript paintings, where the character for window is drawn for the windows; the building on the right of the central group here shows a similar, though not exact, way of depicting a window.

84

Hugging knees

Vol. 18 of a 23-volume edition, probably a reprint of an edition printed in Kyoto 1812–17
H 27.0 cm
Bodleian Library, Sinica 3938/18, juan shang 卷上 (first part), p. 14

Xu Bing has placed the figure of a servant boy (identified by his hairstyle of twin topknots) hiding among trees. The figures on this opening of *The Mustard Seed Garden Manual* are shown singly, and mostly engaged in various tasks, while most of those in Xu Bing's scroll are in groups, reinforcing its narrative dimension.

郭熙雜樹畫法

85

Guo Xi's method of painting trees

Vol. 2 of a 5-volume edition, Republican era
(1911–49) lithograph
H 29.0 cm
Bodleian Library, Sinica 3937/2, juan 2,
p. 22. Presented by Dr Arthur Waley, 1963

Guo Xi (eleventh century, dates unknown)
was one of the great master painters of the
Northern Song dynasty (960–1127), when
landscape first equalled figure painting in
importance. He grew up in the foothills
of the Taihang mountain range, where his
contemporary Fan Kuan also spent years

wandering; as a result the area has become
inextricably associated with the landscape
tradition. Both artists painted works that
became central in the canon of Chinese
landscape painting: Guo Xi's *Early Spring*
(1072) and Fan Kuan's *Travellers Amongst
Streams and Mountains*, both of which are
now in the National Palace Museum, Taipei.
Further along the scroll, in the large group
of trees near the end, Xu Bing has also
used an example of Fan Kuan's method of
painting trees. Guo Xi was also well known
for his writing on painting, in particular his
'Essay on landscape painting', in which he
comments in details on technique: 'using

the brush tip and placing it down briefly is
called a dot, dots are suitable for figures,
and for leaves on trees; using the brush to
make a long stroke is called a brushstroke,
brushstrokes are suitable for buildings, and
for pine needles'.

This edition of *The Mustard Seed Garden
Manual of Painting* previously belonged to
Arthur Waley, the renowned linguist and
translator of Chinese poetry. From 1913 to
1929 he was Assistant Keeper of Oriental
Paintings at the British Museum, and
published the Museum's Stein Collection
of Tang dynasty and other early paintings
from Dunhuang.

86

Example of wild geese in flight

Vol. 3 of a Qing dynasty edition, undated
Bodleian Library, Sinica 3059/3, juan 4, p. 22

The lower pair of geese on this page have been repositioned in Xu Bing's scroll. He has also used the group labelled *Example of geese resting on flat sand* that appears on the same page, in fact using the upper half of the page in the original manual for the lower part of the scroll at that point. The

page itself is a rare instance in *The Mustard Seed Garden Manual* of an entire page forming something like a self-contained composition, though several views in the 'mountains and rocks' section might be read as such.

87

While going to a place at the water's edge to sit and watch clouds rise

Vol. 3 of 4 from a photolithographic edition, 1921

H 26.0 cm

Bodleian Library, Sinica 3939/3, juan 4, 初集 (first part), p. 5

In the *Mustard Seed Garden Landscape Scroll* Xu Bing has reworked this image in two ways. He has reduced the title text by half to *Two people watching mist rise* 两人看云 起 and he has reversed the figures so that they are facing the opposite direction from their appearance in the printed book. The manuscript annotation in red, written in Japanese, identifies the poem as being by the famous Tang dynasty poet and man of letters Wang Wei (699–759). The two lines reproduced on this page are lines five and six of his eight-line poem 终南别业. Wang Wei was also famous as a landscape painter.

山口分泉法

雲流泉隔法
画泉古人多用雲鎖然
画雲時不可露出筆墨
痕跡但以淡色暈輝漬
出方為妙手。

88

Method for a waterfall from a winding stream in a valley

Vol. 1 of 3 remaining from a 5-volume
edition, Qing dynasty, undated
H 27.0 cm
Bodleian Library, Sinica 899/3, juan 3, p. 40

In the landscape scroll Xu Bing has used
the same line of text but repositioned it
from the area directly above the water
source to the blank rock area to its left.
In addition, a waterfall of this type, with
its sharp meander before cascading, is

prominent in Xu Bing's landscript scroll
after Zhai Dakun's *Admiring the spring rain
from a thatched hut* (cat. no. 77c). It is,
however, a conventional waterfall motif,
and the two may not be connected.

89

Mountains by Mi Youren
(1074–1151) and Ni Zan (1301–74)

Vol. 3 of a 5-volume edition, Republican era (1911–49) lithograph

H 29.0 cm

Bodleian Library, Sinica 3937/3, juan 3,

p. 28 (left) and p. 27 (right). Presented

by Dr Arthur Waley, 1963

The mountain rocks adjacent to the text on the righthand page here are reproduced without annotation in Xu Bing's scroll. The text is headed *Mi Youren* and is a commentary on the stylistic consistency between the paintings of Mi Youren and his father Mi Fu (1051–1107), the great scholar, official and painter who was also renowned as one of the four masters of calligraphy of the Northern Song dynasty.

The mountain on the lefthand page appears at an earlier point in Xu Bing's scroll than the Mi Youren rocks and is annotated with the title of the text only: *Ni's high distant mountains* 倪高远山. The text begins by mentioning him by surname alone along with the names of the other three of the Four Yuan Masters, and continues with a commentary on his landscape style.

By these discussions the texts emphasise the role of reproducing iconic standards from previous generations.

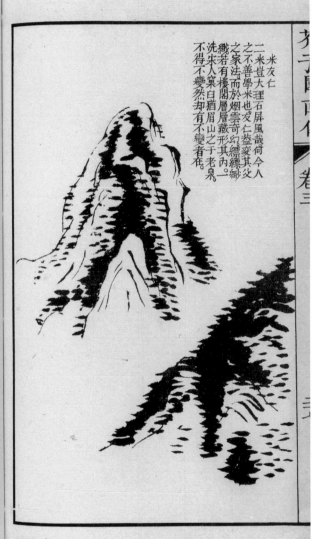

倪高遠山

90

Method for rounded peaks in level distance

Vol. 3 of a 23-volume edition, probably
a reprint of an edition printed in Kyoto
1812–17
H 27.0 cm
Bodleian Library, Sinica 3938/3, juan 3,
p. 22 and p. 23

'Level distance' is a phrase used in
discussions and descriptions of landscape
painting, and refers to distance depicted
as far away, as opposed to using landscape
(and scroll) height to imply inaccessible
distance. This page appears approximately
a third of the way through the section on
rocks. It is, however, the conclusion to Xu
Bing's scroll, and one of the sections (along
with the city gate towards the left of the
scroll) that approximates perhaps most
closely to the iconic twelfth-century Song
dynasty scroll *Qingming Festival on the River*
to which the *Mustard Seed Garden Scroll*
may be related.

Forest Project paintings

cat. nos 91–3

http://forestproject.net

This group of three paintings comprises one part of the outcome of an ongoing project that Xu Bing developed from his involvement in 2005 in *Human/Nature: Artists Respond to a Changing Planet* (see p. 153–4). Artists were invited to visit a UNESCO-protected site of their choice with the undertaking to produce a work of art that would raise environmental awareness and produce some benefit for the area. Xu Bing elected to go to Mount Kenya.

The Forest Project that he established involves teaching children aged seven to thirteen to think about their local landscape and environment, including trees and animals, in terms of language and history, and to then create pictures. The drawings and paintings are auctioned online, and the funds raised used to buy and plant new trees locally. Xu Bing wrote a primer for teachers to use so that the project could expand and continue. The large paintings exhibited here were painted by Xu Bing in response to the children's drawings, so the project as a whole comprises their drawings, Xu Bing's large-scale landscape paintings, the teaching material primer and the auction website.

The work was conceived as a means of using art to acknowledge and address in some way the imbalance between rich and poor countries. At the same time it creates a cycle of trees: paper – drawings – money – trees. The work also enacts Xu Bing's belief that contemporary artists have a responsibility to use their work for the benefit of the environment. He has led the project in Kenya, Shenzhen, Hong Kong and most recently in Brazil, where it formed part of his contribution to the 2012 São Paulo Biennale, in which he was the only artist representing the People's Republic of China. The web-based auction site is, of course, not constrained by any place or time.

The three paintings are each composed of Xu Bing's versions of words and motifs from the children's drawings. The words vary from the long and serious – 'environment', 'eucalyptus' – to names and fun phrases, to sequences of letters whose meaning is hard to decipher. Many small animals can be seen among the leaves and branches, but there are very few human figures. The paintings are a rare instance of Xu Bing's brushwork.

91

Forest Project 1

2008–9

Inscribed in Square Word Calligraphy:
*I have copied the work of these children
just as if I were copying from a book of old
masters. I haven't dared make any changes;
to me, like real trees, they are a part of
nature. You must perfect them. Xu Bing*
Two square seals: Xu Bing (in relief),
top right; one (in relief), lower left

Ink on paper
146.5 x 341.0 cm

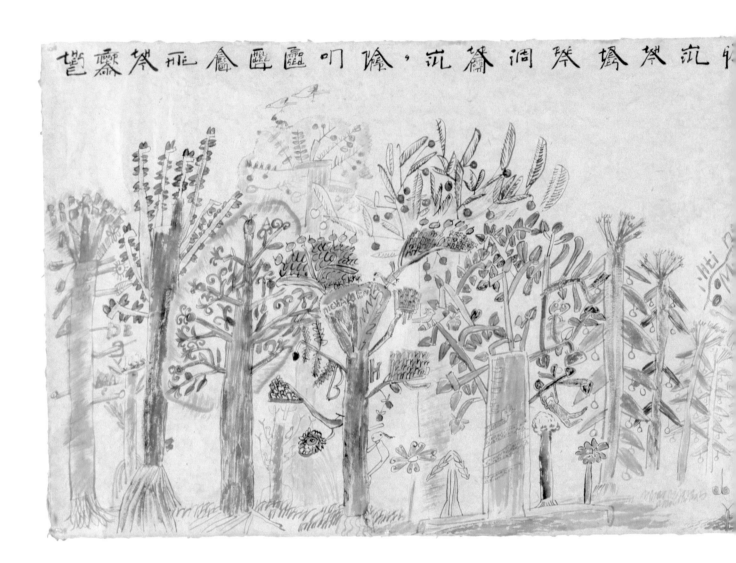

92

Forest Project 2

2009

Inscribed:

These illustration that the African children composed on paper, will transform into real trees that will grow in the areas surrounding Mount Kenya. Xu Bing two thousand and nine Beijing Huajia di

Two square seals: Xu (relief) at the top; Bing (intaglio) lower right

Ink on paper

116.5 x 344.0 cm

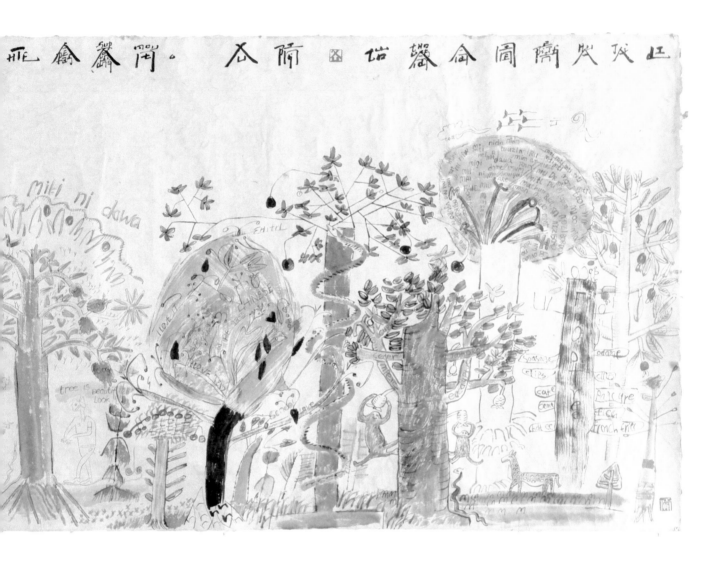

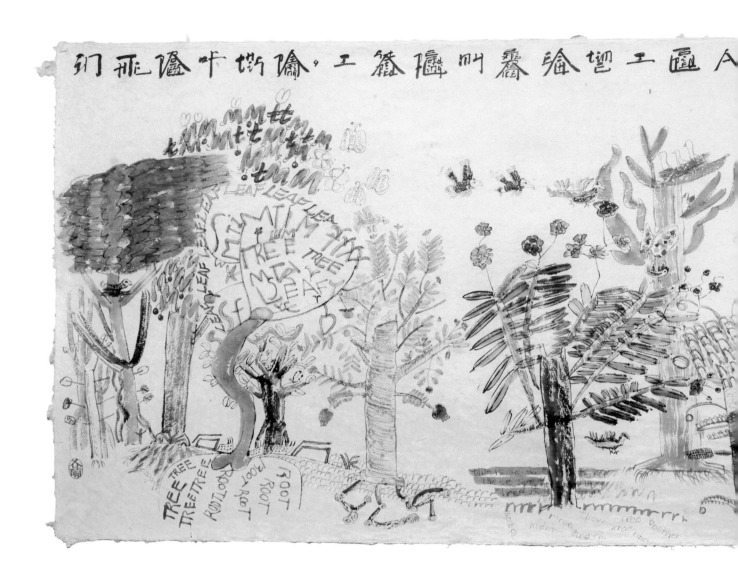

93

Forest Project 3

2009

Inscribed: *In the process of this painting, I started recording my experience each time I copied a tree. I discovered that each tree contained in it the secret of a child. Xu Bing*

Two seals: one square seal, Xu Bing (in relief), upper right; one oval seal, Xu Bing (in relief), lower left
Ink on paper
116.5 x 344.0 cm

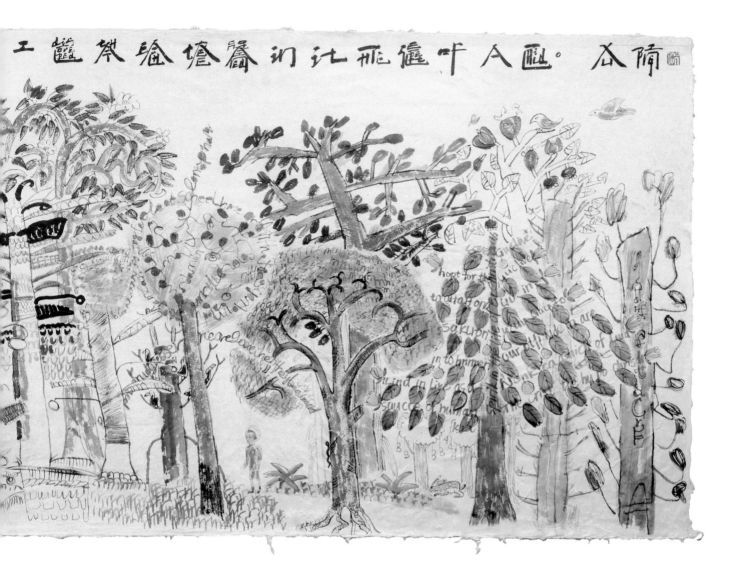

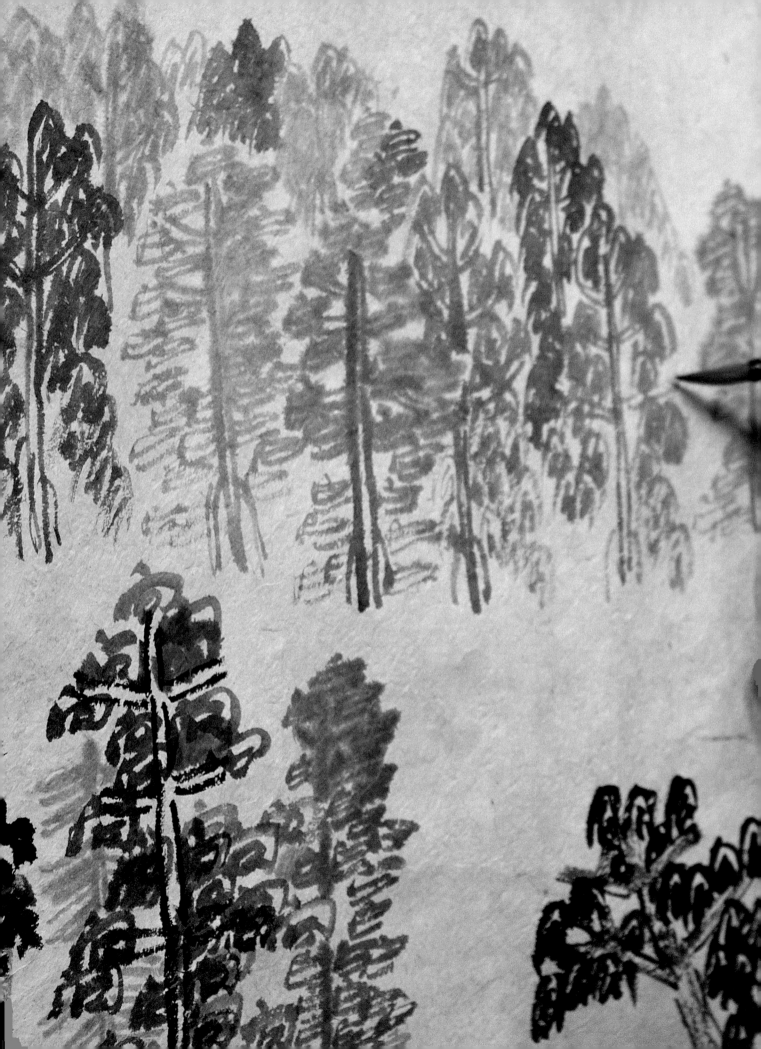

Part Four

'The Space Between'
Ways of Looking at the Art of Xu Bing

Peter D. McDonald

ooking at the art of Xu Bing, even in the apparently safe surroundings of the Ashmolean Museum, is a risky undertaking. As he once put it, his works are 'like a computer virus that functions in the human brain'.

They break our familiar patterns of thought and mix connections between concepts. In the process of searching for a new method of understanding, the fundamentally lazy nature of thought is challenged. This forces you to find a new conceptual foundation.[1]

None of this is said lightly, as we shall see, and so it is perhaps unsurprising that we might at first want to respond by trying to play down the threat. If your knowledge of art is based primarily on so-called 'Western culture', you might, for instance, feel tempted to protect yourself by labelling Xu Bing a 'conceptual artist' in the tradition of, say, Marcel Duchamp and Joseph Kosuth, absorbing him into a reassuringly familiar history of 'Western postmodern art'. That something can be said for this approach makes it only more inviting. After all, on his own account, Xu Bing did find inspiration in Duchamp's Dadaist experiments as a young artist trying to find his way during the short-lived era of cultural openness that revitalised the Beijing art world in the early 1980s. It is also not difficult to see connections between his playfully verbovisual installations and Kosuth's, given their shared interest in language; or to hear echoes of his thinking in Kosuth's conceptualist manifesto 'Art after Philosophy' (1969). Like Xu Bing, the leading

post-war American conceptual artist looked to Duchamp, whom he identified as the founder of a new artistic self-consciousness. 'The "value" of particular artists after Duchamp', Kosuth wrote, 'can be weighed according to how much they questioned the nature of art.'[2] Again, like Xu Bing, Kosuth saw his own work as a challenge to thought, rather than an aesthetic object. 'Aesthetics,' he remarked, 'are conceptually irrelevant to art.' (19) Similarly, in response to a question about the beauty of his own work, Xu Bing commented in a recent interview: 'I'm not consciously looking to aesthetic values or styles. If your goal is to create something beautiful it can easily become contrived.'[3]

It does not take much, however, to see that these efforts to defuse the threat his works pose are not in the end very helpful. For one thing, even a cursory glance through his now considerable output reveals that Xu Bing cannot be contained within any single artistic tradition. If his influences extend to twentieth-century Euro-American conceptual art, they also look sideways to the mezzotint experiments of twentieth-century Japanese artists such as Hamaguchi Yōzō and Hasegawa Kiyoshi, and back to the long traditions of Chinese calligraphy, printmaking, and landscape painting. For another thing, as Xu Bing's wording in the opening quotation reveals, his idea of the conceptual has always been broader and more ambitious than Kosuth's. For the American in the 1960s, conceptual art was at once a turn inward – 'Artists question

the nature of art by presenting new propositions as to art's nature' (18) – and a turn against the high modernist, principally formalist, aesthetics associated with Clement Greenberg, the foremost American art critic of the previous generation who had made his name as a champion of abstract expressionism. Kosuth's preoccupation with ideas and his interest in repeatable, anti-aesthetic installations was, among other things, a conscious rejection of what he took to be Greenberg's fetishisation of artistic form and the unique art object. By contrast, Xu Bing's idea of the conceptual is directed not so much at any artistic tradition as such but, as his comments on computer viruses show, at our ordinary ways of thinking and looking, most of which are culturally learned. Unlike Kosuth, he also sees the conceptual disruptiveness of his works less as an end in itself than as a stage in a process of radical transformation that eventually 'forces you to find a new conceptual foundation'.

To appreciate what lies behind this formulation we need to look not to the conventions of 'Western postmodernism', nor, indeed, to any specifically *artistic* practice, but to the teasing, disorienting traditions of the Zen (or Chan) Buddhist *kōan*, especially as articulated by the Japanese scholar D.T. Suzuki in his *Introduction to Zen Buddhism* (1949), one of Xu Bing's favourite books. The *kōan*, as Suzuki explains, is a short, pithy 'statement or question' intended to encourage novice monks to re-examine all they have 'so far accepted as a commonplace fact' and to challenge their 'former way of looking at things'.[4] The influential eighteenth-century Japanese monk Hakuin Ekaku produced what has become one of the most well known: 'Two hands clap and there is a sound. What is the sound of one hand?' As Suzuki emphasised, the *kōan* in this tradition is 'neither a riddle nor a witty remark', and it is certainly not a philosophical or literary end in itself (108). Rather, it is simply a means, a 'leaven', he says at one point, or 'only a piece of brick used

to knock at the gate' (105-106). The real object of the *kōan* always lies beyond itself. It aims 'to strike at the root of our everyday experience', principally by 'the arousing of doubt and pushing it to its furthest limits' (108). Having been provoked into an 'inquiring attitude' via the *kōan*, he added, the novice must then 'go on' until 'he comes to the edge of a mental precipice, as it were, where there are no other alternatives but to leap over' (105). This idea of the *kōan* as a challenge to look and think beyond our current frameworks and assumptions informs every aspect of Xu Bing's own search, through the medium of his art, 'for a new method of understanding'. It is also what makes his work so compelling and unnerving, whether we are looking at it for the first or the fiftieth time.

For those of us rash enough to write about the pleasures and perils of this experience in catalogues like this Xu Bing poses a further inescapable challenge. 'Handing one's work to society', he remarked in February 1989, a few months after making his Beijing debut, 'is just like driving living animals into a slaughterhouse.'[5] Expressing the kind of disquiet many emergent young artists feel as their work becomes part of a larger public discourse over which they have no control, he went on: 'The work no longer belongs to me; it has become the property of all the people who have touched it. It is now concrete and filthy.' Tellingly, he made these remarks well before his early work, as well as the mid-1980s New Wave movement it was taken to epitomise, began to attract hostile criticism, first from established Chinese art critics and then from the Ministry of Culture itself, following the epochal Tiananmen Square protests on 4 June 1989. In figuring critics, curators and all the other intermediaries who make up the contemporary art world as butchers in charge of a slaughterhouse, Xu Bing did not, in other words, simply have conservative or official commentators in mind. All second-order reflection is, on this analysis,

potentially filth that not only sullies the purity of the artist's intentions but is lethal to the work itself. It is as if commentary is by definition parasitic: it feeds off inventive works, now figured not as 'computer viruses' but as 'living animals', adding nothing but its own unproductive, ultimately toxic grime. Hence the challenge and the obvious question for any commentator on Xu Bing's art: can the relationship between commentary and art be construed in more positive terms, as, say, symbiotic, bringing a mutual benefit to both practices? Given the way his work frequently troubles the borders between languages and cultures, this question forms part of a much larger one about the sometimes fraught intersection between different intellectual, linguistic and artistic traditions, exposing the often too sheltered world of art criticism to the unpredictable currents of our intercultural modernity. What follows is a sequence of four

Fig 1 *Tianshu* (Book from the Sky), 1987-91, woodblock printed book in four volumes, 49 x 33 x 10 cm

short commentaries addressing various aspects of this challenge, focusing not just on the pressure Xu Bing's work brings to bear on 'our familiar patterns of thought' but, unavoidably, on the more primordial questions 'whose thoughts?' and 'which patterns?'.

Sensible/intelligible: *Book from the Sky*

The work that initially made Xu Bing's name, the monumental installation *Tianshu* (1987–91), now generally known in English as *Book from the Sky*, divides its viewers into two groups: those who can read traditional Chinese characters and those who cannot (fig. 1). When it was first exhibited in Beijing towards the end of 1988, a subset of the former group found much to praise in the way it juxtaposed a meticulous rendering of conventional Chinese print forms with a vast, absurdist register of illegible characters, all, once again, produced with scrupulous attention to detail. Yet, as Stanley K. Abe notes, 'there was also considerable perplexity over whether to read the work as a critique, or as an instantiation of Chinese culture, or as both.'[6] All this predated the adverse comments it attracted after Tiananmen. When *Tianshu* reached the United States in the early 1990s, the initial response was very different. There it was most often considered 'an audacious political statement', allegorised through American perceptions of the 1989 protests and communist China more generally.[7] Such responses tended to ignore the fact that Xu Bing started work on the project in 1987 and that it was first exhibited before the protests. When it was not being presented to American viewers as a direct 'political statement', however, *Book from the Sky* was celebrated as an astonishing aesthetic object. As the catalogue for one of the first US exhibitions noted, for those who can read Chinese it 'frustrates the viewers' inescapable urge to decode the written word', adding that once 'he' can 'let go' of this 'urge', then 'he can accept and appreciate its beauty'. By contrast, those without Chinese were, it said, from the start 'free

to absorb the work's beauty without having to confront its unintelligibility'.[8]

The difference between the initial Chinese and American responses is marked, testifying, as Abe and others have shown, to the hold cultural mythologies – American as much as Chinese – have over the way works of art are understood. Yet what is perhaps more striking about these responses are the assumptions they share about *Tianshu*'s status as a certain kind of object, or assemblage of objects, and about the act of reading. Whether focusing on the illegibility of the mock characters, or, conversely, on the aesthetic appeal of the project as a whole, the suggestion is that the characters alone belong to the realm of the intelligible, or the potentially intelligible, and so ask to be read as signs. As the US catalogue put it, the 'urge to decode' centres on the 'written word', implicitly relegating all the other material features of the project – the reams of paper, the look of the printed pages themselves, the physical layout of the installation and so on – to the realm of the sensible, or what the catalogue called 'beauty'. This 'urge' is perhaps 'inescapable', given the nature of writing. For any mark, let's say 'x', to function as a repeatable written or printed sign – as, for example, the twenty-fourth letter of the English alphabet, representing the sound value 'ɛks' – we need to recognise that X, **X**, and *X* are in some sense all the same. As a celebrated series of psychological experiments carried out in the 1930s revealed, however, this seemingly automatic tendency to bracket off the material form and context of written or printed signs is a powerful habit that literate people acquire in the process of learning to read. John Ridley Stroop, the American psychologist who conducted the research, was interested in studying cognitive reaction times, not in the consequences of literacy. In fact, he barely acknowledged that his subjects comprised around seventy, highly literate US college students. Yet, in discovering what came to be called the 'Stroop effect', he

established that this elite group saw printed words first and foremost as abstract, intelligible signs, rather than as concrete, sensible marks. They had no trouble reading the word 'red', for instance, no matter whether it was printed as RED, RED, **RED** or RED; they experienced some difficulty, that is, a slight cognitive delay, however, when asked to identify the colour rather than the word when confronted with a card saying RED. In their 'urge to decode', they effectively put the intelligible (the word) before the sensible (the colour), and so had to work against that 'natural' tendency in order to give the correct answer 'green'.[9]

This is one of the 'familiar patterns of thought' that *Book from the Sky* disrupts not simply by using thousands of nonsensical Chinese characters, but by presenting them in a particular form and a specific material context, all of which are, in fact, highly legible if you have some knowledge of Chinese print traditions and if you are willing to broaden your conception of what constitutes a decipherable sign. Though the characters are unreadable, for instance, the font in which they are printed is not. Xu Bing consciously based his mock characters on the Ming dynasty (1368–1644) font, itself derived from the earlier Song style, which is associated with the first widespread use of print in China and which the Chinese state subsequently adopted as its official font. He also carefully modelled the stroke configuration of his nonsense characters on the *hanzi* conventions of the eighteenth-century *Kangxi Dictionary*, once again linking them to officially codified cultural forms. Finally, he printed them, using artisanal woodblock techniques (of the moveable kind developed in China some two centuries before Gutenberg) and orthodox typographical designs, in three iconic publishing formats: Buddhist sutras or scrolls, traditional paper-bound and thread-stitched books, and modern poster-style newspapers.

As an assemblage of material signs, then, every aspect of the *Tianshu* installation pointed to official or elite culture and its canonical

print media. The difference was that all these seemingly ordinary publications were also supersized, arranged in a monumental display in an art gallery, and, of course, printed with meaningless nonsense. As a consequence, the material signs, which are at once sensible-intelligible, cast a particularly interrogative light on the linguistic characters, which are no less sensible but completely unintelligible, and vice versa. The medium, in this case, is the anti-message. By challenging the way literate viewers conventionally distinguish the intelligible, what is supposedly understood in the mind, from the sensible, what is supposedly apprehended via the senses, there is no doubt that Xu Bing had among his targets the producers of Chinese elite culture. Yet, by asking questions about how we read and understand signs, he evidently had the 'familiar patterns of thought' of its consumers in mind as well. The fact that an early version of the project included nonsense Chinese/English bilingual books suggests that he was from the start aware that his audacious, category-confounding anti-statement had wider implications. Blindness to the materiality of things bred of the 'urge to decode the written word' is, as Stroop demonstrated, not peculiar to Chinese literate culture. As *Tianshu* showed, such blindness is also not exclusive to those taught to read the 'Western' phonetic alphabet, contrary to what the Canadian communications theorist Marshall McLuhan claimed in *The Gutenberg Galaxy* (1962). Xu Bing reinforced the cross-cultural implications of his project in 1991 with *A Dictionary of Selected Words from A Book from the Sky*, which mimicked European typographic and book conventions, offering bogus English definitions of the original mock Chinese characters.

Word/object: *Monkeys Grasp for the Moon*

Book from the Sky marked the beginning of Xu Bing's search for a 'new method of understanding' centred on writing, seen not as an abstract system of signs but as a culturally specific

material practice, a search informed at every point by a deeply felt scepticism about literate culture and, more importantly, about literate modes of understanding. This scepticism has a long history in what we still clumsily call 'the West'. In the *Phaedrus*, which is often taken to be the founding text of this tradition, Plato, for instance, has Socrates condemn anyone who thinks 'written words were anything more than a reminder to the man who knows the subjects to which the written things relate'.[10] St Paul of the Christian New Testament takes this further. For him writing is not so much a dispensable aide-memoire as a threateningly murderous force. 'The letter killeth,' he declares, 'but the spirit giveth life.'[11] Such concerns resurface in 'Western' literature as well, perhaps no more strikingly than in Dickens' novels. With his cast of illiterately or semi-literately honourable heroes (Sam Weller, Joe Gargery and Jo, the crossing-sweeper, to name just three) and his scorn for all official institutions of the written word – think of the spurious verbiage that emanates from the governmental Circumlocution Office in *Little Dorrit*, or the nightmarish documentary maze that is the Court of Chancery in *Bleak House* – Dickens gave Socrates and St Paul's high-minded scepticism a new, more populist life in the English novel. Of course, like his illustrious predecessors, he expressed his anxieties about the deforming effects of writing in writing, an irony that has always haunted this tradition.

As Xu Bing's works repeatedly attest, this scepticism has an equally long history in what we still clumsily call 'the East'. This is particularly evident in *Monkeys Grasp for the Moon* (2001–2003), a site-specific sculpture originally made for the Smithsonian's Arthur M. Sackler Gallery in Washington DC. A second version has been on display at the US Embassy in Beijing since 2008. This vast suspended sculpture is based on the Chinese proverb from which its title is derived, that itself alludes to a traditional Buddhist folktale

about a group of monkeys who try to rescue the moon from a well. In the story the monkeys lower themselves into the well by forming a chain, linking their arms and tails. Once the final monkey reaches its hand into the water, however, they are amazed to discover that what they have been trying to save is merely a reflection. The actual moon, they then see, is still floating serenely above them in the night sky. According to the Smithsonian's website, the moral of this Aesop-like fable is that 'the things we work hardest to achieve may prove to be nothing but an illusion'.[12] Adding a somewhat obscure political dimension to this interpretation, it then links this moral to a statement made by Soong Mayling, the most famous wife of the Chinese nationalist leader Chiang Kai-shek, to the US Congress in 1943: 'We in China, like you, want a better world, not for ourselves alone, but for all mankind, and we must have it.' The explicit justification for relating this quotation to the fable is that the sculpture, which Mayling's family gifted to the Sackler, was intended to commemorate her 'historic visits to the Joint Session of Congress in 1943 and a memorable return to the U.S. Capitol in 1995'. Yet, given what they take to be the fable's wryly mournful moral, the precise political significance of this juxtaposition remains unclear. Does the family's generous bequest imply that the story is about the failed American efforts to broker peace between Chinese nationalists and communists in the 1940s? Or about Mayling herself, who as an Anglophile Christian, embodied many of America's hopes for China? Or about Sino-US relations in general? It is difficult to be sure which strivings and which illusions are most pertinent.

Xu Bing's explicitly verbovisual rendering of the fable makes these interpretations seem even more uncertain. In his version, the chain of monkeys becomes a colossal interlinked series of ornately carved wooden signs, representing the word 'monkey' in over twenty languages and almost as many stylised scripts, ranging from 'aap'

(Afrikaans, Roman) to 'बंदर' (Hindi, Devanagari), all made to resemble monkeys. The moral of *his* fable, it seems, is that all the world's languages, especially in their written or printed forms, strive vainly to grasp the objects of experience, though, in reality, all they point to are reflections of things, not the things themselves. This sounds like a familiar expression of postmodern doubt, akin, say, to the questions Kosuth raises about language and representation in his installation series *One and Three Chairs* (1965). In this series, Kosuth set an ordinary chair alongside a full-scale photograph of it and an extract from Eric Partridge's *Origins: A Short Etymological Dictionary of Modern English* (1958) detailing the history of the word 'chair'. The extract shows how the English word, which is derived from the Greek *kathedra*, refers not just to ordinary objects in its literal sense, but to positions of authority in its many figural guises (e.g. 'a professorial chair' or 'to chair a committee', hence the expression *ex cathedra*, which means literally 'from the chair'). Reflecting Kosuth's playful engagement with Platonic theories of knowledge, the installation asks its viewers to consider the troubled relations among words, images and things. For Plato, of course, all three elements of the installation are only shadowy, imperfect illusions, since the real chair, in his view, is the abstract idea or essence of 'chairness' as defined by the philosopher kings who rule his ideal republic.

With *Monkeys Grasp for the Moon*, Xu Bing took these concerns to another level, reflecting his identification not so much with postmodern conceptualism or Platonic idealism but with the 1,500-year-old Zen/Chan Buddhist tradition of 'radical empiricism', as Suzuki termed it (132). 'All Buddhist teachings as propounded in the sutras and sastras are treated by Zen', Suzuki explained, adding a further gloss to *Tianshu*, 'as mere waste paper whose utility consists in wiping the dirt of intellect and nothing more' (38). The reason for this is that Zen was, in his view, founded on the

primacy of 'simple, unsophisticated experience' (33). Around this, Suzuki admitted, Zen 'constructs all the verbal and conceptual scaffold which is found in its literature', but, as we have seen in his account of the *kōan*, this remained merely 'an elaboration and artificiality', the 'whole significance' of which is lost 'when it is taken for a final reality' (33). The *kōan*, he added, once again insisting on its status as means not an end, is 'an index-finger pointing at the moon' (106). This phrasing reiterated an ancient Zen saying to which Suzuki referred more than once in his introduction: 'A finger is needed to point at the moon, but what a calamity it would be if one took the finger for the moon!' (74, 78) The bearing this has on Xu Bing's verbovisual interpretation of the traditional folktale about the monkeys delusional rescue mission is not difficult to see, though, if we follow this line of thought to its conclusion; it is no less clear that the message of his *kōan*-like installation is not simply that words should not be mistaken for the objects to which they purportedly refer. It is, rather, to quote Suzuki again, that the 'tyranny of the name' has to be overcome (60). 'Life itself must be grasped in the midst of its flow', Suzuki concluded, since, in the end, 'no amount of reading' can ever be adequate to the intensity of lived 'personal experience', and no 'name' can ever capture the being of things in their all their unrepeatable singularity (132).

Xu Bing's indebtedness to this tradition of 'radical empiricism' is evident in many of his works. It forms the background to *Tianshu* and resurfaces in various versions of *The Living Word* (2001–2002) installation, which shows the Chinese character for 'bird' (鳥) breaking free of its dictionary definition, returning via a history of writing to its pictographic origins, and ultimately gesturing to the vividly singular reality of living birds as it might be experienced in the world beyond the art gallery. It is there, too, in *A Case Study of Transference* (1994), arguably his most provocative comment on literate culture. In this installation, two live pigs,

one male, one female, one tattooed with nonsense English words, the other with illegible Chinese characters, contentedly get on with their wordless lives, eating, mating and excreting, in a pen strewn with discarded books and newspapers; meanwhile the human viewers look on, ideally in a state of awkward perplexity. Yet it was with *Monkeys Grasp for the Moon* that Xu Bing most explicitly aligned his own efforts to find a 'new method of understanding' with the long tradition of Zen Buddhist empiricism and its associated scepticism about literate culture. This act of alignment has a particularly testing resonance in the context of the Smithsonian in Washington and the US embassy in Beijing, two powerful institutions dedicated to promoting so-called 'Western' methods of understanding, many of which are fixated on pointing fingers.

Speech/writing: *Landscript*

Creating a heightened awareness of the treacheries of writing is, however, only one of Xu Bing's guiding preoccupations. His oeuvre also engages with the differences between the world's writing systems, particularly as manifest in the contrast between English, which is based on what is now commonly called the 'Roman script' with its phonetic alphabet, and Chinese, which reflects a long history of evolving logograms or characters, many of which are pictographic in origin. The impact these differences have had not just on writing as a cultural practice but as a concept in these respective linguistic traditions cannot be underestimated. The centrality of the phonetic system in Europe or 'the West', and, in the wake of colonialism, in much of the rest of the world, has, for instance, underpinned and been underpinned by a long philosophical tradition according to which writing is simply a second-order representation of speech. We have already seen this in Plato's *Phaedrus*. It is also evident in Aristotle's contention that 'words spoken are symbols of affections or impressions of the soul', whereas 'written words are symbols

of words spoken'.[13] This classical idea of writing, which enjoyed an extraordinarily long afterlife in European thought, eventually went on to shape the development of modern linguistics in the early twentieth century. According to the Swiss linguist Ferdinand de Saussure, who is usually credited as its founder, the new field had to concern itself with 'spoken forms alone' because 'language and writing are two distinct systems', and 'the second exists for the sole purpose of representing the first'.[14] This kind of thinking also shaped communications studies later in the century after Marshall McLuhan insisted in his influential introduction *Understanding Media* (1964) that 'the content of writing is speech'.[15]

Reflecting in part its pictographic rather than phonetic starting point, the Chinese tradition makes no such assumptions about the primacy of speech. The fifth-century writer Liu Xie, for instance, argued that 'when the mind is at work, speech is uttered', a claim Aristotle would no doubt have found uncontroversial. However, Liu Xie then went on to say that 'when speech is uttered, writing is produced', thereby blurring Aristotle's clear-cut, hierarchical distinction.[16] Liu Xie's subsequent observation that 'the Tao inspires writing and writing illuminates the Tao' only complicates matters further. As Coulmas explains, on this account, 'writing is credited with creative analytic potential: it illuminates the Tao', which, in this context, 'corresponds to nature, that is, things about which ideas are formed in the mind'.[17] Conversely, and again contrary to Aristotle, 'the Tao inspires writing, apparently unmediated by speech'. In other words, while Liu Xie acknowledges with Aristotle that speech constitutes an 'impression of the soul', and that it is linked to writing, for him it does not follow that writing has a secondary status or that it does not have its own shaping influence over how we see the world or grasp ideas. For Coulmas, this sensitivity to the creative self-sufficiency of writing as a system in its own right, not a

secondary replication of speech, can also be seen in the Zen Buddhist tradition, which, for all its scepticism about the 'cognitive value of writing', considers calligraphy to be 'one of the most highly valued and sublime arts' (6). Such respect, which is widespread throughout China, is part of Confucianism as well.

Xu Bing engages with these cultural and conceptual differences in a variety of ways. At times he treats them as an occasion for whimsical fun. The installation *A, B, C...* (1992), for example, comprises a series of thirty-eight ceramic blocks, mimicking the forms used in woodblock printing, each of which includes a traditional Chinese character that when read out sounds like the Roman letter stamped on the same block. In this play on phonetics, which amounts to a kind of dictionary for creating your own weird and wonderful sound sentences, the sounds represented in English by the letters 'A', 'B', 'C' can be approximated in Chinese by saying the characters for 'sorrow' (哀, 'ai' in pinyin), 'other' (彼, 'bi') and 'west' (西, 'xi'); whereas the sounds 'I', 'O', 'U', 'P' and 'V' come out in written Chinese as the sentence 'Oh Europe you fart danger' (唉 'ai', 欧 'ou', 幽 'you', 屁 'pi', 危 'wei').[18]

The extended *Landscript* (1999–) series reflects on these differences from the opposite angle and, in a more serious mood, by foregrounding the pictographic elements of Chinese writing and drawing attention to the intersections between calligraphy and painting in the Chinese tradition. *Landscript* (2000), for example, depicts a wooded mountainous landscape, much like the one Xu Bing experienced in rural China during his period of Maoist 're-education' in the 1970s, using the traditional characters for 'rain' (雨), 'apricot' (杏), 'tree' (木), 'pine' (松), 'stone'(石), and so on (fig. 2). Importantly, for Xu Bing, this is not just about the 'pictographic aspect of Chinese characters'.[19] It is also about the word-like aspect of Chinese painting, which students learn by practising repertoires of strokes outlined

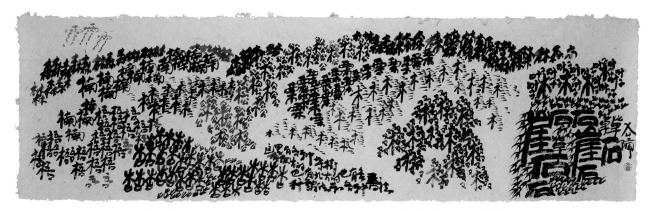

Fig 2 (Cat. 74) *Landscript*, 2002, Ink on Nepalese paper, Signed *Xu Bing*, One seal: Xu Bing, 50.0 x 173.0 cm. On Loan from the Khoan and Michael Sullivan Collection

in manuals that are more like dictionaries than anything else. This conjunction, he emphasises, is specific to Chinese culture not simply because its pictographic forms, whether in painting or writing, passively represent the world in certain ways, but because they actively shape it. Echoing Liu Xie's remarks about writing illuminating the Tao and vice versa, Xu Bing asks, in relation to Chinese window design, for example, 'did the construction pattern of Chinese windows influence the form of the character? Or did the character "window" (窗) influence the design of Chinese windows?' Underscoring his larger, cross-cultural argument, he notes that this visual and creative interchange is 'not present in alphabetic writing', which focuses on the transcription of sound values. Seen in the context of the *Landscript* series, and against the background of Stroop's phonocentric experiments, it is clear that Chinese characters, as pictograms, presuppose a relationship between the intelligible/cultural and the sensible/natural that alphabetic writing achieves only exceptionally, as in the case of onomatopoeic words like 'buzz', 'quark' or 'plop'.

We should not overplay these differences. It is worth recalling, for instance, that the English writing system includes a number of non-phonetic marks (notably, all forms of punctuation, not to mention the white space between words) as well as logograms (for example, '&' and '£'). In addition, you are sometimes required to call on considerable contextual knowledge to grasp some of its phonetic complexities. Think, for example, of what you need to know beyond the sound value of particular letters in order to recognise that the following sentence can be read – that is, sounded and understood – in at least two ways: 'Reading is fun'. Conversely, the Chinese system is not *only* pictographic. Some characters have a purely or largely phonetic function. To write 'mother' (妈) in traditional Chinese, for example, you need to combine the characters for 'female person' and for the phonetic value 'mǎ' – on its own the latter means 'horse' (马). Other characters are more conceptual than pictographic. Consider the differences 木 ('a single tree'), 兩棵樹 ('two trees'), 林 ('wood') and 森林 ('forest'). Xu Bing is aware of these nuances – hence the emphasis he places on the 'pictographic *aspect* of Chinese characters'. Yet his preoccupation with the cognitive and cultural dimension of this aspect, particularly as understood in contrast to the phonetic English alphabet, serves as a useful corrective to the ways in which traditional Chinese writing has commonly been understood in 'the West' and, indeed, in China at least since Mao.

The Polish-American historian I.J. Gelb, for instance, had no doubt about the place the Chinese logographic system occupied in the evolutionary narrative that informed his pioneering *A Study of Writing: The Foundations of Grammatology* (1952). 'The development of a

full Greek alphabet, expressing single sounds of language by means of consonant and vowel signs, is', he argued, 'the last important step in the history of writing.'[20] In comparison, Chinese, which is 'perhaps the most difficult system in the world to master', was self-evidently on a 'lower level' of 'evolution' (238). To make matters worse its complexities, in Gelb's view, brought significant social and political costs. They served 'rather well the needs of a selfish bureaucratic clique at the top' and ensured that '90 per cent of the population remain illiterate' (237–8). Gelb made these remarks just as the Maoist writing reforms of the 1950s, which led to the introduction of romanised pinyin, were getting underway, but his views continued to shape 'Western' attitudes for years to come. The only significant European thinker to take issue with his teleological argument and ethnocentric assumptions was Jacques Derrida whose *De la Grammatologie* (1967) remains the most powerful critique of 'Western' phonocentrism and its cultural-conceptual consequences. By foregrounding the impact 'the pictographic aspect of Chinese writing' has had on Chinese thought and culture, Xu Bing's *Landscript* series raises a similar set of questions to Derrida, albeit on its own terms and not just for 'the West' but for China after Mao as well.

Globe/village: *Book from the Ground*

The assumed primacy of speech, implicit in the history of how alphabetic writing systems have been understood, permeates everyday English usage. We talk about a young writer 'finding her voice', for instance, and frequently use the word 'talk' itself as a shorthand for 'think', 'speak' or 'write'. It is also there, albeit less obviously, in popular descriptions of the contemporary world as a 'global village'. The latest online edition of the *Oxford English Dictionary* identifies the first use of this phrase with Marshall McLuhan, its greatest champion. In a letter of 16 May 1959, McLuhan wrote:

The tribe is a unit, which, extending the bounds of the family to include the whole

society, becomes the only way of organizing society when it exists in a kind of Global Village pattern. It is important to understand that the Global Village pattern is caused by the instantaneous movement of information from every quarter to every point at the same time.[21]

In making this claim, McLuhan was echoing an observation that his friend, the English modernist writer Wyndham Lewis, had made a decade earlier in *America and Cosmic Man* (1949). 'The earth has become one big village,' Lewis remarked, 'with telephones laid on from one end to the other, and air transport, both speedy and safe.'[22] In their different ways both Lewis and McLuhan saw the globally interconnected world that was emerging in the post-war era as an intimate, though now large-scale, 'village' because new technologies made it possible to extend the reach of the oral, face-to-face communication characteristic of tribal life. As McLuhan put it in *The Gutenberg Galaxy* (1962), 'we live in a single restricted space resonant with tribal drums'.[23] Importantly, for McLuhan, the new re-tribalising electronic media – he had in mind radio, film and television – not only promised to overcome the 'visual bias' associated with Gutenberg's print revolution, which, in his view, set cultures on the 'paths of schizophrenia' by privileging the eye above all the other senses (29, 35). By recovering and extending 'audile-tactile' forms of sociability, they promised political emancipation as well, since print also fuelled 'aggressive' forms of centralisation, whether imperial or nationalist (21, 35). 'What we call "nations" did not and could not precede the advent of Gutenberg technology,' he said, 'any more than they can survive the advent of electric circuitry with its power of totally involving all people in other people' (front matter). Out of the conflict-ridden era of print nationalism and imperialism, he believed a new decentralised, interdependent age, a kind of e-cosmopolitanism, would emerge in which a supposedly peaceable village-like culture, rooted in *all* the primary

senses, would become a global force. Skype might be considered the closest we have come to a technological expression of McLuhan's hopes, though hybrid forms, like the aptly named Facebook, show just how different our digital present is to the future he envisaged in the 1960s.

Aspects of Xu Bing's *Book from the Ground* (2007–) project recall McLuhan's utopian vision, though it is also an implicit critique of his 'audile-tactile' cultural fantasies. Like McLuhan, he acknowledges that the politics of language and of the nation state are inseparable. Yet, whereas McLuhan put all the blame on print, Xu Bing recognises that spoken and written forms have had an equally important part to play in the way unitary national cultures are fashioned and imposed. 'Emperor Qin Shi [259–210 BC] eliminated the Six Kingdoms and unified the Chinese language,' he remarks in a supplementary note to his project, while 'Mao popularized "standard" Mandarin characters through political means'.[24] As in many other contexts – think of the English suppressing Gaelic in colonial Ireland, the elevation of Afrikaans in apartheid South Africa, or the predicament of the various Tibetan languages in today's China – this is done with 'the aim of effectively communicating orders and unifying a country'. In contrast to this, McLuhan, who never shied away from making grandiose claims about other cultures, looked to China and its 'ideograms' for an antidote to the deforming politics bred of what he took to be the 'visual bias' exclusive to the 'Western' phonetic alphabet. For Xu Bing, the other key difficulty with McLuhan's 'global village' is that it always risks becoming more like a global Tower of Babel, given its continued reliance on natural languages. Implicitly taking issue with McLuhan's primitivism, as well as his fixation on the evils of print, he points out that 'this "big village" differs from the villages that first gave rise to individual written scripts: the "villagers" now use a rich variety of different vocal systems, and write in sets of peculiar symbols that are incomprehensible to users of other sets, even though we live and

work together'.[25] In fact, the 'inconveniences of language', which are, in his view, not just entangled with questions of economic and political power but 'based fundamentally on shared ethnicity', have now become 'burdensome to humanity'.

To overcome these burdens we need, in his view, to bypass both written and spoken forms by reviving an idea for a 'Universal Script' modelled on the Chinese pictographic tradition, an idea that Xu Bing, following Umberto Eco, traces back to the seventeenth-century French thinker Jean Douet.[26] Douet himself was part of a wider group of European thinkers at the time who responded enthusiastically to the discovery that Chinese script was understood not just by the speakers of different Chinese dialects, but by the Japanese, the Koreans and others, a feature that continued to impress European commentators well into the twentieth century. Even a steadfast critic of the Chinese writing system like Gelb conceded that the 'small percentage of the population, who know how to read and write, can communicate with each other by writing even when speaking mutually ununderstandable dialects' (238). The challenge for today, according to Xu Bing, is to develop a 'writing system' that surpasses 'any current textual knowledge' and that is accessible to anyone 'immersed in contemporary life', no matter what their linguistic or cultural background. And so, like the American cultural anthropologist Margaret Mead who, contra McLuhan, saw the urgency of the need to create a new 'shared culture' in the mid-1960s that transcended natural languages, he looks to what Mead called '*glyphs*, that is, graphic representations, each of which stands for an idea: male, female, water, poison, danger, stop, go, etc.' 'What is needed, internationally,' Mead remarked, 'is a set of glyphs which does not refer to any single phonological system or to any specific cultural system of images, but will, instead, form a system of visual signs with universally recognised referents.'[27]

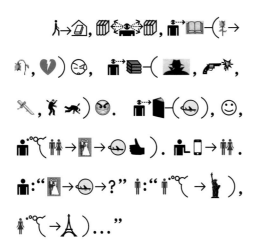

Fig 3 *Book from the Ground,* Guangxi Normal University Press, 2012

Book from the Ground, which exists as a website, an installation, a computer programme, a printed book, perhaps even as an ongoing generative dictionary, is Xu Bing's version of just such a system. Drawing on glyphs, or what he calls 'pictograms', developed in a variety of contexts over the past half century – from airport signage to international brand logos and from emoticons used for texting to the International Organization for Standardization – the book version tells the story of a day in the life of an ordinary, even slightly dysfunctional man. It captures not just his actions, but his feelings, dreams and bodily functions, as well as his complex interactions with others through a wide range of media, including the telephone, email, Skype and CNN. At one point, the man decides to visit a bookshop to buy gifts for a couple who are getting married. This is how the beginning of the scene is rendered (fig.3):[28]

A rough 'translation' into English produces something like the following:

> The man then visited a bookshop, where he found a bewildering array of books on offer. He considered a romance story, but he thought that was too sad [or he didn't like that?]; then he looked at a murder mystery, but felt it was too violent [or that it was an even worse choice?].

Finally, he settled on a travel guide, which he thought might appeal to both the man and the woman. 'After all', he thought, 'they are getting married and so will be going on a honeymoon.' To be sure, he decided to give them a call. 'Will you be flying somewhere for your honeymoon?' he asked. The groom-to-be replied: 'Yes, though I think we are going to New York, and she thinks we are going to Paris …'.

At first glance what is most noticeable about this translation is how much it shares with the original. Throughout *Book from the Ground,* Xu Bing uses English or Roman punctuation marks and some logograms like '&'. These marks alone demand a fair degree of literacy, making it less likely that with his book, as he hopes, 'the illiterate can enjoy the delight of reading just as the intellectual does'.[29] The use of complicatedly layered thought bubbles, derived from comics and cartoons, requires another kind of literacy.

Pointing this out seems ungenerously pedantic, given the extraordinary amount of nuanced, and often readily comprehensible, detail that the main pictograms are able to convey. Yet it is also when we turn to the pictograms themselves that the expressive limitations of the medium become more pronounced. This is in part because some, like the emoticons for 'sad' or 'violent', are potentially ambiguous. More significantly, the pictographic version, which is told from a particular point of view – third-person, since the narrator has access to all the characters' thoughts – has no way of signalling narrative temporality in the grammatical and literary sense; whereas, in the translation, I opted for the past, the traditional tense for storytelling, while also keeping to the equally traditional form of third-person narration. In addition, if we exclude the two iconic places mentioned, New York and Paris, it is noticeable that the original, and so the translation, uses no proper nouns. While the man and the couple remain nameless, the books and the bookshop are merely generic.

The consequences of these various limitations can be seen more clearly via a comparison. Here is another description of a man visiting a bookshop, this time taken from J.M. Coetzee's fictionalised autobiography *Youth* (2002):

> In the window of a second-hand bookseller off Charing Cross Road, on another of his expeditions to the city, he spots a chunky little book with a violet cover: *Watt*, by Samuel Beckett, published by Olympia Press. Olympia Press is notorious: from a safe haven in Paris it publishes pornography in English for subscribers in England and America. But as a sideline it also publishes the more daring writings of the avant-garde – Vladimir Nabokov's *Lolita*, for instance. It is hardly likely that Samuel Beckett, author of *Waiting for Godot* and *Endgame*, writes pornography. What kind of book, then, is *Watt*?[30]

In this passage what stands out most immediately, especially when compared to the Xu Bing extract, is the specificity of the detail: not just a 'bookshop' but a 'second-hand bookseller off Charing Cross Road'; not just a genre, but Beckett's *Watt* as published by Olympia Press. Equally noticeable is the importance, perhaps the oddity, of the temporal mode and narrative voice: present tense, third-person narration, which is, none the less, significantly coloured by the main character's knowledge and perceptions of the world. As readers we are effectively locked into an uncertain, always unfolding present and into the character's point of view. This leaves us in the tricky position of having to relate to the events of *Youth* through a third-person voice, which offers us little assurance about the difference between reality and perception. Finally, as the Coetzee passage reveals, natural languages are replete with abstract, often highly contested concepts, such as 'pornography', which are difficult – though, as Chinese shows, not impossible – to render pictographically.

Xu Bing is well aware of these limitations. In his supplementary note to the *Book from the Ground*, he expresses some 'embarrassment' at having to resort to a natural language to describe his project and he recognises that his new 'written script' is still at 'an elementary pictographic stage', particularly 'when compared to a mature written language'.[31] It is also doubtful that many features of his day-in-the-life narrative are as 'intuitive' or as culturally neutral as he would like. Consider the implicit gender assumptions about genre fiction, for example, or the idea of going on a honeymoon, or the joke about the couple's conflicting thoughts about their destination. Yet, as he rightly insists, focusing on these issues is not really the point, since the value of the project lies chiefly in the extent to which 'it presents to people a new perspective for looking at things'. In this sense, its real significance is not so much that it constitutes a 'new category of artwork', or that it prefigures a new form of communication, but that it raises important questions 'related to semiotic, visual communication, or typeface design', and, I would add, linguistics, translation, literacy and longstanding debates about international auxiliary languages, all of which have a particular pertinence for our interconnected, multilingual and multimedia age. That *Book from the Ground* also casts a new light on McLuhan's vision of a 'global village' only makes it more relevant as a resource with which to think about the culture and politics of expression today.

Post/script: *Art for the People*

How are we to place Xu Bing's work in a wider contemporary context? Is it, for example, best understood as part of a newly emergent, hybrid 'world culture'? It is not difficult to see why some might be tempted think so. His project of rewriting English words in Chinese character forms, generally known as Square Word or New English Calligraphy, seems, for instance, to satisfy our contemporary longing for new forms that translate across cultures and that

Fig 4 *Introduction to Square Word Calligraphy*, 1994–6. woodblock printed album, 38.9 x 23 cm. Ashmolean Museum, EA2009.35. Purchased with assistance from the Friends of the Ashmolean Museum

are peculiarly appropriate to our globalised, multicultural times (fig. 4). For the Smithsonian this is equally true of *Monkeys Grasp for the Moon*. To accompany the installation it has created a series of educational resources designed to help schoolchildren 'develop an understanding of and respect for diversity in language use, patterns, and dialects across cultures, ethnic groups, geographic regions, and social roles'.[32] Like campaigns for clean drinking water, this initiative is incontrovertibly a good thing, particularly given the age group (six to eighteen) for whom the resources are intended. For children who are in all likelihood emerging from a monocultural family background, *Monkeys Grasp for the Moon* has much to teach about cultural diversity, multilingualism and translation. Yet, as Xu Bing's own comparison of his work to 'a computer virus' suggests, and as I have attempted to show in these commentaries, this way of looking at his extraordinarily varied output misses something important about its peculiar and demanding intensity. In particular, by placing the emphasis on 'diversity *across* cultures', as if cultures are themselves readily identifiable, unitary things, it downplays the extent to which his work confronts challenging questions about the treacheries of translation, about the limits of

cultural hybridity and about what it means to be living through our dynamically inter-, rather than multi-, cultural modernity.[33]

Tellingly, in his own autobiographical reflections, Xu Bing conspicuously refuses to present himself as a free agent who is able to move among the world's cultures with effortless ease. As he put it in 2001, 'I am incapable of entering culture, and at the same time I am unable to escape it.'[34] The reason for the latter, he says, is that 'your cultural background and your life' is 'not of your own choosing': it is 'decided by fate' (19). In his case, as the child of academic parents born into Mao's China in 1955, this 'fate' was 'a jumbled knot of socialism, the Cultural Revolution, the Reform Period, Westernization, modernization' (13). As he sees it, this tangled 'knot' binds him ineluctably to a historically specific experience of a very particular, and fraught, cultural moment. Yet, if this speaks to his feelings of inescapable situatedness, it also goes some way towards explaining why he finds 'entering culture' no less taxing. His 'earliest education', which coincided with Mao's writing and other reforms, for example, left him 'confused about the fundamental conceptions of culture' (14). Later, these feelings were exacerbated as he experienced the effects of censorship, of 'being labelled "the bastard son of a reactionary father"' during the Cultural Revolution, and of discovering, during his own period of re-education, that older cultural traditions continued to survive in remote rural areas of China, despite being officially proscribed (16). Importantly, his experience of living through Mao's China did not just leave him feeling dislocated. It also shaped his abiding wariness about cultural elites, evident not only in his continued respect for Mao's campaign to promote 'Art for the People', but in his efforts to encourage active participation among all ages and backgrounds in initiatives like the Forest Project and the *Square Word Calligraphy Classroom*. (Cat. nos. 91–3; p.149 fig.2). Art, in his view, as

in Mao's, is not an object of contemplation, but a way of acting in and on the world.

The sense of confusion about what might constitute 'Chinese culture' that defined Xu Bing's early experience has remained with him, contributing to his sense of dislocation not just from his 'own culture' but from others as well. 'That which belongs to you is yours', he says. 'You may wish to get rid of it, but you cannot.' Equally, however, 'there are those things that do not belong to you and, regardless of your effort, will never belong to you' (19). These observations, which sit uneasily with popular ideas about cultural hybridity and translation, not to mention the basic tenets of 'Western' liberalism, have important implications for how he sees himself as a contemporary artist with a global audience. They also speak to the way we look at his work, since, like Xu Bing or indeed any artist, each of us is the bearer of what the literary critic Derek Attridge has called an 'idioculture'. What every viewer brings to an encounter with any artwork is, according to Attridge, a 'changing array of interlocking, overlapping, and often contradictory cultural systems absorbed in the course of his or her previous experience, a complex matrix of habits, cognitive models, representations, beliefs, expectations, prejudices, and preferences that operate intellectually, emotionally, and physically.'[35] While this 'idioculture' may be 'fated', as Xu Bing puts it, it is not unalterable. After all, as an artist who seeks to disturb 'our familiar patterns of thought' and in the end to oblige us 'to find a new conceptual foundation', this idiocultural 'matrix' is his primary target. Importantly, this way of describing his interventionist ambition, which, as I have suggested, comes from the Zen Buddhist tradition, has little to do with celebrating cultural diversity or even the promise of a harmonious

'world culture' fostered by translation. Rather, it foregrounds Xu Bing's effort to disclose and then disrupt the boundaries of every viewer's 'idioculture', or, to use his own words, to open up 'the space between understanding and misunderstanding, as concepts are flipped, customary modes of thought are thrown into confusion, creating obstacles to connections and expression'.[36]

For Xu Bing, this disorienting space, which exists beyond the ultimately reassuring promise of translation, is what defines the intercultural world we now inhabit, making it at once a place of infinite inventiveness and endless uncertainty. It is also what makes viewing his works a vertiginous experience. Rather than building bridges across pre-defined cultures, each of his works takes us by various routes to the edge of our own 'idioculture', as we have seen, challenging commonly accepted distinctions between the sensible and the intelligible, word and object, speech and writing, East and West. At the same time, by creating a unique experience of doubt, each work also points beyond itself, like the *kōan* in Suzuki's formulation, to an as yet inconceivable future in which new 'patterns of thought' might emerge. Implicitly inviting us, as viewers, to forget the allure of aesthetic contemplation for its own sake, a temptation it is difficult to avoid in the comfortingly solid surroundings of the Ashmolean, each work asks us in its own way to 'go on', after we leave the exhibition, until we come 'to the edge of a mental precipice, as it were, where there are no other alternatives but to leap over'.[37] Not, perhaps, an easy lesson for schoolchildren or for the faint-hearted, but one that has compelling significance for our intercultural times. |PMcD

Notes

1 Xu Bing, 'An Artist's View', *Persistence/Transformation: Text as Image in the Art of Xu Bing*, eds. J. Silbergeld and D. C. Y. Ching (Princeton: Princeton University Press, 2006), 103–105.

2 Joseph Kosuth, *Art after Philosophy and After* (Cambridge, Mass.: MIT Press, 1991), 18.

3 R. Tomii, D. Elliott, et. al., *Xu Bing: Belief* (London: Albion, 2011), 49.

4 D. T. Suzuki, *An Introduction to Zen Buddhism* (1949; London: Rider, 1991), 104–105.

5 Wu Hung, 'A "Ghost Rebellion": Notes on Xu Bing's "Nonsense Writing" and Other Works', *Public Culture*, 6 (1994), 418.

6 Stanley K. Abe, 'No Questions, No Answers: China and *A Book from the Sky*', *boundary 2*, 25.3 (1998), 175.

7 J. S. Taylor, 'Non-sense in Context: Xu Bing's Art and its Publics', *Public Culture*, 5 (1995), 321.

8 Ibid., 323.

9 See John Ridley Stroop, 'Studies of interference in serial verbal reactions', *Journal of Experimental Psychology*, 18.6 (1935), 643–62.

10 Plato, *Phaedrus*, trans. Christopher Rowe (Harmondsworth: Penguin, 2005), 63 (275d1).

11 R. Carroll and S. Prickett, eds., *The Bible: Authorised King James Version* (Oxford: World's Classics, 1997), 224 (2 Corinthians 3:6).

12 'Xu Bing: Monkey's Grasping for the Moon', http://www.asia.si.edu/exhibitions/current/xuBing. asp, accessed 8 June 2012.

13 Aristotle, *Peri Hermenias (On Interpretation)*, trans. H. P. Cook (London: Loeb Classic Library, 1938), 115.

14 Ferdinand de Saussure, *Course in General Linguistics*, trans. Wade Baskin (New York: Philosophical Library, 1959), 23.

15 Marshall McLuhan, *Understanding Media* (1964; London: Routledge, 2001), 8.

16 Liu Hsieh (Xie), *The Literary Mind and the Carving of Dragons*, trans. Vincent Yu-chung Shih (Hong Kong: Chinese University of Hong Kong Press, 1983), 13–17.

17 Florian Coulmas, *Writing Systems* (Cambridge: Cambridge University Press, 2003), 4.

18 *Xu Bing: Belief*, 130.

19 Xu Bing, 'Landscript series', (p. 124) in Shelagh's new translation for the catalogue.

20 I. J. Gelb, *A Study of Writing* (1952; Chicago: University of Chicago Press, 1963), 184.

21 Marshall McLuhan, *Letters of Marshall McLuhan* (Toronto: Oxford University Press, 1987), 254.

22 Wyndham Lewis, *America and Cosmic Man* (New York: Country Life Press, 1949), 21.

23 Marshall McLuhan, *The Gutenberg Galaxy* (Toronto: University of Toronto Press, 1962), 31.

24 Xu Bing, 'Regarding Book from the Ground', http://www.bookfromtheground.com/home_english. htm, accessed 8 June 2012.

25 Xu Bing, 'Book from the Ground', unpublished ts.

26 See Umberto Eco, *The Search for a Perfect Language* (Oxford: Blackwell, 1995), 158–59.

27 Margaret Meade, 'The Future as the Basis for Establishing a Shared Culture', *Daedalus*, 94.1 (Winter 1965), 148–49.

28 Xu Bing, *Book from the Ground*, 2012 book version, 41–42 (fig. 3).

29 Xu Bing, 'Book from the Ground', unpublished ts.

30 J. M. Coetzee, *Youth* (London: Secker & Warburg, 2002), 155.

31 Xu Bing, 'Book from the Ground', unpublished ts.

32 Smithsonian Education, 'Transforming Language: Xu Bing's Monkey's Grasp for the Moon', http://www.smithsonianeducation.org/educators/ lesson_plans/transforming_language/index.html, accessed 8 June 2012.

33 For a more detailed account of the distinction between multiculturalism and the idea of the intercultural, see Peter D. McDonald, 'Thinking Interculturally: Amartya Sen's Lovers Revisited', *Interventions*, 13.3 (2011), 369–85.

34 Xu Bing, 'The Living Word', trans. Ann L. Huss, *Words without Meaning, Meaning without Words*, ed. Britta Erickson (Washington: Smithsonian, 2001), 14.

35 Derek Attridge, *The Singularity of Literature* (London: Routledge, 2004), 21.

36 Xu Bing, 'Living Word', 18–19.

37 Suzuki, *Introduction*, 105.

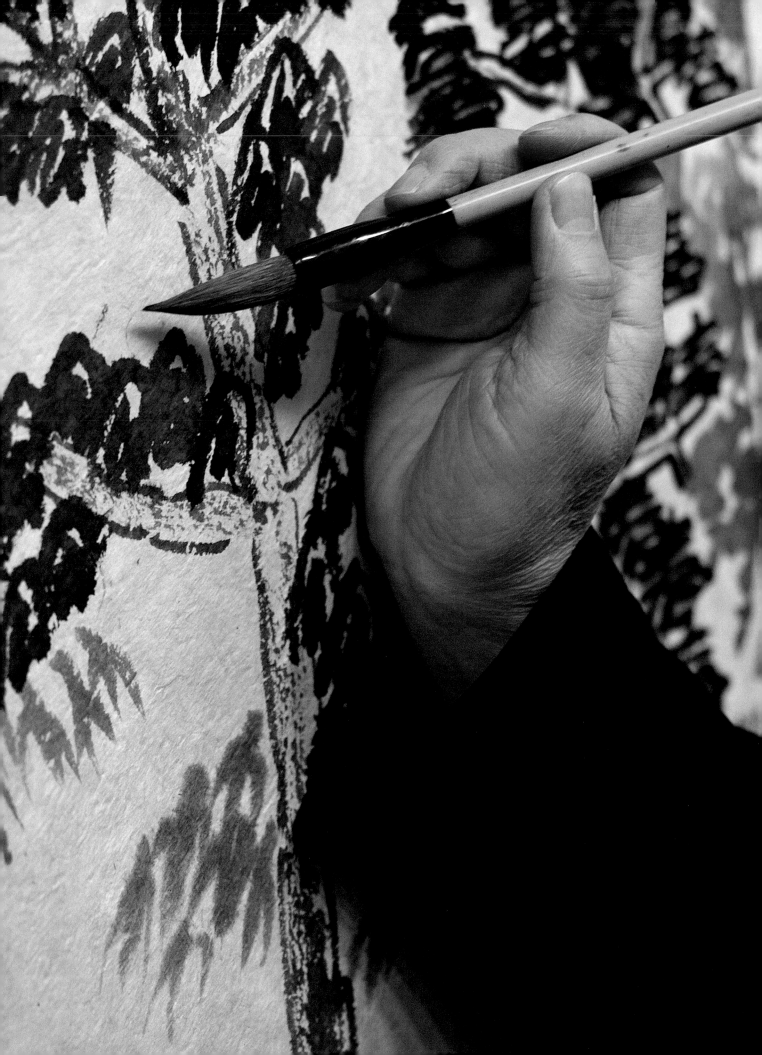

The Sort of Artist I Am

Xu Bing

I am first and foremost a typically Chinese person because once, in an attempt to make myself more 'profound', I went and read books on contemporary Western theory but eventually discovered that even after spending half a day's effort on it, the gain amounted only to a few dry concepts. When you read these sort of books you have to follow closely step by step; it's like solving a mathematical problem – if you miss a step then you don't understand what the next part is saying, and it's wearing. But when occasionally I read books on Eastern philosophy by Eastern authors, on the contrary I feel extremely comfortable. These books are on the whole not thick, and every time I turn to a page at will and read a short passage I just feel that the book has articulated so clearly the things that I feel. So I firmly believe that I am a Chinese person through and through, of the species 'Chinese artist'.

Secondly, I am a person who occupies a position of awkwardness in relation to culture. When I was still small I heard of Liang Shuming's saying, 'If in your whole life you write one book then you are rich'. This made me worship people who can write books. To write books you need to have culture – writing them is not something that everyone can achieve.

I grew up on the campus of Peking University and was surrounded by people who could write books, but my generation did not receive a proper education; this has meant that there has always been a sense of intractability between me and culture, and this awkwardness is reflected in my art. I like using text in my work as it gives people a strong sense of books and scrolls, this is entirely the behaviour of a 'culture vulture'. My characters function in complete opposition to that of regular characters: they are a dictionary with a virus, they obstruct the function of thought and are a type of 'troublemaking script'. Their inaccessibility makes people feel envious and provoked. This element, in the reckoning of some people, has made my work 'discomfiting to intellectuals'. One day I finally wrote a book that looked at first sight very like a book – it was incredibly serious, in fact it was bound in a way that looked very learned, but the characters were entirely wrongly written. Recently I went on to make a book using signs that you can see everywhere, it is a book that everyone can read – this has at last levelled the educated and the illiterate, and I think it's great.

Furthermore I am a persistent person, when I've set my mind on something

I do it heart and soul. For example, for mainland artists of my generation our earliest established view of art was a socialist one, which was, roughly: art comes from life, art is higher than life, art returns to and enriches life. I have discovered that no matter where I go I have never departed from this artistic mindset. Those fashionable theories of modern art are for me a kind of reference for pondering artistic problems, yet it's very difficult for them to dislodge the 'obsolete' ideas that already occupy the dominant position in my mind. My skill therefore is this: firmly grasp the life of the times; if the times become modern then I am a modern artist; if the times step into the contemporary then I am a contemporary artist; if the times fling me outside the country then I become an international artist. Today's China is an extremely experimental place and we live in the midst of it, so I should be an extremely experimental artist.

So in fact, the kind of artist I myself am is only understood through turning around and looking at my works – this is more authentic than other people's evaluations or my own explanation. |XB

Translated by Shelagh Vainker

Xu Bing Biographical Timeline

The exhibitions listed here are solo exhibitions only. For a comprehensive exhibition history and listings of lectures, publications and single-work displays the reader is referred to Reiko Tomeii, ed. , *Xu Bing: Belief,* (London, 2011).

1955
Born 8 February in Chongqing, Sichuan province.

1956
The family moves to Beijing, where Xu Bing's parents Xu Huamin and Yang Shiying both work at Peking University.

1962
Peking University Junior School. In 1966 the Cultural Revolution (1966–76) began and classes were suspended.

1968–72
Peking University Middle School as a work-study student. In the absence of many members of the teaching staff, students were encouraged to take on teaching and Xu Bing undertook art instruction and work for the school's propaganda office.

1972–3
Peking University Senior School. During this period Xu Bing continued to produce creative work for the school.

1974–77
Xu Bing spends three years in the remote village of Shouliang Gou in the Taihang mountains in northern Hebei province as a 'sent-down' Educated Youth. Daytimes were spent in agricultural labour, and he drew and painted before or at the end of the working day. Xu Bing also produced calligraphy for the villagers, and typography and artwork for the Huapen Commune magazine *Brilliant Mountain Flowers* that he and his friends initiated.

1977–81
Central Academy of Fine Arts, Beijing. Xu Bing studied in the printmaking department, and began work on the ten-year series of small woodcuts titled *Shattered Jade.* Prints and drawings he produced in 1980 for his 1981 graduation project were exhibited in Beijing, Paris and London.

1981–90
Central Academy of Fine Arts, Beijing. After his graduation in 1981, Xu Bing was retained as an instructor at the Central Academy. He introduced new teaching methods for drawing and wrote numerous articles about teaching, creativity and other aspects of art. He travelled extensively throughout China, particularly in the north, and read widely the Western writing on art, philosophy and literature that became available following China's opening up to the rest of the world during the 1980s. His

own art moved away from the rural subjects and mid-twentieth century approaches of his undergraduate years towards both technical and conceptual experimentation.

1987
Master of Fine Arts, Central Academy of Fine Arts, Beijing. Xu Bing's thesis exhibition included the *Series of Repetitions* woodblock prints and the *Stone Series* mezzotints.

1988
Xu Bing Printmaking Exhibition, National Art Museum of China, Beijing. The exhibition included the first finished section of *Book from the Sky.*

1989
Huo Yingdong Education Foundation Award, China National Education Association.

1990
Moves to the USA as fellow at the University of Wisconsin-Madison.

1991
Completes *Book from the Sky.* It was exhibited complete for the first time at the Tokyo Gallery, Japan. In his first solo exhibition in the US, 'Three Installations by Xu Bing', at the Elvehjem Museum, University of Wisconsin-Madison, *Book from the Sky* was exhibited with *Ghosts Pounding the Wall* and *Series of Repetitions.*

1992
Moves to Vermillion, South Dakota. Solo exhibition at the North Dakota Museum of Art.

1993
Moves to New York. Exhibitions in Ohio, Beijing and Sydney.

1994
Begins work on *Square Word Calligraphy*. Exhibitions in Beijing, Madrid and New York.

1995
Begins work on *American Silkworm Series*. Solo exhibitions in North Dakota, Minnesota, Chicago and South Dakota.

1996
ArtPace Foundation Resident Artist. *Introduction to Square Word Calligraphy* exhibited for the first time. Appointed to the Artist Advisory Board of the New Museum of Contemporary Art, New York.

1997
2nd Johannesburg and Gwangju biennales. Exhibition at the Institute of Contemporary Art, London.

1998
Pollock-Krasner Foundation grant. Exhibitions in New York Mexico, Ottawa, Tokyo.

1999
MacArthur Fellows Program award, the John D. and Catherine T. MacArthur Foundation. Xu Bing visited the Himalayas and drew the first landscript sketches. Exhibitions in Bonn, Cologne and New York.

2000
Completes *The Helsinki-Himalaya Exchange*; money placed by visitors in the Nepalese donation box Xu Bing installed in the Helsinki exhibition made possible the construction of an elementary school in Nepal. Exhibitions in Prague, New York and Durham, North Carolina; contribution to Sydney Biennale.

2001
Major exhibition *Words without Meaning, Meaning Without Words: The Art of Xu Bing* at the Sackler Gallery, Washington, D.C., with accompanying catalogue by guest curator Britta Erickson. Exhibitions at North Carolina, Portland Oregon and Taipei.

2002
Participates in exhibitions and projects in Guangzhou, Shanghai and Beijing. In Oxford, *Tianshu* and *Landscript* (cat. no. 74) were exhibited at the Ashmolean Museum in the exhibition 'The Khoan and Michael Sullivan Collection of Modern Chinese Art Part Two: acquisitions since 1979'.

2003
Arts and Culture Prize, Fukuoka Asian Culture Prizes 2003. Residencies at Hong Kong and Washington State. Named Honorary Professor by Central Academy of Fine Arts.

2004
Artes Mundi: Wales International Visual Art Prize 2004. Inaugural holder of Coca Cola Fellowship, American Academy in Berlin. Exhibitions in Berlin, Valencia and Shanghai.

2005
Youth Friends Award, New York City Department of Education and the School Art League. Exhibition at Wisconsin.

2006
International Association of Art Critics Award for Best Installation or Single Work of Art in a Museum, New England. Exhibitions at Stuttgart and Kansas. Contributions to 6th Gwangju Biennale and 1st Singapore Biennale.

2007
Southern Graphics Council Lifetime Achievement Award. Named member of the Guggenheim Asian Art Council. In Oxford, Xu Bing spoke at the 4th Ashmolean Chinese Paintings Colloquy, 'Printmaking in Modern China' held in conjunction with the exhibition *Chinese Prints 1950-2006,* which included Xu Bing's print *Lost Letters* (1997).

2008
Returns to Beijing to become vice president of the Central Academy of Fine Arts. *Forest Project* exhibited for the first time, at the Museum of Contemporary Art, San Diego. Exhibition in Virginia. Begins work on *Phoenix Project*.

2009
Exhibitions *Xu Bing: the Path of Repetition and the Imprint* at Today Art Museum, Beijing and Tianshu: *Passages in the Making of a Book* at Bernard Quaritch antiquarian booksellers, London.

2010
Honorary Doctor of Humane Letters, Columbia University, New York. In Oxford, *Introduction to Square Word Calligraphy* was exhibited at the Ashmolean Museum in the exhibition *The Past in the Present: Script and Archaism in Modern Chinese Art*.

2011
Mustard Seed Garden Landscape Scroll exhibited for the first time, at the Museum of Fine Arts, Boston. Exhibition at Richmond, Virginia. *Background Story 7* at the British Museum.

2012
Exhibitions in Taipei and Shanghai. Contribution to the 30th Sao Paulo Biennale. *Phoenix Project* at Massachussetts Museum of Contemporary Art.

Further Reading

Reiko Tomii's excellent *Xu Bing: Belief* (London, 2011) provides a comprehensive account of Xu Bing's life and career. Tomii's extended biographical essay is supported by shorter contributions from David Elliott, Robert Harrist and Andrew Solomon: a select bibliography of works by and about the artist and a select exhibition history run to nearly thirty pages. The exhibition catalogue 徐冰版画: *Xu Bing Prints* (Beijing, 2010) includes important essays by Xu Bing and a detailed timeline. Readers are referred to these two books and to www.xubing.com as primary sources on Xu Bing. In addition to these sources, much of the information for the present catalogue results from the author's conversations with Xu Bing, and access to archival material.

Erickson, Britta, *Words Without Meaning, Meaning Without Words: The Art of Xu Bing*, Washington, D.C. (Arthur M. Sackler Gallery) and Seattle, 2001.

Farrer, Anne, "Xu Bing's Mustard Seed Garden Landscape Scroll", in *XiaobingTang, Multiple impressions: contemporary Chinese woodblock prints*, Ann Arbor (University of Michigan Museum of Art), 2011, pp.22-5.

Hao, Sheng, *Fresh Ink: Ten Takes on Chinese Tradition*, Boston (Boston Museum of Fine Arts), 2010.

Robert Rauschenburg, A Retrospective. New York (Guggenheim Museum Publications), 1997

Suzuki, D. T., *Introduction to Zen Buddhism*, with a foreword by C. G. Jung, London, 1969. (First published 1934).

Today Art Museum, ed., 第二届中国当代版画学校展：特邀展：古元延安版画作品展：*The Second Exhibition of Chinese Contemporary Prints Specially Invited Exhibition: Prints by Gu Yuan in Yan'an*, Beijing, 2011.

www.xubing.com

Xu Bing, 徐冰版画: *Xu Bing Prints*, Beijing (Today Art Museum), 2010.

Xu Bing, ed., 中央美术学院素描60年: *Central Academy of Fine Arts 60 Years of Drawing*, 1949–2009, Beijing, 2009.

Xu Bing, 徐冰:木刻 小品 (*Xu Bing: small woodcuts*), Changsha, 1986.

Xu Bing,'他们怎样想? 怎样画? (*How do they paint? How do they think?*), 美术 (Fine Arts) 1985.7, pp. 28–32.

Xu Bing, 我画自己爱的东西 (*I picture things that I love*), 美术 (Fine Arts), 1981.5, pp. 18–9.

Acknowledgements

The idea for this exhibition evolved over the summer of 2011, and it could not have been realised in such a relatively short period of time without the support of many individuals and several institutions. I am grateful firstly to the Visitors of the Ashmolean Museum and the Board of the Faculty of Oriental Studies for sabbatical leave in 2011–12. The catalogue has been largely written while in Beijing in the second half of 2012, as J. S. Lee Memorial Senior Fellow attached to the Capital Museum. I wish to thank the Governors of the J. S. Lee Memorial Fellowship Programme and the Chinese University of Hong Kong for granting me this opportunity, and my colleagues at the Capital Museum for their warm welcome and stimulating discussions: Director Guo Xiaoling, Carol Li in the Foreign Affairs Department and in particular Li Mei, whose office I shared, and her colleagues in the Department of Research and Exhibitions. In Oxford I wish to thank the Director of the Ashmolean Professor Christopher Brown for his support, Susan McCormack, Head of Public Engagement at the Ashmolean Museum, for managing the project remotely and with such determination, and Publications Manager Declan McCarthy for ensuring the catalogue was successfully produced; I also wish to thank the Keeper of Eastern Art, Andrew Topsfield for his enthusiasm, Jon Whiteley in the Department of Western Art for help with French drawings and David Helliwell at the Bodleian Library with editions of *The Mustard Seed Garden Manual*. Neither the catalogue nor the exhibition could have happened without the professionalism and dedication of everyone at Xu Bing Studio and I should like to thank Jesse Coffino in particular for his help with so many aspects of the project. Judith Goldman and Peter D. McDonald have been constant sources of ideas, advice and inspiration and I am deeply grateful to them both. My most profound thanks are to Xu Bing: on my own part for his patience and his generosity and on behalf also, I anticipate, of all who read the catalogue or visit the exhibition, for creating the works of art presented in them. |SV